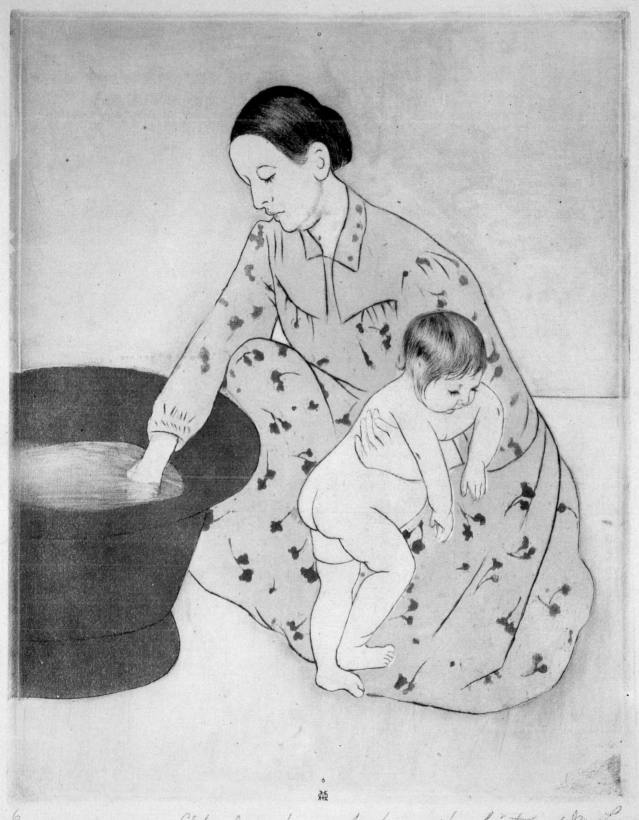

6 Edition de 25 epreuves Imprimé par l'atelier et M. Leroy

Mary Cassatt

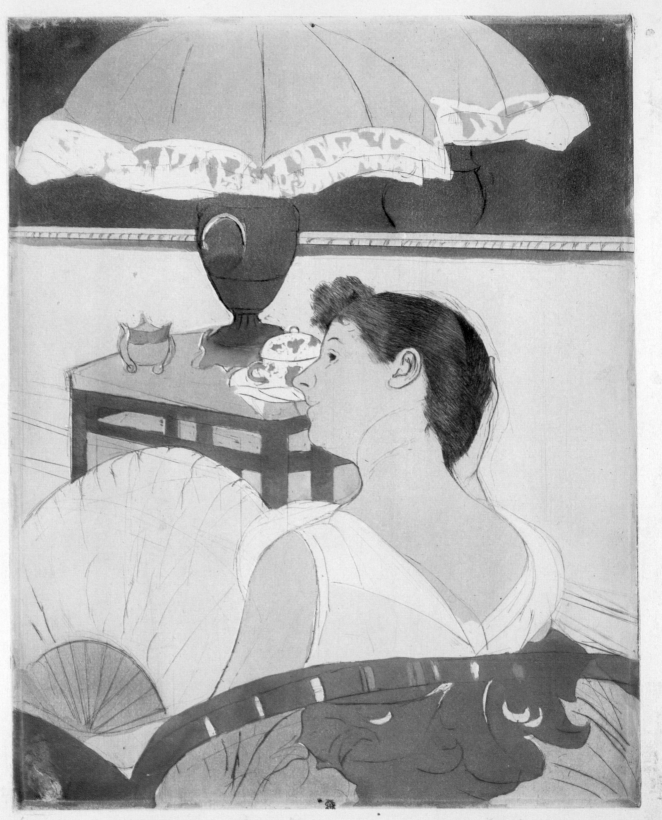

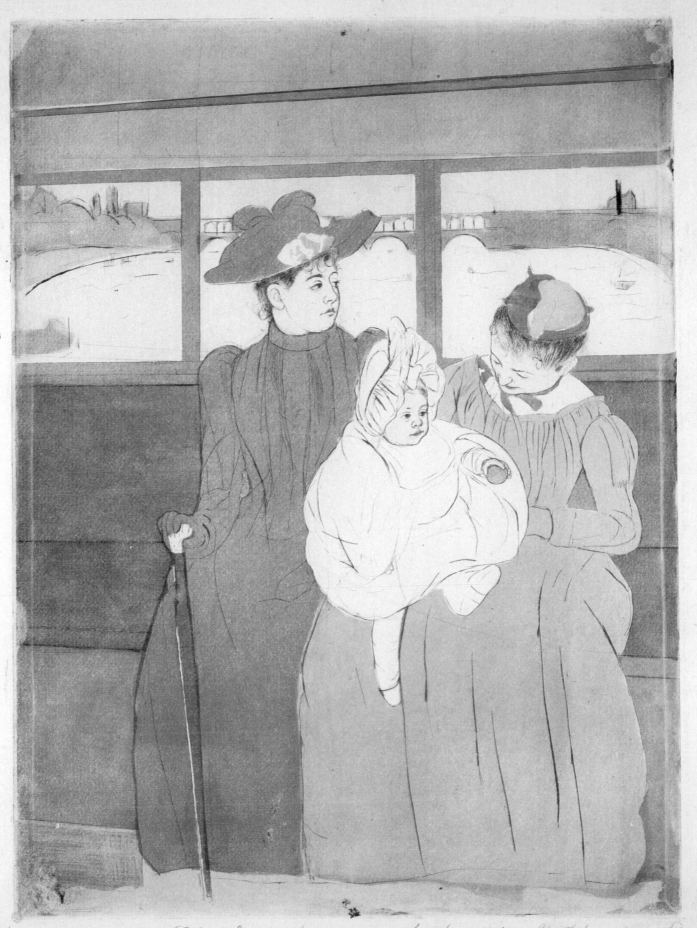

10 Edition de 25 épreuves Imprimée par l'artiste et M. Leroy

Mary Cassatt

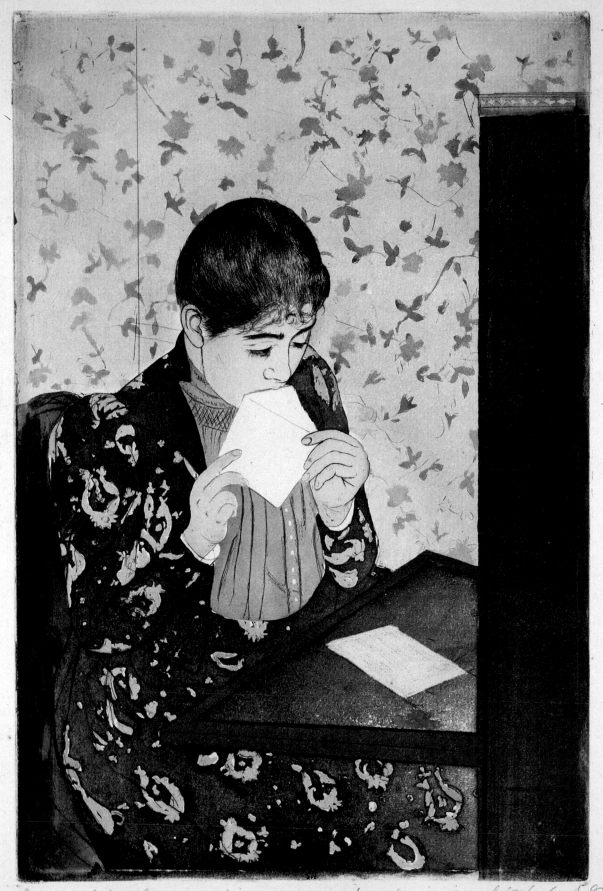

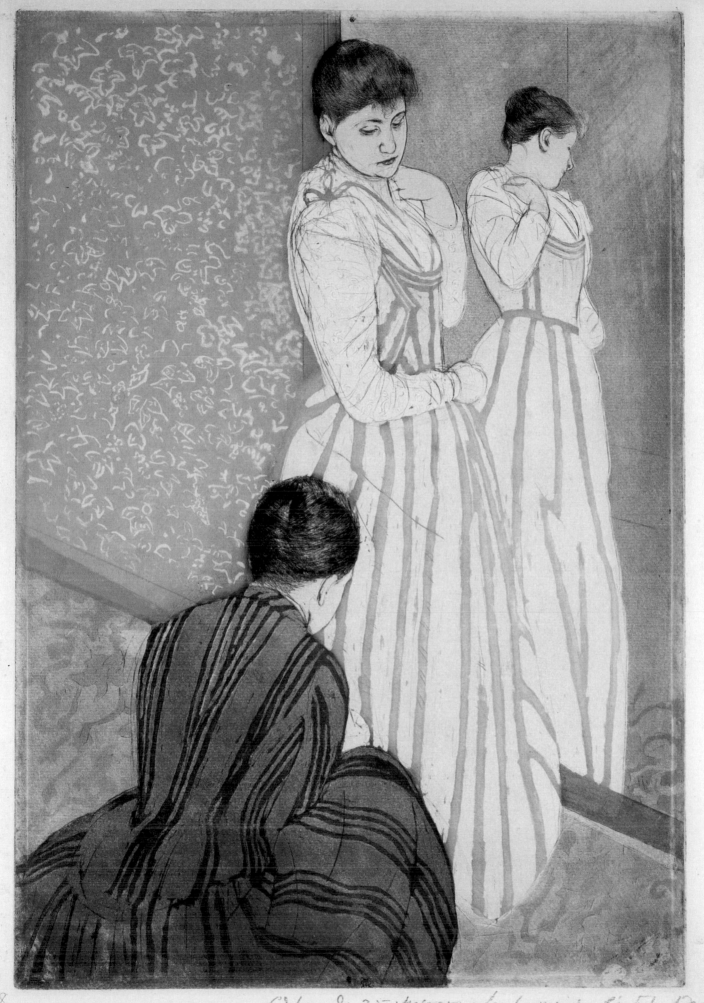

Edition de 25 epreuves Imprimées par l'artiste et M. Leroy

Mary Cassatt

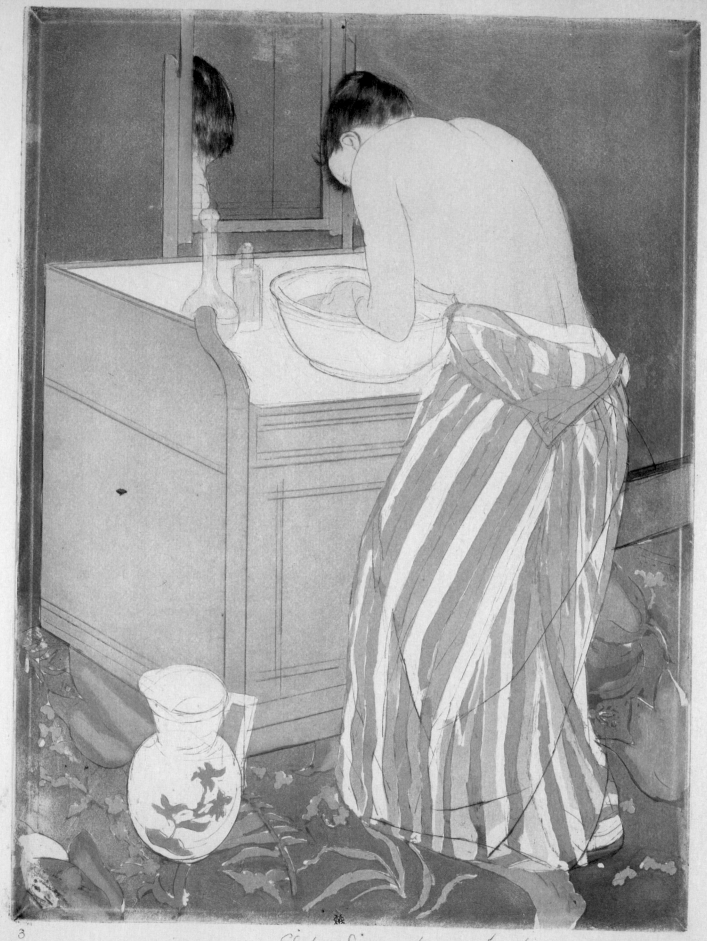

3

Mary Cassatt

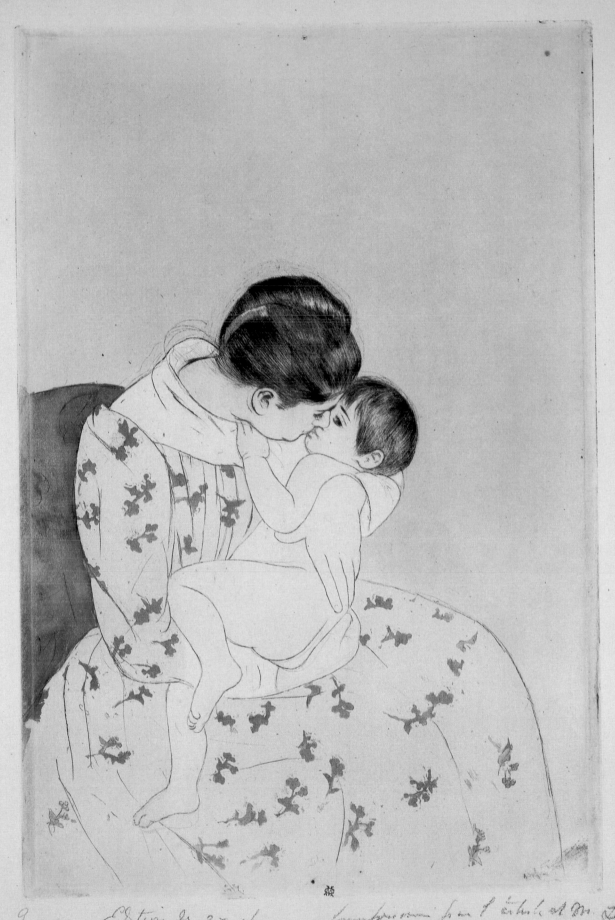

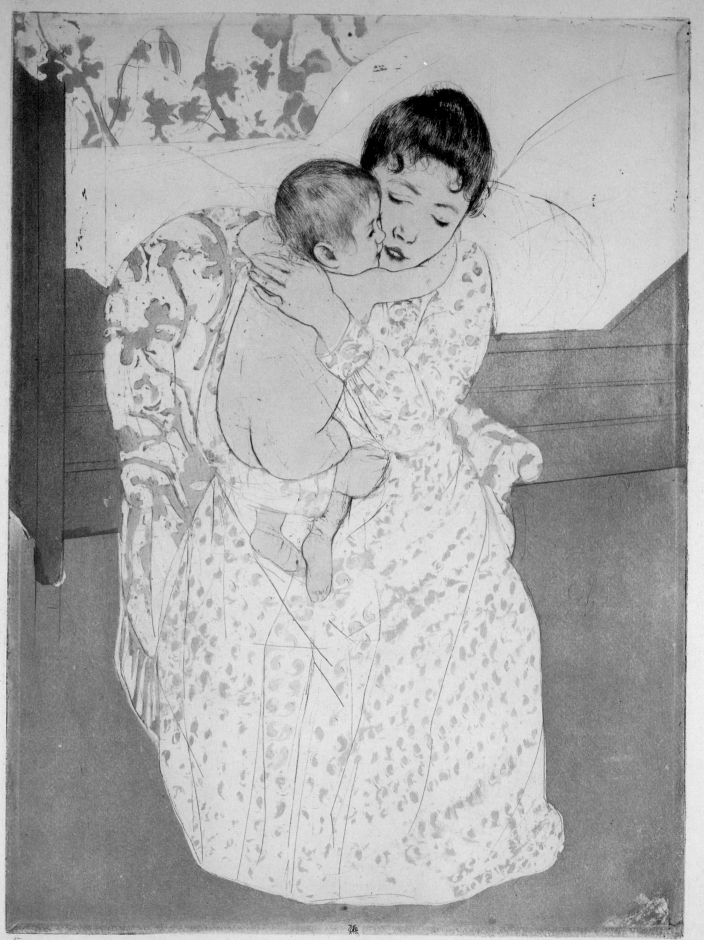

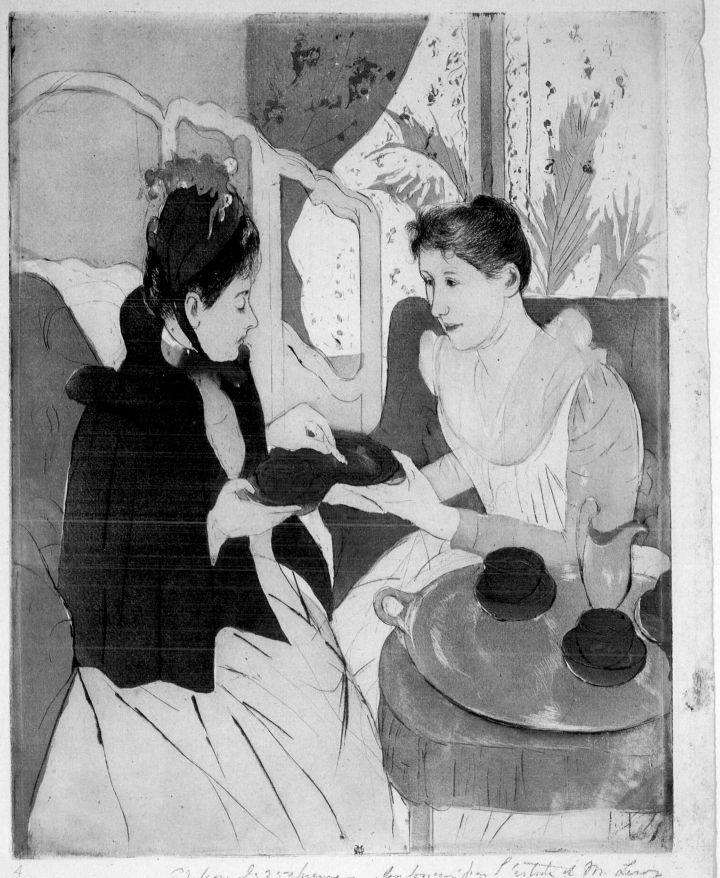

4 *Edition de 25 épreuves imprimées par l'artiste et M. Leroy*

Mary Cassatt

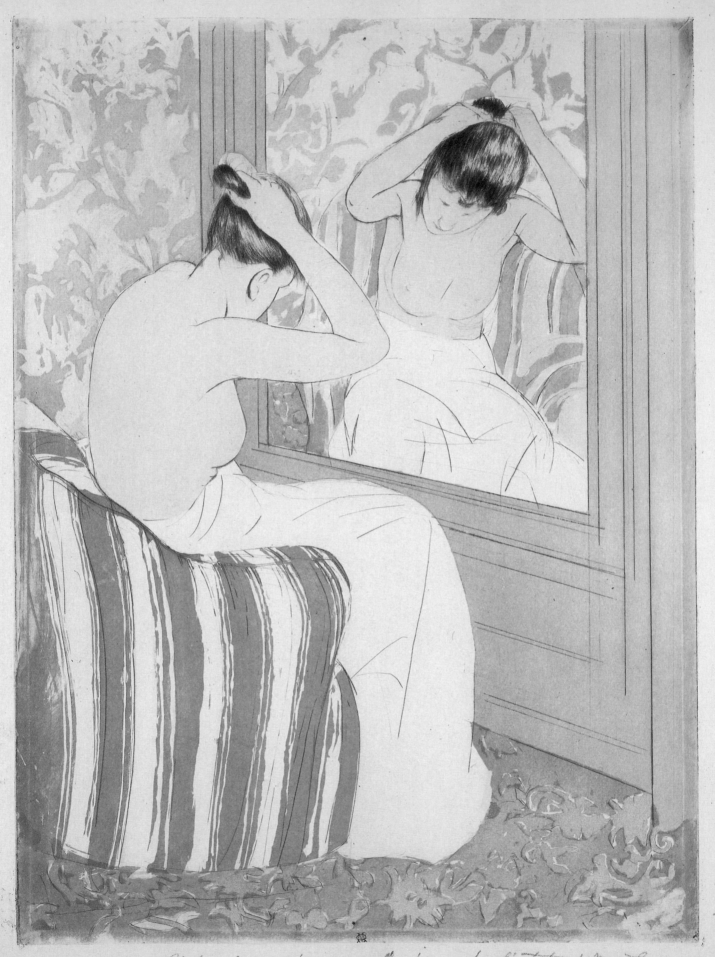

7 *Tableau de 25 épreuves Imprimé par l'artiste et M. Leroy*

Mary Cassatt

Mary Cassatt:
The Color Prints

Nancy Mowll Mathews
and
Barbara Stern Shapiro

Harry N. Abrams, Inc., in association with Williams College Museum of Art

The authors wish to express their special gratitude to Roy L. Perkinson, Conservator, Museum of Fine Arts, Boston for his expert contributions on printmaking techniques and papers.

Exhibition dates:

June 18 – August 27, 1989
The National Gallery of Art, Washington, D.C.

September 9 – November 5, 1989
Museum of Fine Arts, Boston

November 25, 1989 – January 21, 1990
Williams College Museum of Art, Williamstown, Massachusetts

Library of Congress Cataloging-in-Publication Data

Mathews, Nancy Mowll.
 Mary Cassatt: the color prints.
 Catalog of an exhibition held at the National Gallery of Art, Washington, D.C., June 18–Aug. 27, 1989, at the Museum of Fine Arts, Boston, Mass., Sept. 9–Nov. 5, 1989, and at the Williams College Museum of Art, Williamstown, Mass., Nov. 23–Jan. 21, 1990.
 Bibliography: p.
 Includes index.
 1. Cassatt, Mary, 1844–1926—Exhibitions.
I. Cassatt, Mary, 1844–1926. II. Shapiro, Barbara Stern. III. National Gallery of Art (U.S.) IV. Museum of Fine Arts, Boston. V. Williams College. Museum of Art. VI. Title.
NE539.C3A4 1989 769.92′4 88-8107
ISBN 0-8109-1049-7 (Abrams) 0-913697-06-0 (pbk.)

Project Director: Margaret L. Kaplan
Editor: Mark D. Greenberg
Designer: Darilyn Lowe

On pages 1–10 the set of ten color prints by Mary Cassatt are reproduced courtesy of the Worcester Art Museum (see The Catalogue for full descriptions):

page 1	cat. 5-xvi	*The Bath*
page 2	cat. 6-iv	*The Lamp*
page 3	cat. 7-vii	*In the Omnibus*
page 4	cat. 8-iv	*The Letter*
page 5	cat. 9-vii	*The Fitting*
page 6	cat. 10-iv	*Woman Bathing*
page 7	cat. 11-v	*Mother's Kiss*
page 8	cat. 12-vi	*Maternal Caress*
page 9	cat. 13-v	*Afternoon Tea Party*
page 10	cat. 14-v	*The Coiffure*

Contents

Directors' Foreword

Mary Cassatt's color prints, as part of the color print movement that swept the international art world in the 1890s, have proved to be a rich field of study. In addition to their great beauty and warm humanity, these prints are some of the most technically complex of this era and reveal much about Cassatt's working methods and creative process. Furthermore, they are linked to Cassatt's work in other media and to the other experimental graphic work of her circle in France and the United States. In addressing these issues, the curators of the exhibition, Nancy Mowll Mathews and Barbara Stern Shapiro, have elucidated a subject that has long remained a technical puzzle.

When Nancy Mathews came to the Williams College Museum of Art as Prendergast Fellow in 1984, she brought with her the idea for an exhibition of Mary Cassatt's color prints. At first it was to be a small didactic exhibition shown only in Williamstown; but the extraordinary beauty and inventiveness of the works deserved a larger audience. Approaching other museums with this exhibition confirmed that the concept was of great interest, and before long it had increased in scope to its present dimensions. Barbara Shapiro, Associate Curator of Prints, Drawings and Photographs at the Museum of Fine Arts, Boston, a specialist in French 19th-century printmaking, was invited to join the project. She contributed her enormous expertise as co-curator.

Mary Cassatt: The Color Prints is the second major print collaboration between the Williams College Museum of Art and the Museum of Fine Arts, Boston. Once again, the College Museum has benefited in many ways from its neighbor to the east. Along with Barbara Shapiro came the resources of the Museum of Fine Arts Print Department as well as their Paper Conservation Laboratory under the direction of Roy Perkinson. Their time and knowledge were indispensable to the completion of the project.

In the nearly one hundred years since they were executed, proofs of preliminary states as well as many of the final impressions of the Cassatt color prints have entered museum collections mainly in the United States. No collection, however, equals that amassed by Lessing J. Rosenwald and donated to the National Gallery of Art. Therefore, it was appropriate that the National Gallery of Art be the third partner in this exhibition and be the first to open it to the public. Andrew Robison, Senior Curator and Head of the Department of Prints and Drawings, and Ruth Fine, Curator of Modern Prints and Drawings, through their encouragement and cooperation, have helped to formulate the final shape of this exhibition and to bring it to fruition.

The generous support of this project by the National Endowment for the Arts has also been crucial to its realization. Today, even print exhibitions are expensive for museums to mount, and a debt of thanks is owed to those who recognized the significance of this project, a handsome print show with a catalogue that makes a major contribution to scholarship and offers the visitor the opportunity to consider afresh the exceptional graphic achievement of one of America's most gifted artists.

Thomas Krens, Former Director
W. Rod Faulds, Acting Director
Williams College Museum of Art

Alan Shestack, Director
Museum of Fine Arts, Boston

J. Carter Brown, Director
National Gallery of Art

Acknowledgments

W hat at first seemed a simple project turned out to be one of almost overwhelming complexity. In the course of unraveling Mary Cassatt's technique in each of the 23 color prints, we found ourselves relying on the generosity and cooperation of scholars, curators, and collectors across the United States and in Canada, Australia, and Europe. Although each deserves to have his or her unique contribution recognized in depth, the following listing will have to serve as a small token of our sincere gratitude.

A tribute must be paid first and foremost to the late Adelyn Dohme Breeskin, whose work we have taken as a starting point, and who, in her generous spirit, would be pleased to see the intricacies of these prints finally sorted out. Thanks go also to her daughter, Gloria Breeskin Peck, who made Mrs. Breeskin's files on Cassatt's prints accessible to this project.

Of the American museums, those who deserve the most credit are the curators of collections with major Cassatt holdings who became participants in our project in spite of themselves. These include Andrew Robison, Ruth Fine, Margaret Morgan Grasselli, and Carlotta Owens of the National Gallery; Robert Rainwater and Roberta Waddell of the New York Public Library; Colta Ives, David Kiehl and Suzanne Boorsch of the Metropolitan Museum; Stephen Ostrow and Carol Pulin of the Library of Congress; and Douglas Druick and Suzanne McCullagh of the Art Institute of Chicago, whose generous loan of the set of ten prints could not be illustrated in this catalogue.

Others to whom we are indebted are David Acton, Janine Bailly-Herzberg, Juliet Wilson Bareau, Laure Beaumont-Maillet, Ann and Arsène Bonafous-Murat, C. Reynolds Brown, Victor Carlson, Philip Dennis Cate, Anne Distel, Richard Field, Jay M. Fisher, Sue Fuller, Patricia Gilmour, Jane Glaubinger, Money Hickman, Sinclair Hitchings, John Ittmann, Ellen Jacobowitz, Robert Johnson, Stanley Johnson, Roger Keyes, Joan London, Pierre Michel, Paul N. Perrot, Judith Pillsbury, Susan Pinsky, Maxime Préaud, Michèle and Hubert Prouté, Marc Rosen, Janet Ruttenberg, Nicholas Stogdon, Marilyn Symmes, Martha Tedeschi, Barry Walker, Judith Walsh, William Weston, and Peter Zegers, as well as the directors, Evan Turner and James Welu who were most cooperative.

A special acknowledgment is owed to Caroline Durand-Ruel Godfroy for generously permitting access to the Durand-Ruel archives and to France Daquet for her kind assistance.

At Harry N. Abrams, Inc., this publication was encouraged by Paul Gottlieb and patiently shepherded along by Margaret Kaplan, Mark Greenberg, and Darilyn Lowe.

In addition to the many colleagues who have made this project possible, we are both individually grateful to those with whom we worked most closely.

Nancy Mowll Mathews:

I would like to express my thanks to all those at the Williams College Museum of Art who in their many ways helped to make this project possible: Tom Krens, who supported the idea from the beginning; Rod Faulds and Zelda Stern who inherited it and helped see it come into being; Susan Dillman who calmly grappled with the organization of the photographs; and my graduate assistants, Laura Coyle, Brent Benjamin, and Courtney Braun, who were all invaluable at different stages of the project. I would also like to thank Cathy Hemming, Ellen Schall, and Susan Hobbs for specialized assistance, and Ingrid Montecino for her services as sounding board.

Barbara Stern Shapiro:

Without the wholehearted encouragement of Clifford S. Ackley, curator of the Department of Prints, I could not have agreed to participate in this project; he was not only enthusiastic in having the exhibition at the Boston Museum but, despite other commitments, he has actively reviewed my writings and discussed printmaking ideas with me. Roy Perkinson was a major participant, and I have depended greatly on his expertise. I am profoundly grateful to all my colleagues in the department for their loyal and thoughtful support during this work period. A special debt of thanks is due Samuel Josefowitz, who provided a living space in Paris during the early stages of researching the prints.

Nancy Mowll Mathews
Prendergast Curator
Williams College Museum of Art

Barbara Stern Shapiro
Associate Curator
Department of Prints, Drawings,
 and Photographs
Museum of Fine Arts, Boston

EXPOSITION

de

TABLEAUX, PASTELS

ET

GRAVURES

PAR

M^{lle} Mary Cassatt

Galeries Durand-Ruel

Avril 1891

fig. 1. Title Page of the catalogue for the Exposition de Tableaux, Pastels et Gravures par Mlle. Mary Cassatt/Galeries Durand-Ruel, Avril 1891
Document Archives Durand-Ruel

opposite:
fig. 2. List of Works: Exposition de Tableaux, Pastels et Gravures par Mlle. Mary Cassatt/Galeries Durand-Ruel, Avril 1891
Document Archives Durand-Ruel

The Color Prints in the Context of Mary Cassatt's Art

by Nancy Mowll Mathews

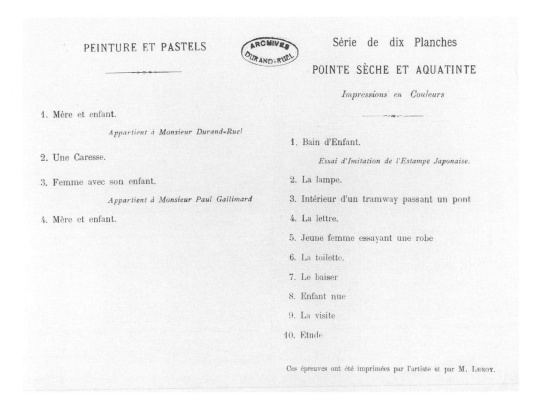

PEINTURE ET PASTELS

Série de dix Planches

POINTE SÈCHE ET AQUATINTE

Impressions en Couleurs

1. Mère et enfant.

 Appartient à Monsieur Durand-Ruel

2. Une Caresse.

3. Femme avec son enfant.

 Appartient à Monsieur Paul Gallimard

4. Mère et enfant.

1. Bain d'Enfant.

 Essai d'Imitation de l'Estampe Japonaise.

2. La lampe.

3. Intérieur d'un tramway passant un pont

4. La lettre.

5. Jeune femme essayant une robe

6. La toilette.

7. Le baiser

8. Enfant nue

9. La visite

10. Étude

Ces épreuves ont été imprimées par l'artiste et par M. LEROY.

Mary Cassatt had strong opinions about the relative importance of the various branches of art, and from the first, she devoted herself only to those she considered the highest. According to statements she made throughout her life, she held figure painting in higher esteem than landscape; she wanted to paint "pictures," rather than portraits; and even from her student days, she would not waste her time on drawing when she could paint. Printmaking, therefore, as one of the lesser arts, played no part in the first two decades of her artistic output (1860–1879), and it is crucial to the understanding of her later activity in this field (1879–ca. 1910) that she came to printmaking with an innate prejudice against it.

There were two major factors that influenced Cassatt to overcome her prejudice. The first was her discovery of the etching revival and the prestige that was increasingly attached to printmaking in the later 19th century. While her immediate context was French, and her work shaped by the French artists in her circle, her attitudes were often influenced by the American or Anglo-American art world in which she continued to partici-

pate. The role of Whistler, who was well known to Cassatt, and his brother-in-law, Seymour Haden, in bringing American artists into the etching movement cannot be overestimated. The combination of the proselytizing writings of etching revival writers such as Haden and the demonstration of Whistler's use of printmaking as a major art form with importance equal to his paintings served as a persuasive model for many American artists. In addition, the emergence of important American print collectors such as Samuel Avery and print curators such as Sylvester Koehler (who were both important collectors of Cassatt's work) assured a ready market. Finally, the charm of printmaking for the American leisure-class hobbyist[1] and the introduction of the portable printing press took printmaking out of the commercial workshop (where Cassatt had first become acquainted with it) and into the home as an elite and eminently personal expression.[2]

The second factor was Cassatt's exposure to experimental prints done by artists in her immediate circle that forged a new relationship between printmaking and painting. Cassatt's knowledge of reproductive engraving that imitated painting came from important early sources such as the Sartains in Philadelphia and Carlo Raimondi in Parma. Her resistance to this graphic art went hand-in-hand with her resistance to slavish drawing techniques of any kind. However, when she discovered the methods being used by Degas, Pissarro, and others, which adapted the more creative and spontaneous processes of painting to printmaking, she more readily saw the advantages of producing prints in the same vein as her paintings.

The relationship between Cassatt's prints and her work in other media and the "reproductive" nature of the prints are interesting issues, as with all of the painter-printmakers of this era.[3] While Cassatt often used her own works in oil or pastel as models for prints, this was never remarked on or considered a fault by fellow artists or critics in an age of acute sensitivity to the "original" print. Everywhere, she was credited with supreme originality as a printmaker during her lifetime, and to the present day her prints have been treated as independent works of art.

And yet, Cassatt was from the start an artist who took advantage of opportunities to promote her work. Not only did she exhibit whenever possible, she also placed her work with dealers early on and she cultivated critics ("I know you don't like the Ryan set but still it is just as well to be in with the "*press*."[4]). Among her friends, Degas and Pissarro both saw prints in a semicommercial light—as a way of gaining a wider distribution of their work through the sale of less expensive multiples. It is also possible that they went so far as to suppose that if the prints echoed paintings, they could also serve to stimulate the sale of the larger, more expensive pieces.

If this commercial motive lurked behind Cassatt's printmaking, it did little to diminish the quality of the prints themselves. In fact, reintegrating Cassatt's prints into the main body of her work demonstrates that, for the most part, the echo of a motif from painting to print, no matter what spurred it, heightens the impact of both. That Cassatt herself saw the prints as integral to her output is evidenced by the occasional reversal of the "re-

productive" direction, when she uses prints as models for paintings (see p. 49) or when she bases a finished print on a pastel or oil sketch. In fact, occasionally it seems that Cassatt treated all media interchangeably. In the instances where she produced a series of works in various processes— e.g., the *Nurse and Baby Bill* series in pastel, pencil, drypoint, and etching— she changed the composition enough in each one to give the impression that she switched media while the model was posing, rather than making one sketch from life and basing all other productions on it.

In terms of the reformulation of the relationship of painting and printmaking, Cassatt arrived at her most complete statement in the color prints. Beginning with four experimental prints in late 1889 or early 1890, she went on to produce a set of ten large plates for exhibition and sale in April 1891. In the next several years she designed nine more, leaving the last unfinished by the end of 1897. During these years Cassatt exhibited more prints than paintings and had her first solo exhibition when she showed the set of ten color prints in 1891 with only four works in larger media. The color prints were treated as seriously by Cassatt, her dealer, and the critics as her works in painting and pastel.

The many existing early states of the prints and the time-consuming hand-inking of the plates show that Cassatt put as much labor into them as she would a major work in another medium. Although certain techniques were used consistently in the 1891 set of ten, the color prints show Cassatt typically treating each print as a new technical departure and, wherever possible, applying a "painterly" approach to the printmaking media. In all, they display a range of graphic processes that includes softground etching, drypoint, aquatint, monotype, and hand-touches.

As representative of Cassatt as a printmaker, and as illuminating of Cassatt as an artist in all media, the color prints hold a special place in her oeuvre.

In her formative training in Philadelphia, Mary Cassatt entered an artistic milieu in which the dominant figure was an internationally known print-maker, John Sartain (fig. 4). When Cassatt entered the Pennsylvania Academy of the Fine Arts in 1860, Sartain, a successful engraver of fine-art reproductions who had emigrated from London in 1830, was the driving force behind the Academy's progressive curriculum. He modeled the Academy's course of study on the Ecole des Beaux-Arts in Paris, expecting students to spend two years mastering techniques of drawing by copying from engravings and plaster casts before they picked up a brush.

We get a glimpse of Cassatt in her second year of drawing class through the eyes of her fellow student, Eliza Haldeman:

> We have several new pupils both male and female but Miss Cassatt and I are still at the head (i.e. of the ladies). Most of the old gentlemen scholars have gone away and commenced to paint. Mr. McIlhenney is going to commence after Christmas, but he has been

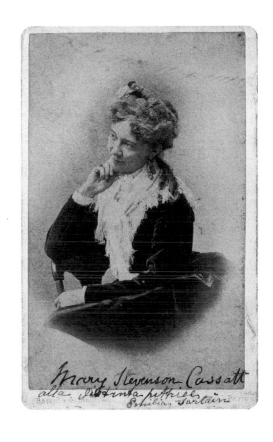

fig. 3. Carte-de-Visite photograph of Mary Cassatt taken in Parma, 1872
Photograph
Courtesy The Pennsylvania Academy of the Fine Arts Archives, Philadelphia

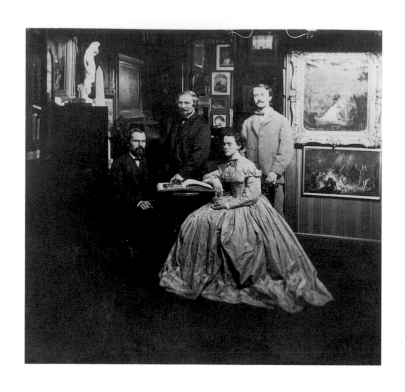

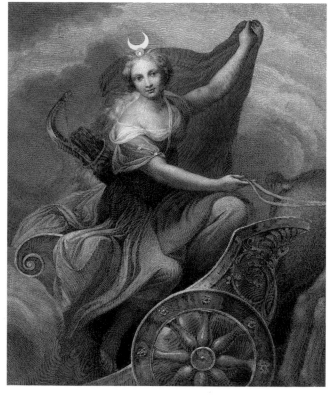

drawing 3 years. Miss C— (Cassatt) is doing the Atlas. We keep pretty nearly together. She generally getting the shading better and I the form, she the "ensemble" and I the "minutia" but I am trying hard to get ahead. I have not taken my Laocoon up yet so I dont know what Schuessele will think of it. The last one he said was better in some respects than hers and worse in others. So it left us equal . . .[5]

Cassatt's penchant for shading rather than form, the "ensemble" rather than the "minutia," together with the fact that she began painting at the Academy at the first opportunity (after only a year and a half of drawing), suggests her impatience with the traditional drawing skills that were valued at the Academy under the influence of the printmaker Sartain. Years later she would look back with distaste at the practices of the Academy, where the students "drew haphazardly from old copies and Antique casts."[6]

Cassatt left for Europe in late 1865 for what would become a stay of over four years. In that time we know that she studied with masters such as Gérome and Chaplin in Paris, Soyer and Couture in the art colonies north of Paris, and probably numerous other masters in her travels around France, Switzerland, and Italy. But so little work in any medium has survived from these years, it is difficult to assess how this experience might have contributed to her eventual adoption of printmaking.

We do know, however, that when she returned to Philadelphia in 1870 she became a close friend of John Sartain's daughter, and from Emily Sartain's comments about Cassatt over the subsequent five years of their friendship, we receive the strong impression that Cassatt had moved no closer to the graphic arts. Emily Sartain had been trained by her father in mezzotint engraving and by 1870 had begun to achieve recognition on her own as a printmaker (fig. 5). At the same time she was studying painting at the Pennsylvania Academy with the ambition to become a painter as well as a printmaker. She and Cassatt painted together in Philadelphia and then traveled together to Europe, arriving at their first destination, Parma, in late December 1871. Cassatt's objective in Parma was to paint copies of two Correggios on commission for the cathedral of Pittsburgh, while Sartain's was to begin her next phase of painting studies in Europe. Cassatt had sufficient stature as a painter by that time that Sartain looked to her for guidance, acknowledging that "I have improved by constantly looking at the Correggio, and seeing Miss Cassatt work . . ."[7]

Cassatt offered steady encouragement to her friend, whom she called *distinta pittrice* (distinguished painter) in the inscription of her carte-de-visite photograph, which she sent to Emily in Paris that May (fig. 3). But she also irritated Sartain by her lack of knowledge of the technical aspects of Sartain's printmaking. The two Americans had become friendly with the director of the School of Engraving at the Parma Academy, Carlo Raimondi (fig. 6), who was instrumental in arranging studio space and models for them at the Academy. Raimondi admired Cassatt as a painter

left:
fig. 7. Miss Mary Ellison, ca. 1878
Oil on canvas
33½ x 25¾ in. (851 x 654 mm)
National Gallery of Art, Washington,
D.C., Chester Dale Collection

below:
fig. 8. Lydia Leaning on Her Arms,
Seated in a Loge, 1879–1880
Pastel on paper
21⅝ x 17¾ in. (549 x 451 mm)
The Nelson-Atkins Museum of Art,
Kansas City, Missouri (Anonymous Gift)

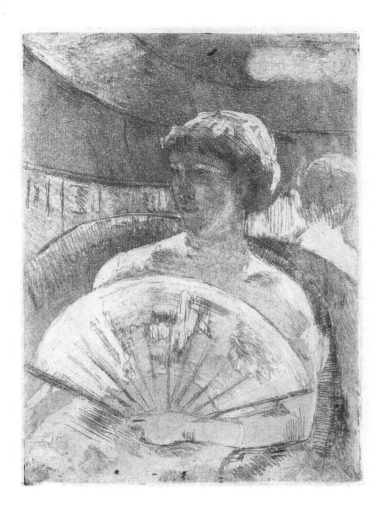

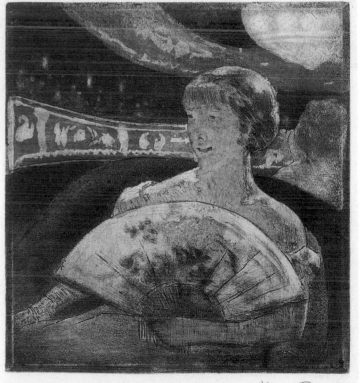

left:
fig. 9. **In the Opera Box (No. 2)**
1879–1880
Br. 21
Softground etching and aquatint
8⅜ x 6¼ in. (213 x 159 mm) platemark
The Museum of Modern Art, New York,
Gift of Abby Aldrich Rockefeller

below:
fig. 10. **In the Opera Box (No. 3)**
1879–1880
Br. 22
Softground etching and aquatint
8⅛ x 7⅜ in. (207 x 187 mm) platemark
Museum of Fine Arts, Boston (on loan)

and valued her opinions about art but does not seem to have served as a teacher to her, particularly not of printmaking. Naturally, printmaking was discussed among them, but apparently not with any clear knowledge on Cassatt's part of the various print processes, and she could not communicate to Raimondi and the others the Sartain mezzotint technique, which was unfamiliar to them. Emily wrote to her father, "They have no idea of what mezzotint engraving is,—and I learned the other day that from Miss C's [Cassatt] description of it they had made up their mind I engraved in acquatint [sic]."[8]

In the next four years artistic differences caused an ever-widening gulf between Cassatt and Sartain. To mutual friends they criticized each other's opinions and choice of direction, and very often the key issue was careful preparation for the finished work, particularly how much attention need be paid to drawing. In musing to her father about a possible trip to Granada with Cassatt, Sartain brought up the issue, "It is a pity that both Miss C. and I both are so defective in drawing—Mr. L. (Luminais)[9] says he is no longer anxious about my color, or luminousness, he is sure of that now,—but he commences to torment himself and me about my drawing....Next week I'm going to commence to draw every afternoon..."[10]

Her teacher was as severe on Cassatt, whose recent Spanish sketches Sartain had shown him: "He spoke of them as having a great deal of talent but mostly *talent of the brush*, as (he) called it . . ."[11] A year later Sartain again gave Cassatt credit for her painting ability in her latest work but criticized her drawing: ". . . she has a picture now at her dealer's in the Boul. Haussmann, that is superb and delicate in color. . . . It is as slovenly in manner and in drawing as her Spanish pochades, however."[12]

Sartain's criticism was not the only voice heard against Cassatt. She began to experience sporadic rejection from the Salon and other major juried exhibitions in Paris from 1875 to 1878, and in spite of other indications of success, Cassatt was shaken in her pursuit of official recognition. When Degas, whose work she had discovered in 1875, extended an invitation to exhibit instead with the Impressionist group, Cassatt did not hesitate to accept. With the Impressionists, Cassatt could at last indulge her "talent of the brush" with maximum freedom. Ironically, it was within the Impressionist context that Cassatt began to produce finished drawings and become interested in printmaking.

Between the time she accepted Degas's invitation to become an Impressionist (1877) and her first Impressionist exhibition (1879), Cassatt had had two years to explore the new ideas of this group. In those two years she adopted a new style, new subjects—specifically theater scenes—and new materials. In the exhibition of 1879 she showed three pastels, and later that year (May 1 and August 9) she had two drawings after paintings published in the contemporary art journal *La Vie Moderne*.[13] For the first time she was producing finished work in a medium other than painting. Cassatt may have been won over to the merits of drawing first by working in pastel, a medium used by the Impressionists with unprecedented freedom,

because it so obviously combines color and line. For the theater scenes, Cassatt worked interchangeably in oil and pastel. The drawings were likewise related to oil paintings; they duplicated finished oils and constituted a sophisticated form of reproduction.

Later that fall, Cassatt returned from a three-month tour of the Alps to find that Degas, Pissarro, and Bracquemond had been discussing for some months launching a new print journal, *Le Jour et la nuit*, for which many in their circle would make major prints. Degas and Pissarro had been working on etchings of such tonal complexity that even they, who knew printmaking, found themselves calling on others for advice. Cassatt, who had spent the last two years relearning her craft in new media, was soon drawn in. "At the moment Mlle Cassatt is full of it," wrote Degas to Bracquemond.[14]

Cassatt had known from her early days in Philadelphia that drawing and printmaking went hand-in-hand. But only now, with the immediacy and relevance of Impressionist subjects before her and with the experimental approach to graphic media that Degas and Pissarro offered, could she finally acknowledge the importance of these art forms. Years later she pointed to one of her Impressionist prints and said to her biographer, "That is what teaches you to draw."[15]

In some ways, Cassatt's adoption of printmaking was predictable from her background with the Sartains and Carlo Raimondi. Her first completed prints were "reproductive," based on works in oil or pastel and, like her first finished drawings, were intended for publication (in *Le Jour et la nuit*). Furthermore, the aquatint process she used resembled the Sartains' mezzotint process in her habit of covering the plate with tone and then, in addition to stopping out, scraping some areas away to achieve lighter accents.

But on the whole, Cassatt's prints were as unlike the traditional prints of her early friends as possible. Whereas Emily Sartain had switched from printmaking to painting and brought with her a respect for graphic perfection, Cassatt went from painting to printmaking and brought with her a love of the manipulable surface and variety in tone and texture. Like Degas and Pissarro, she was willing to draw, paint, dust, heat, bite, and scrape the plate to force from it the extended range of expression she knew was possible from her work in other media. From the first, her prints illustrate what is hidden in her paintings and pastels—the struggle, perseverance, and plain hard work that were part of her creative process.

The series of prints that resulted in Cassatt's entry for the first edition of *Le Jour et la nuit* is related to several of her theater pictures, in particular, *Miss Mary Ellison* (fig. 7) as well as the pastel *Lydia Leaning on Her Arms, Seated in a Loge* (fig. 8). Using three different plates, Cassatt began by transferring her drawing to the plate by using a softground technique and then applying an aquatint tone, which provides in each one the hazy atmosphere of the partially lit theater. Highlights are created dramatically in *In the Opera Box, No. 2* (fig. 9) and *In the Opera Box, No. 3* (fig. 10) by painting stop out varnish over the aquatint with a flourish of the

brush. Further lightening is created by scraping the aquatint off the plate—so forcefully in the last print that the woman's facial features seem equally discarded. The effect conveys an impression of blinding light that washes out detail.

In other prints, such as the one traditionally called *Lydia and Her Mother at Tea* (fig. 11), Cassatt duplicated a painting more closely in the manner of Degas's duplication of his own pastel in his *Mary Cassatt at the Louvre: The Etruscan Gallery* (see fig. 27). And in her large print *The Visitor* (see fig. 26), she comes close to Degas's composition of the standing and sitting woman.

Degas, Cassatt, and Pissarro exhibited a number of etchings they had done over the winter of 1879–1880 in the next spring's Impressionist exhibition. However, they showed not only finished prints but proofs of preliminary states as well. As Barbara Shapiro and others have pointed out,[16] the value these artists placed on preliminary states is demonstrated by the fact that they occasionally signed, exhibited, and even sold them. States thus must be seen as part of a larger work of art; in a sense, they form a "series" as in other Impressionist groups of related works.[17] Frequently, the early states appear as finished as the final state, which can be seen in the first, third, and fourth states of Cassatt's *At the Dressing Table* (figs. 12–15), and yet the artist keeps reworking the plate and redefining the lights and darks in endless variation as if to capture the changing light of the actual scene.

All that was missing from this painterly approach to the print was color, and even that was discussed as a possibility. In a letter to Pissarro, Degas suggested a stencil and woodblock combination to print watercolor onto one of Pissarro's finished prints.

> Could you find someone at Pontoise who could cut on very light copper some thing traced by you? That kind of pattern could be applied on a line proof—touched up a little for effect—of etchings or soft ground etchings and then the exposed parts printed with porous wood coated with water colours. That would enable one to try some attractive experiments with original prints and curious colours. Work a little on that if you can.—I shall soon send you some of my own attempts along these lines.[18]

Pissarro apparently did not pursue Degas's suggestion, but Degas did print early states of Pissarro's *Crepuscule avec meules* (1879), an aquatint with etching and drypoint, in colored inks.[19]

While there is no evidence that Cassatt attempted printing in colored inks at this time, the notion of "color" in her prints was still an important one. It was not uncommon for monochromatic prints with a great deal of tonal richness to be discussed in terms of their "color," as the critic for the *New York Tribune* did in praising Cassatt's "...feeling for the value of color as well as line" when her Impressionist prints were shown in New York in 1888.[20] Years later, Cassatt's biographer described her print *In the*

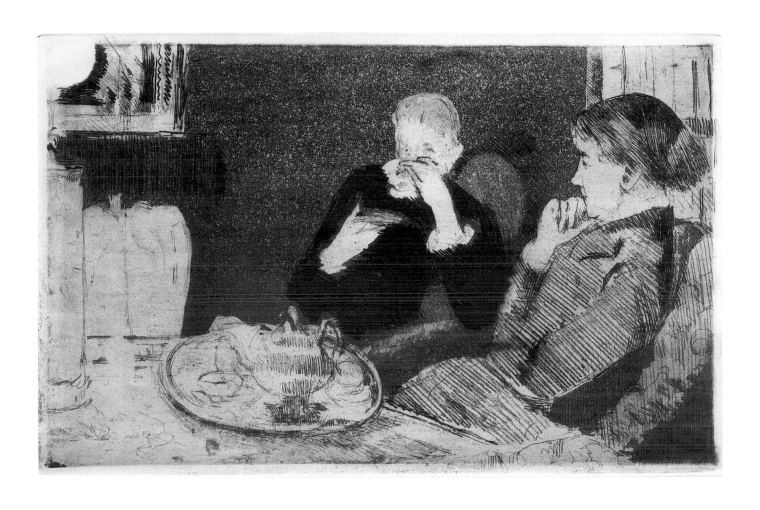

fig. 11. Lydia and Her Mother (?) at Tea,
ca. 1880
Br. 69
Fourth state
Softground etching and aquatint
7 x 11 in. (178 x 279 mm) platemark
National Gallery of Art, Washington,
D.C., Rosenwald Collection

Mary Cassatt: The Color Prints 29

fig. 12. *Drawing for* At the Dressing
Table, 1879–1880
Br. CR 714
Recto: Graphite
Verso: Softground adhering to traced lines
Cream, thin, smooth, wove paper
16 x 12 in. (405 x 306 mm) irregular sheet
including folds
Initialed lower left: "M. C."
Anonymous Loan

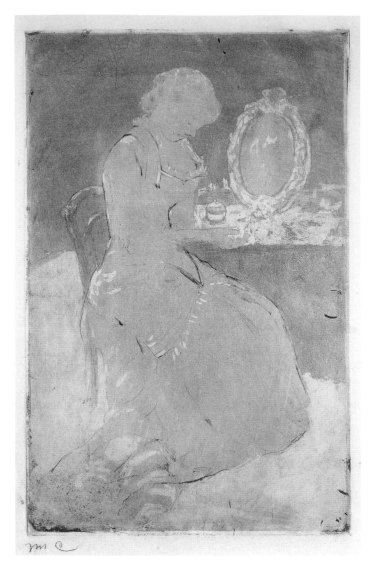

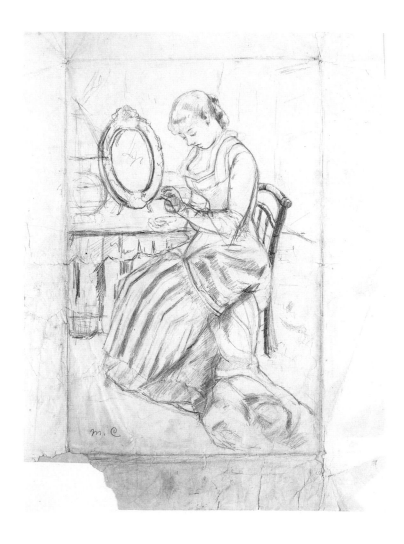

fig. 13. At the Dressing Table, ca. 1880
Br. 10
First State
Softground etching and aquatint
Cream, medium-weight, moderately
smooth, laid paper
17 x 11¾ in. (433 x 299 mm) sheet
Watermark: fragment of ARCHES
Initialed lower left: "M. C."
Anonymous Loan

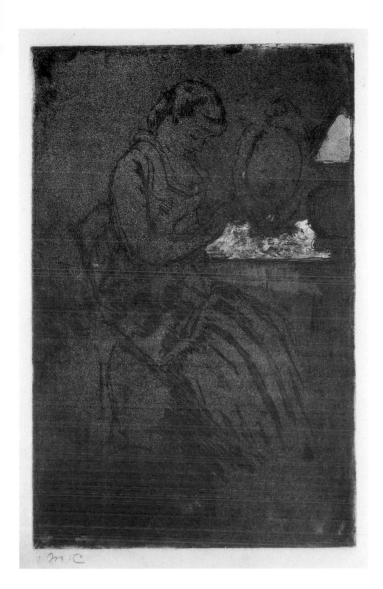

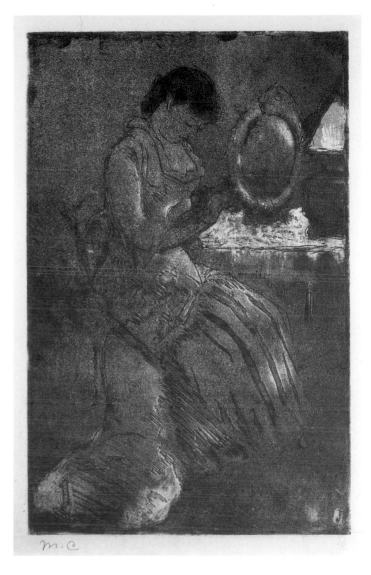

fig. 14. At the Dressing Table, ca. 1880
Br. 10
Third state
Softground etching and aquatint
Off-white, medium-weight, moderately
smooth, wove paper
14⅛ x 10⅛ in. (359 x 276 mm) sheet
Initialed lower left: "M. C."
Anonymous Loan

fig. 15. At the Dressing Table, ca. 1880
Br. 10
Fourth state
Softground etching and aquatint
Off-white, medium-weight, moderately
smooth, wove paper
14¼ x 10⅛ in. (360 x 277 mm) sheet
Initialed lower left: "M. C."
Anonymous Loan

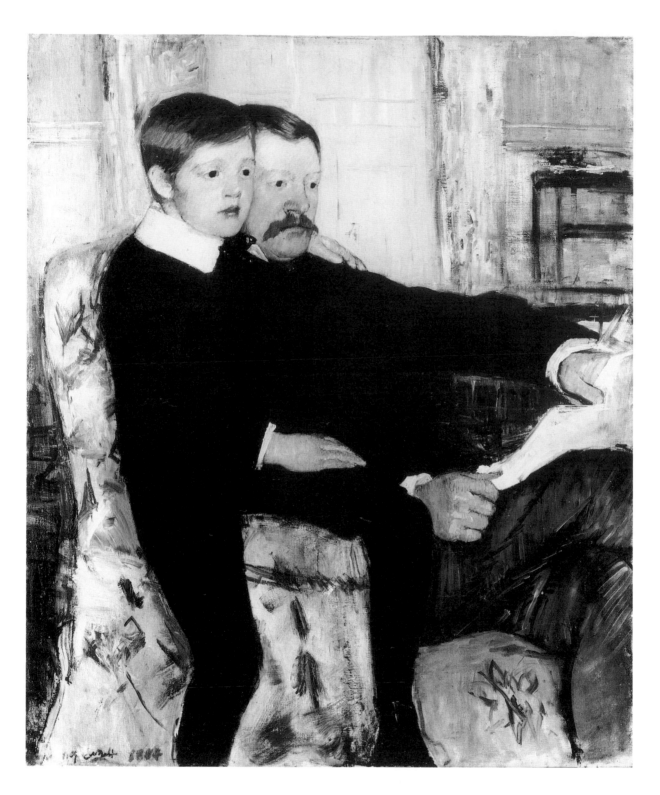

fig. 16. Portrait of Alexander Cassatt
and His Son Robert Kelso, 1885
Oil on canvas
39½ x 32 in. (1003 x 813 mm)
Philadelphia Museum of Art,
W. P. Wilstach Collection

Opera Box, No. 3 (fig. 10) as "an investigation [of the subject] in line, complicated by the investigation of color in white and black . . ."[21]

It is hard to trace Cassatt's printmaking activity after 1880 since she did not show any prints in 1881 or 1886, her last two Impressionist exhibitions. Like Degas, she undoubtedly lost her momentum after the journal project fell through, although with her own printing press at home she certainly continued on her own. The next securely dated prints, however, come in 1885[22] and are a reversal of the technique she had developed to express her Impressionist ideas. In conjunction with a large portrait of her brother Aleck and his youngest son, Robbie (fig. 16), which she began early in 1885, Cassatt produced several very spare and restrained drypoints of Robbie (fig. 17).

Although Cassatt had used drypoint as one of her methods of attacking the plate in such works as *The Visitor*, she had seldom used it as an independent medium before this time. The drypoint process involves scratching lines directly into the plate with a specially hardened or diamond-tipped drypoint needle. While it is a less cumbersome method than ones involving biting the plate with acid, which she had used previously, at the same time it is a slower and more painstaking way of achieving a design—the least like "the brush" of any medium Cassatt had yet tried.

Drypoint was a relatively rare medium for artists of this period, although it was gaining in popularity. In Hamerton's *The Etcher's Handbook* (1871) drypoint was considered to combine the velvety blacks of mezzotint (the "velvety" quality of drypoint blacks are produced by the burr of copper left by the needle next to each line) with a freedom of line akin to etching. It was best for the drawing of "fine curves" rather than "picturesque irregularities,"[23] and required a great deal of practice. "A man of genius," claimed Hamerton, "who loved dry point, and did nothing else, would get very fine effects indeed."[24]

Cassatt's adoption of drypoint in her prints indicates the dramatic change in attitude that had also affected her paintings: she was no longer interested in the active, transitory images of the Impressionist style; she now sought a quieter, more classic art.

A distinct new era of printmaking had begun for Cassatt by the beginning of 1888.[25] Interest in original prints had once more picked up on both sides of the Atlantic and given Cassatt new incentive. A group of her earlier prints, which had entered the collection of Samuel Avery in the early 1880s, was exhibited as "Twenty-four unfinished studies" in the exhibition The Work of the Women Etchers of America held in Boston in late 1887 and then in New York in April 1888. Meanwhile, in Paris, print activities propelled by Bracquemond in 1888 included a new print society, a short-lived journal, *L'Estampe originale*, and a major exhibition at the Durand-Ruel gallery, Exposition de Peintres-Graveurs, which opened in January 1889.[26] Cassatt submitted three works to the exhibition: a pastel, a drypoint, and an etching.

fig. 17. Robert Seated, Facing Left, 1885
Br. 82
Drypoint
6¼ x 4⅝ in. (159 x 117 mm) platemark
The Metropolitan Museum of Art, New York, Gift of Mrs. Imrie de Vegh, 1949

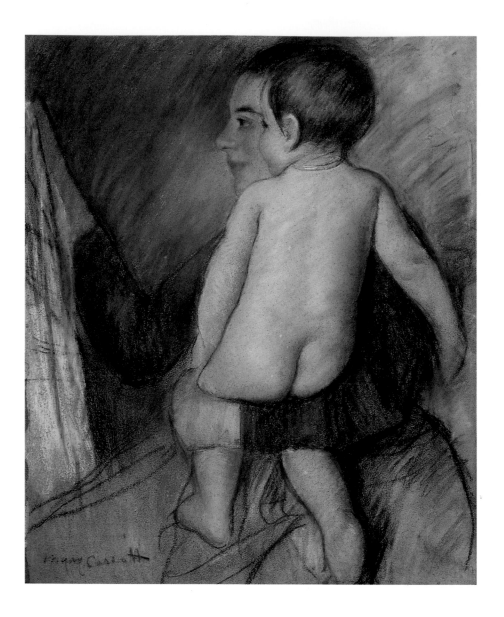

The etching Cassatt exhibited, titled *Liseuse*, could have been any one of a number of prints of a woman reading that she executed during her Impressionist printmaking phase. The pastel and the drypoint, however, were both of the mother-and-child subject. As was the case ten years before, Cassatt's prints were closely tied to increased work in other "drawing" media, specifically pastel, and as with the theater subjects, this new phase of printmaking was tied to her adoption of a new and compelling subject. While the thrust of the Peintres-Graveurs movement was to free the print from its previous reproductive function,[27] Cassatt did occasionally repeat her former practice of basing a print on a composition in oil or pastel, as in *At the Window* (fig. 18) and *Baby's Back* (fig. 19).

In the next year, Cassatt produced a large number of prints that were shown at the Deuxième Exposition de Peintres-Graveurs in March

fig. 18. **At the Window**, 1889
Pastel and charcoal on gray paper
29¾ x 24½ in. (756 x 622 mm)
Musée du Louvre, Paris, Cabinet des Dessins

1890. From her work in drypoint she assembled a group listed in the catalogue as a "series of twelve,"[28] and in another medium called "aquatint" she showed another series of unspecified number. The drypoint series is well documented through the sales of the set by Durand-Ruel and through contemporary collections that show the group still intact (figs. 24 a–l). The second series of aquatints is less identifiable, but was probably a group of prints done in an unusual combination of aquatint and softground etching, as in *Nurse and Baby Bill (No. 1)* (cat. 2), which were collected and reproduced along with the series of drypoints at this time.[29] While occasionally the same subject is treated in both drypoint and aquatint, as in *Mathilde Feeding a Dog (No. 1)* (Br. 85) and *Mathilde Feeding a Dog (No. 2)* (Br. 86), in general the two series appear to be following different trains of thought. The drypoints display a coolness and deliberation that comes from the careful incision of delicate lines into the copperplate. The aquatints, on the other hand, appear quickly drawn and less refined, reflecting the process Cassatt used of creating a very textured softground design and covering large areas with a grainy aquatint.[30]

As different as these two series were in process and outcome, they must be seen as equally important to the development of Cassatt's full-blown color-print technique in the next year. The drypoints foreshadow the precise drawing of the outlines in the color prints as well as the notion of a well-composed series of a definite number of images. The aquatints, on the other hand, display Cassatt's first experiments with color.

Into this series of works fall the three color experiments, *Nurse and Baby Bill (Nos. 1 and 2)* (cats. 1, 2) and *Hélène Held by Mathilde* (cat. 3). The development of the *Nurse and Baby Bill* design is reminiscent of her old Impressionist approach to the plate—adding and subtracting lines and tones, experimenting with untraditional combinations of techniques, and ending up with states that display less of a march toward perfection and more of a capturing of changing lights and darks. Furthermore, the soft, grainy line produced by the combination of softground and aquatint, and the application of the aquatint tonal areas by either shaking the resin on by hand or floating it on with alcohol reintroduces a "painterly" quality not seen in her recent drypoints. Throughout Cassatt's color prints is a continuing attempt to make the print achieve qualities of the brush to balance the linear perfection of the drypoint design.

A final experimental color print was, like *Hélène Held by Mathilde*, also reproductive in nature. Cassatt chose a monumental oil portrait of her mother (fig. 20) to duplicate in a color print. While the choice of a formal portrait for a print design was unusual for Cassatt, the choice of a family member was not. She had often portrayed her mother both in large-scale oils (fig. 21) and in prints, and at this time produced a similar print (fig. 21) of her niece Katherine (her mother's namesake), which was also based on a finished oil portrait. Although two of the three known final states of this print are colored, no edition was printed, nor did Cassatt seem to have released this print to the public until late in her life, when she was releasing

fig. 19. Baby's Back, 1889–1890
Br. 128
Third State
Drypoint
9³⁄₁₆ x 6⁷⁄₁₆ in (234 x 164 mm) platemark
Library of Congress, Washington, D.C.

most of the proofs left in her studio. At the time, it may have merely served as an experiment that was successful enough for Cassatt to go on to a major color printmaking effort.

The first documentary evidence of Cassatt's interest in color printing is in a well-known letter to Berthe Morisot written after the opening of the enormous exhibition of Japanese ukiyo-e prints at the Ecole des Beaux-Arts on April 15, 1890. Morisot had investigated color lithography as early as 1888[31] and was only one of several artists in Cassatt's circle with such interests. Gauguin and Emile Bernard had both created hand-colored zincographs that were included in the exhibition of the Groupe Impressioniste et Synthétiste, at the Café Volpini on the grounds of the Exposition Universelle in 1889.[32] Even Degas had expressed renewed interest in color printing.[33] While at the Japanese print exhibition, Cassatt ran into several others and urged Morisot to go with her:

> . . . you could come and dine here with us and afterwards we could go to see the Japanese prints at the Beaux-Arts. Seriously, *you must not* miss that. You who want to make color prints you couldn't dream of anything more beautiful. I dream of it and don't think of anything else but color on copper. Fantin was there the 1st day I went and was in ecstasy. I saw Tissot there who also is occupied with the problem of making color prints. Couldn't you come the day of the wedding, Monday, and then afterwards we could go to the Beaux-Arts?[34]

Afterward, Morisot made a color lithograph and worked over the summer at her country home near Cassatt's at Septeuil to plan more. We may reasonably expect that Cassatt was busy at the same time with her own plans—on copper.

Did Cassatt, therefore, immediately begin the prints that were exhibited as a series of ten at Durand-Ruel's gallery one year later (see figs. 1, 2)? The technical coherence of the group, so different in process from her early color prints, makes this doubtful. With the long summer vacation ahead, Cassatt, who worked on her press in her apartment-studio in Paris, would probably not have started, stopped for the summer, and then been able to pick up where she left off. It is more likely that she began experimenting, perhaps with the prints discussed above, spent the summer working in other media and sharing ideas with her neighbor Morisot, then embarked on the grand project when she returned to Paris.[35] That she and Morisot worked closely during this time is attested to by the similarity of at least one shared motif: a woman combing her hair (figs. 22, 23). The drawings of the two colleagues suggest that they were drawing side by side from the same model.

The idea of a set of color prints would have come to Cassatt from many sources. Other artists, such as Gauguin and Bernard, had already

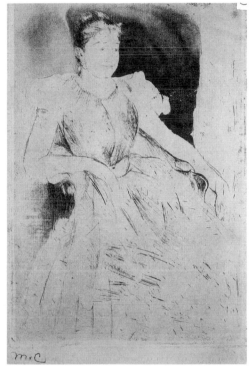

adopted the Japanese style of binding a group of prints into a portfolio, and in fact, the serial approach had infected every medium that members of the Impressionist group used. Cassatt herself had already put together a set of drypoints that was successful with collectors. On the practical side, her dealer, Durand-Ruel, claimed credit for the idea of that original set of drypoints[36] and enforced the sale of the color set for the same reason: "The individual sale of your prints would be very inconvenient. Everyone would want the same plates and once the sets were broken they would become unsaleable."[37] A set, therefore, from the dealer's point of view was a marketing device for guaranteeing the even sale of all of one's prints.

But there is no doubt that Cassatt had a Japanese portfolio of color prints in mind when she began. As she wrote to Frank Weitenkampf some years later, "The set of ten plates was done with the intention of attempting an imitation of Japanese methods . . ."[38] She goes on to say that she aban-

above left:
fig. 20. **Reading** *Le Figaro*, ca. 1878
Oil on canvas
39¾ x 32 in. (101 x 81.3 cm)
Private Collection

above right:
fig. 21. **Katherine Kelso Cassatt**, ca. 1888
Br. 198+
Drypoint and aquatint
9⅜ x 6¼ in. (236 x 159 mm) platemark
(whereabouts unknown)

doned the effort "somewhat" after the first plate, and indeed in the catalogue the description *Essai d'Imitation de l'Estampe Japonaise* appears only after the first title in the series. But Cassatt's point of reference was established at once and was taken for granted by viewers and critics.

Scholars since then have searched for specific Japanese models for each individual print as well as the whole and have proposed many reasonable possibilities. Since Cassatt had such a large number of prints to draw upon, virtually every comparison of one of Cassatt's prints with a Japanese original is a valid one. Japanese prints were abundantly available in Paris (the Ecole des Beaux-Arts exhibition alone contained 725 examples), and Cassatt had a collection herself, although dates of acquisition and the specific prints themselves are hard to reconstruct from the sale that took place in 1950.[39] Only a small group from Cassatt's collection has been kept together (see figs. 31 a–f) and offers an intriguing but inconclusive survey of works she might have had close at hand.

But even more important than locating specific prints that may have inspired Cassatt is discovering what she thought of Japanese prints as an art form when she embarked on her "imitation of the Japanese print." By 1890, Cassatt had been seeing and reading about Japanese prints for over 20 years, and in that time she would have arrived at a general idea of what it would add to her art if she were to work in a Japanese style. For Cassatt, as for all artists working in a modern style in Europe and America, Japanese art had acquired a mystique that encompassed both subject matter and technique.

In the literature on Japanese art in both English and French in the 19th century, the prints were praised for three major characteristics: their abstract compositional qualities, particularly the stylized beauty of line; the uniqueness of each printed image; and the populism that was strongly believed to be at the heart of their appeal.

A debate between Louis Gonse and the American Ernest Fenellosa arose in 1885 when Gonse's *L'Art Japonais* appeared, praising the prints above all other Japanese art forms. Contested was the value of these prints, which Gonse called "the last incarnation of the Japanese genius" relative to Japanese painting, something that Fenellosa had studied since taking up residence in Japan six years before and that he argued was a more refined and important product of Japanese aesthetics.[40] For Gonse, and for other proponents of Japanese prints, it was these prints, particularly Hokusai's, rather than the upper-class art form of painting, that opened up another culture to Westerners. "Even though Japanese society despises him (Hokusai) today because of his popular origins, for us Europeans, he has a special appeal. He doesn't need an introduction or commentary; he is human, he speaks of himself. Almost all the examples of this art are taken from the ranks of the people."[41] Furthermore, it was commonly believed that the art was intended for a mass audience. Painters like Utamaro took up printmaking for its wider distribution. As Gonse explained, "The popular school, addressing the middle classes, learned to take up a vehicle of rapid dissemi-

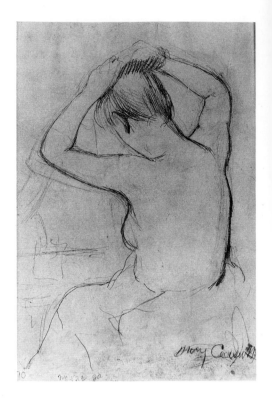

fig. 22. *Study for* The Coiffure (No. 1).
1890–1891
Pencil on white paper
8½ x 5½ in. (216 x 140 mm)
(whereabouts unknown)

nation and low cost."[42] It is Gonse's and his French contemporaries' passionate belief in the Japanese print as an art of the people that informs Cassatt's populist statement about her own color prints.

> I love to do the colored prints, and I hope the Durand-Ruel's will put mine on the market at reasonable prices for nothing, I believe, will inspire a taste for art more than the possibility of having it in the home. I should like to feel that amateurs in America could have an example of my work, a print or an etching for a few dollars. That is what they do in France. It is not left to the rich alone to buy art, the people—even the poor—have taste and buy according to their means and here they can always find something they can afford.[43]

Cassatt's insistence on the individualized inking of each plate, like others who followed the Japanese manner,[44] resulted in the "uniqueness" valued by connoisseurs of Japanese art. In a popular book written for American collectors of Japanese art, *Among the Curios: The Student's Guide to the Japonesque* (1885), James Crabbe listed desirable traits to look for. Stressing the Japanese artist's love of "singularity," Crabbe explains,

> Duplication is the commercial, not the artistic, idea. True art seeks not the publicity of the chromo of a thousand impressions an hour, but it is proud of its singularity. The form and decoration of an article of the Japonesque may be repeated again and again, but it is a repetition, like unto Nature's which may beflower the field with a million daisies, and yet there are not two exactly alike.[45]

While Cassatt had long been in the habit of printing her own plates, never before had she produced works of such "singularity." Curiously, she had been immune to the fashionable practice of creative wiping, including *retroussage* (dragging the ink out of the lines to create a tonal effect), in her black-and-white prints; she began specialized inking and wiping only in her attempts at "imitation of the Japanese."

Finally, the characteristic stylization and emphasis on line that were common observations about Japanese art were similarly observed about Cassatt's art. In her letter to Weitenkampf, she felt that she abandoned Japanese principles after the first plate and "tried for more atmosphere," but it was the compositional simplicity throughout that struck most viewers. The critic Félix Fénéon pointed out that her "compositions without shadows, modeling, or values are colored with clear tints which, protected by their outlines, retain their purity."[46] Later, Segard singled out the back of the bending woman in *Woman Bathing*: "It is traced with a single stroke and yet it is round and firm. It turns as naturally as do the soft backs of young women. In front of this print, Degas had said, 'This back, did you draw this?'"[47]

But Cassatt may have turned to the model of Japanese color prints because of the romance that had long surrounded them in contemporary

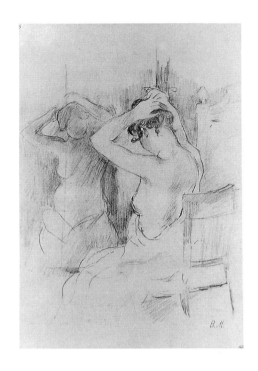

fig. 23. Berthe Morisot (1841–1895)
Drawing for The Cheval Glass, 1890
Pencil on paper
11¾ x 7⅞ (298 x 200 mm) sheet
Musée du Louvre, Paris,
Cabinet des Dessins

a

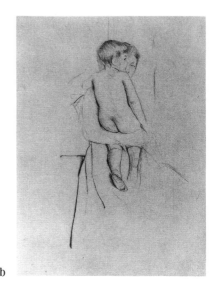

b

fig. 24a. **The Map**, 1889–1890
Br. 127
Drypoint
6 x 9 in. (152 x 229 mm) platemark
National Academy of Design, New York,
Samuel Colman Collection

fig. 24b. **Mother and Child (Baby's Back)**, 1889–1890
Br. 128
Drypoint
9 x 6 in. (229 x 152 mm) platemark
National Academy of Design, New York,
Samuel Colman Collection

fig. 24c. **The Stocking**, 1889–1890
Br. 129
Drypoint
10 x 7 in. (254 x 178 mm) platemark
National Academy of Design, New York,
Samuel Colman Collection

fig. 24d. **The Mandoline (The Mandolin Player)**, 1889–1890
Br. 130
Drypoint
9⅜ x 6⁵⁄₁₆ in. (238 x 160 mm) platemark
National Academy of Design, New York,
Samuel Colman Collection

fig. 24e. **Reflection**, 1889–1890
Br. 131
Drypoint
10⅜ x 7 in. (264 x 178 mm) platemark
National Academy of Design, New York,
Samuel Colman Collection

fig. 24f. **Resting** (also called **Repose**),
1889–1890
Br. 132
Drypoint
9 x 6¹¹⁄₁₆ in. (229 x 170 mm) platemark
National Academy of Design, New York,
Samuel Colman Collection

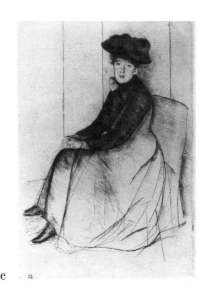

e

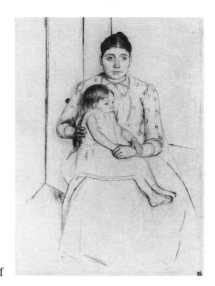

f

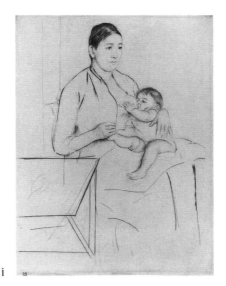

i

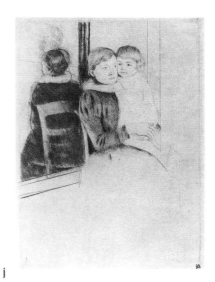

j

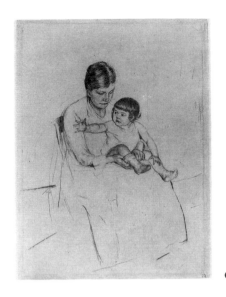

c

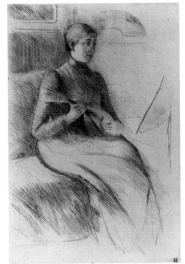

d

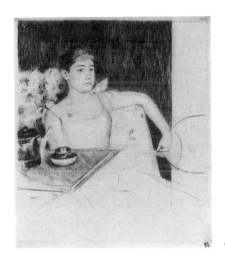

g

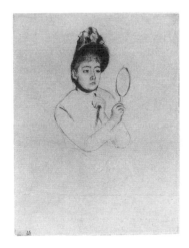

h

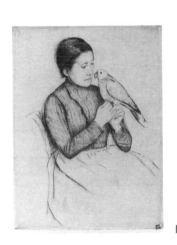

k

l

fig. 24g. **The Tea**, 1889–1890
Br. 133
Drypoint
7⅛ x 6³⁄₁₆ in. (181 x 157 mm) platemark
National Academy of Design, New York,
Samuel Colman Collection

fig. 24h. **Hélène de Septeuil**, 1889–1890
Br. 134
Drypoint
9 x 6 in. (229 x 152 mm) platemark
National Academy of Design, New York,
Samuel Colman Collection

fig. 24i. **Nursing**, 1889–1890
Br. 135
Drypoint
9⅜ x 7¹⁄₁₆ in. (238 x 179 mm) platemark
National Academy of Design, New York,
Samuel Colman Collection

fig. 24j. **The Mirror**, 1889–1890
Br. 136
Drypoint
9 x 6¹¹⁄₁₆ in. (229 x 170 mm) platemark
National Academy of Design, New York,
Samuel Colman Collection

fig. 24l. **The Parrot**, 1889–1890
Br. 138
Drypoint
6⅜ x 4¾ in. (162 x 121 mm) platemark
National Academy of Design, New York,
Samuel Colman Collection

French literature, which was Cassatt's other great love. The first rage for Japanese prints came in the 1860s when Cassatt was in Paris as an art student and the novel that passed from hand to hand in the studios was the Goncourt brothers' *Manette Salomon*, published in 1867.[48] The Goncourts wove a memorable image of the painter Coriolis de Naz, disheartened by the gray Paris winter day, putting down his brush and losing himself in the exquisitely colored world of his Japanese print albums. "Before him passed women, some wound round with cherry-colored silk, others covered by fans; women drinking with tiny sips from red lacquer cups; women in boats gliding on rivers, nonchalantly bent over the poetic and fugitive water...."[49] Above all, in the Goncourt view, Japanese prints suggested a world of heightened sensory pleasure where color, taste, and feeling all surpassed what was to be had in a cold and colorless Paris. Cassatt, who had devoted the last six or seven years to the restrained black-and-white drypoints and a similar "severe" style in paintings, once again could indulge her natural love of color and provide for her Parisian audience the escape that the Goncourts' Coriolis found.

Sensory pleasure also included eroticism, which was, from the early days of Western rage for these prints, an ineluctable part of the Western attitude toward them. Since many of the ukiyo-e prints were frankly pornographic, and most were understood to represent the nether world of courtesans and actors, Japanese prints as a whole were morally questionable. While the Parisian art world could take eroticism in stride, Anglo-American Victorian society, of which Cassatt was also still somewhat a part, had another view. John La Farge, who was an early collector and writer on Japanese art, found that in America "people thought moral ill of a lover of Jap art—as for the lover of Blake or Goya."[50] Eroticism, albeit veiled, is acknowledged by Cassatt in her choice of seminude poses for her adult models (which was unusual in her art) and even of the intimacy of mother and nude child. The Japanese prints in her own collection (figs. 31 a–f) appear to Western eyes to cast this relationship in a sensual light and provide a revealing context for Cassatt's interpretation.

As a group, the ten prints form a single work of art. Regardless of the individual circumstances of technique or inspiration that shaped each one, it was as a whole that the prints were consistently exhibited, sold, and presumably hung in collectors' homes. As Japanese prints were typically made to be seen in groups, usually bound so as to preserve a specific order in which they were to be seen, so might we see Cassatt's prints as achieving an overall impact. It is doubtful that she had in mind the kind of strict sequence that a Japanese artist working in the ukiyo-e tradition strove for, which, according to Jack Hillier, had to be "leafed through, page by page, picture by picture, the impact of the prints being of cumulative effect, the artist purposefully organizing the serial contents to awaken and hold interest, often with a calculated crescendo at the end."[51]

Nevertheless, Cassatt's series, with its occasional repetition of models and its suggestion of times of day—morning rituals, daily errands, after-

noon socializing, evening entertaining, and bedtime rituals—suggests the many such surveys of Japanese women in similar daily cycles. If Cassatt's intention was to achieve a Western version of such a survey, these ten prints provide us with a more complete glimpse of "daily life" as Cassatt would see it than anywhere else in her art. While "daily life" had been her subject since the late 1870s (and many of the color prints echo themes she had explored in her Impressionist paintings and prints), in this cycle she was forced to round out the survey with subjects she had never before attempted. *In the Omnibus*, *The Letter*, and *The Fitting* (cats. 7–9) are all without parallel in Cassatt's work, and the two nude studies *Woman Bathing* and *The Coiffure* (which was originally titled "Study of a Nude")[52] (cats. 10, 14) are rare. Although the three prints of mothers and children, *Afternoon Tea Party*, and *The Lamp* are familiar subjects for Cassatt, the remaining five—half of the cycle—are new.

The topics that Cassatt chose to explore just for this series of prints are ones that offer a wider view of a woman's life in Paris and deal implicitly with issues not seen elsewhere. Juxtaposition of classes, for instance, is seen not only in the mistress and maid from *In the Omnibus* but also in seamstress and customer from *The Fitting*. While Cassatt shared the upper-class belief in an orderly society in which servitude is necessary, she also respected hard work and craftsmanship wherever it occurred. Her dignified depiction of the seamstress blurs obvious class distinctions and may reflect Cassatt's own interest in and respect for that profession.

The Letter reflects a theme that also reveals a personal side of Cassatt and leads us to wonder why she did not use it in her other art. Since she was in the expatriate's position of having a great deal of correspondence herself, and since writing and reading letters was a long-standing staple of 18th- and 19th-century art's repertoire of female pursuits (along with reading, sewing, and playing with a pet animal—all of which Cassatt used freely), her failure to use this subject more than this once is remarkable. Perhaps its appearance here, along with other "chores" (riding the omnibus, having clothes fitted) that are equally rare in Cassatt's art, indicates that her own experience with obligatory letter writing overshadowed for her the "romantic" qualities of the theme. Only in the context of Japanese imagery, which often showed a woman with a cloth or tissue in her mouth (often indicating an agitated state of mind), could Cassatt see the potency of such a theme.

Finally, the nude studies acquire an intimacy that is heightened by seeing the same red-haired model dressed and active as a public person in *The Lamp*, *The Fitting*, and *Afternoon Tea Party* (cats. 6, 9, 13). In viewing the prints as a whole, the models lose their anonymity and become familiar characters in the daily drama unfolding before us. It is perhaps not an accident that Cassatt used this model as a pivotal figure in her mural *Modern Woman*, in which Cassatt again examined and depicted women—this time symbolically—in the modern world.

Like the Goncourts' Coriolis, who put down his brush and turned to

prints, Cassatt also used her color prints as a respite from her work in other media. We have seen how frequently Cassatt based her prints on paintings and pastels, but the set of ten, unlike both earlier and later prints, is remarkably free of duplication, and only a few are related even distantly to other works. While models and costumes can be identified in earlier or later prints and pastels, it appears that once Cassatt began her printmaking project, she ceased activity in the other media. Of the four paintings and pastels she exhibited with the color prints in April 1891, none can be dated later than the summer of 1890.[53]

As for the actual technical procedure Cassatt used in making the prints, we know very little from documentary evidence. What we do know can be summarized as follows: according to both her own account of her method and Pissarro's report to his son Lucien, she worked out her design in drypoint on one plate, then transferred it to one or two others, using the linear design as a guide to the laying on of the aquatint. Some existing drawings (including *The Bath*, *In the Omnibus*, etc.) show that she used a softground method for transferring the design, but others without the traces of softground indicate that some other method of transfer was involved.

According to Pissarro, her tones were exceptionally fine—the result of using the best-quality plates (copper), a dusting box (*boîte à grain*), and a good printer. There is no evidence that she used softground for her tonal areas either by hatching or by applying a textured fabric to the plate.[54]

As for inking, she used commercial printer's ink and mixed the colors to achieve just the right tint,[55] then "painted" the colors onto the plate "as it was to appear in the proof."[56] She felt that since she was doing the inking, she could vary "the manner of applying the color"[57] and thus achieve different effects in her impressions.

Cassatt wished she could have pulled more proofs of states but did not have the time: "I had to hurry on and be ready for my printer, when I could get him—"[58] This indicates that she herself was printing the states and got help from the professional printer Leroy only with the final proofs, but this may mean that she printed only the early drypoint states herself (she was experienced at this kind of printing) and got help with the more complicated advanced states with more than one plate and all the colors. At any rate, when she worked with Leroy,[59] they averaged about "eight or ten proofs in the day."[60] If this refers only to the pulling of final impressions, it would have taken the two of them 25 days of working top speed to print the entire edition of 25 for the 10 prints.

Cassatt inscribed the final proofs with the edition size, *Edition de 25 épreuves* or simply *(25 épreuves)*, but this information appears to have been added after the prints were already signed with the long descriptive phrase *Imprimée par l'artiste et M. Leroy/Mary Cassatt*. This may indicate that the edition size was not determined until after a number of final proofs had been pulled and signed, or more likely, that stating edition size on the print was an afterthought (it had never been Cassatt's practice for earlier editioned prints). We do know that the work of printing was not finished by the time

the exhibition opened in the first part of April 1891. Pissarro visited her studio on April 25 and "watched her make color prints of her aquatints."[61]

Beyond the first print, *The Bath* (cat. 5), it is impossible to tell the order in which Cassatt executed each of the ten. *The Bath* was clearly the first in that it was listed first in the catalogue with the subtitle "in imitation of Japanese prints," which she "abandoned" thereafter. It is also the most complicated in terms of number and of sequence of states—illustrating vividly what Cassatt later admitted to Weitenkampf: "I was entirely ignorant of the method when I began."[62]

Cassatt's second print was very likely another mother-and-child composition, *Mother's Kiss* (cat. 11), which, like *The Bath*, is related to the mother-and-child paintings and pastels she was doing before starting the color prints. It also goes through a number of false starts and state changes and, like *The Bath*, uses only two plates (all the others use three). Beyond these two, the order of the prints is obscure. The order in which they appear in the catalogue of the exhibition is apparently not the order in which they were done, and even that numbering was soon abandoned for other sequences, even in early documented sets.[63]

The outline of Cassatt's working method, which is provided by contemporary accounts and inscriptions, is in general borne out by an examination of the prints themselves. However, because Cassatt was not following a set formula of printmaking, and because she allowed herself a great deal of flexibility in the creation and coloring of the prints, many more subtleties are discovered when each print is considered individually. It cannot be emphasized too often that Cassatt approached these prints as an oil painter would—she did not hesitate to scrape off and redo both drypoint and aquatint areas if they did not please her, sometimes leaving faint traces of the previous rejected lines in the plate. Furthermore, although the printing is impeccable and the registration of the plates (using pinholes in the plates as guides) is often uncanny, Cassatt frequently created "errors" or unpredictable nuances to give the print a more painterly quality. In some cases she allowed tonal areas on different plates to overlap, while in others the aquatint is stopped out with a sweep of the brush or casually scraped to leave traces of the hand of the artist.

The great effort Cassatt invested in this set of color prints was spurred by the anticipation of her first one-person exhibition. In planning for 1891, the Peintres-Graveurs passed an exclusionary measure against non-French participants, leaving Cassatt and Pissarro (who was a native of the Danish West Indies) out of the group. The two "foreigners" approached Durand-Ruel, who was once again providing gallery space for the Peintres-Graveurs, for space of their own contiguous to the large exhibition. This granted, they secured the limelight for themselves. Even the conservative American "society" paper in Paris, *The American Register*, acknowledged the exhibition of "paintings and pastels, *pointe-sèche* and aquatints, by the well-known American artist Miss Mary Cassatt . . ." to be "decidedly worth a close inspection."[64]

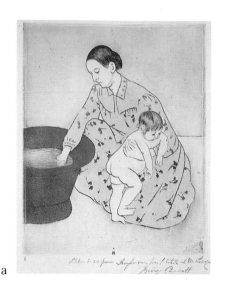

a

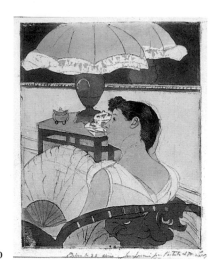

b

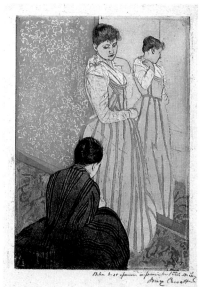

e

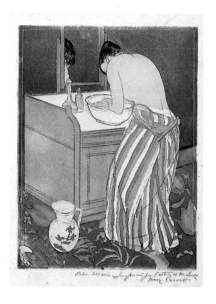

f

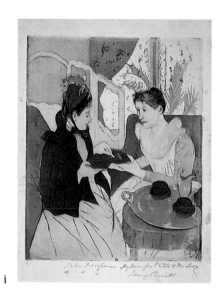

i

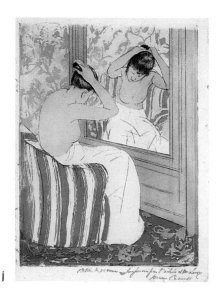

j

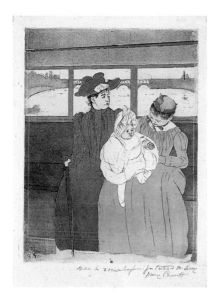

c

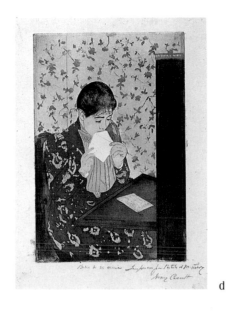

d

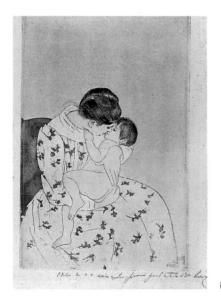

g

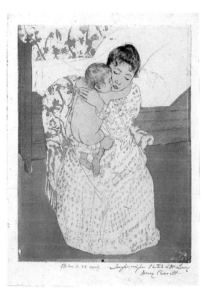

h

The set of ten color prints by Mary Cassatt
are reproduced here courtesy of The Metropolitan
Museum of Art, New York (see The Catalogue for
full descriptions):

a cat. 5–XVII (MMA) *The Bath*
b cat. 6–IV (MMA) *The Lamp*
c cat. 7-VII (MMA) *In the Omnibus*
d cat. 8–IV (MMA) *The Letter*
e cat. 9–VII (MMA) *The Fitting*
f cat. 10–IV (MMA) *Woman Bathing*
g cat. 11–V (MMA) *Mother's Kiss*
h cat. 12–VI (MMA) *Maternal Caress*
i cat. 13–V (MMA) *Afternoon Tea Party*
j cat. 14–V (MMA) *The Coiffure*

The set of ten color prints was marketed by Durand-Ruel, who sold them from his Paris gallery and sent seven sets to the New York branch in the summer of 1891. There three sets were placed on deposit with three other dealers, Keppel, Wunderlich, and Knoedler, and may have been included in an exhibition of Cassatt's prints at Keppel's gallery that fall. Early purchasers were Cassatt's friends the Havemeyers and the influential print curator and writer Sylvester Koehler on behalf of a Boston collector, Mrs. Kingsmill Marrs. That same year the French printmaker and collector Philippe Zilcken acquired at least one of the colored prints for his collection in Amsterdam and a set of ten was sent to an exhibition of Les XX in Brussels the following summer. The interest of French collectors as well as those elsewhere in Europe and the United States pleased Durand-Ruel, although Cassatt felt that the American audience could have been more enthusiastic. In an irritated tone she wrote to Durand-Ruel about the strong market for them in Paris, "Of course it is more flattering from an Art point of view than if they sold in America, but I am still very much disappointed that my compatriots have so little liking for any of my work."[65]

Despite Cassatt's lament, the set of ten color prints was a boost to her reputation and a pleasurable form of work for her. In the next six years she attempted two other sets of color prints but was never able to work with such concentration nor produce such a coherent group. The nine later color prints she ultimately achieved, while having independent success, or appearing as a fragment of a group, have a different character and must be considered separately.

From 1893 to 1895 Cassatt produced five new color prints: *Gathering Fruit*, *The Banjo Lesson*, *Peasant Mother and Child*, *Feeding the Ducks*, and the monotype *The Album* (cats. 15–19). Although her intention was to create a new set,[66] the five prints that resulted—created over a two-year span—are dissimilar in size, medium, and palette and were exhibited and sold separately. It is possible that the final four color prints, begun in 1896, were intended to continue and ultimately complete a projected set of ten, but there is no supporting evidence for this, and the coherence of the last four prints as a group causes us to see them as a separate enterprise.

The first two prints in this "middle" group, *Gathering Fruit* and *The Banjo Lesson*, are directly related to Cassatt's mural *Modern Woman*, painted for the Woman's Building of the World's Columbian Exposition held in Chicago in 1893 (see fig. 15-1). This large mural constituted Cassatt's first substantial body of work in any medium after she completed and exhibited the set of ten color prints in 1891. The illness and death of her father in the fall of 1891 and the subsequent trip to the south of France with her mother early in 1892 kept Cassatt away from her studio for the winter—normally her most productive season and her normal season for working on the printing press kept in her Paris apartment.

When she returned from Cap d'Antibes in April, she was almost immediately engaged by Mrs. Potter Palmer, president of the Board of Lady

Managers of the Woman's Building, to paint the 12-by-58-foot mural that was to hang opposite Mary Fairchild Macmonnies's *Primitive Woman* and show the progress of women into the modern age. This project consumed Cassatt's time and energy and kept her at Bachivillers, her rented summer villa 50 miles north of Paris, until January 1893. As soon as the large, curved canvas was shipped off to Chicago, she and her mother again traveled south (to Italy) until April and then to their summer home at Bachivillers. Returning to Paris in the fall of 1893, Cassatt completed two new color prints and was spoken of by Joseph Durand-Ruel as occupied with this project "d'une façon exclusive" (to the exclusion of anything else).[67]

Even before the mural was shipped, Cassatt expressed her desire to make prints from that monumental composition. That she considered these prints in some way "reproductions" of the mural is evident from her objection to the widespread publication of photographs of the mural. In a letter to Durand-Ruel, she writes, "I just received a letter from Mms. Boussod and Valadon asking me if I would give them photographs to be reproduced, they are the concessioners of the only illustrated publication. Can't I reserve the publication rights? I intended to use the designs for drypoints and I have no desire to see myself vulgarized by their processes."[68] Unlike the earlier set of ten prints, which are almost entirely without reproductive intention, the prints Cassatt wanted to make from mural designs would have a very clear reproductive function: they would stand in for a major work that Cassatt knew she had to ship off to Chicago without being exhibited in Paris. Furthermore, Cassatt may have foreseen that as a decoration of "world's fair" architecture, the mural would not, in fact, survive; it would very likely be dispensed with at the close of the fair along with the pavilion that it decorated (which is, evidently, what did happen to it). Cassatt was also very careful to create a series of mural-related paintings and pastels, which in like manner translated her work on the mural into a smaller and more lasting format.

This group of mural-related paintings, pastels, and prints was featured in Cassatt's first large retrospective exhibition at Durand-Ruel's gallery, Paris, in November and December 1893. The 98 works surveyed Cassatt's output since her involvement with the Impressionists in the late 1870s and emphasized her achievements in printmaking. She showed 17 oils, 14 pastels, and 67 prints, including color prints, etchings, drypoints, and one lithograph. Of the graphic work, she showed her two previous sets (the series of 12 drypoints and the series of 10 color prints), but interspersed among the single prints were early states of both color and black-and-white prints. For the first time since the Impressionist exhibition of 1880, Cassatt showed her prints as works of art "in flux," giving importance to early states as well as to final editioned proofs. Of her last two color prints, *Gathering Fruit* was shown with one preliminary state and *The Banjo Lesson* with three.

Once again, the order in which the prints were done is difficult to determine. Judging from the development of *Gathering Fruit* and *The Banjo*

Lesson, *Gathering Fruit* went through the most preliminary states (11), as if Cassatt were once again having to find her way with the technique after a hiatus of two years, whereas *The Banjo Lesson* went through only three preliminary states, as if she were more sure of the process. Furthermore, a painting based on the print, *Baby Reaching for an Apple*, was finished and exhibited in the exhibition of 1893. There is a pastel that is similarly based on *The Banjo Lesson*, but it was not completed and shown until 1895, suggesting that *The Banjo Lesson* was the later composition to be explored.

With *The Banjo Lesson* we encounter Cassatt's first use of monotype. Previously she had made liberal use of *à la poupée* wiping and occasionally added hand-touches to the plate (as in *Gathering Fruit*) or to the paper (e.g., the gold accents on the tea service in *Afternoon Tea Party*), but she had not explored the possibilities of monotype in which ink is applied to an unworked plate and then printed. In *The Banjo Lesson*, Cassatt applies the color to the young girl's dress, the neck of the banjo, and the polka dots of the woman's dress in monotype. The woman's sleeves are also colored with monotype strokes, but there may have been aquatint tone underneath. This experimentation with monotype in 1893 signals a general awakening of interest in the process among printmakers in Europe and America. In Cassatt's own circle, Degas had long been using monotype for his series of bathers and nudes, while Americans around Whistler and Duveneck in Venice in the early 1880s had made it into a popular pastime. In 1892, Herkomer's *Etching and Mezzotint Engraving* illustrated sophisticated monotypes using a brush to apply the ink, which appears to be Cassatt's technique as well.

In April 1895 Cassatt was given her second major exhibition by Durand-Ruel—this time in the New York gallery. A smaller group of 64 works included more paintings and pastels than it did prints (36 of the former, 28 of the latter), and no preliminary states of the prints. A new color print was added to the previous set of ten and the two mural-related works: a "Mère et enfant," now called *Peasant Mother and Child*. This composition was derived faithfully from a pastel of the same title (Br. 232), which was itself part of a group of at least eight pastel sketches and finished works done in 1894 featuring the same models. Apparently Cassatt's intention of creating a series of color prints based on the mural was abandoned after *The Banjo Lesson*; and when she returned to color prints (once more taking the plate through as many as ten state changes), she based her design on recent work rather than on the mural. The use of monotype over aquatint in the fifth state (see cat. 17-v) indicates an approach similar to that in the woman's sleeves in *The Banjo Lesson*, and in the final state the mother's skirt is also inked in a monotype-like fashion.

Peasant Mother and Child was possibly the last color print to have been developed by Cassatt in her Paris studio. In 1894 she bought the château at Mesnil-Beaufresne not far from her former summer home at Bachivillers and at some point moved her press there from Paris. Louisine Havemeyer recalled her working "in her grey blouse in the small pavilion

over the dam which fed her *pièce d'eau* and where she had installed her printing press. There she would work while daylight lasted with the aid of a printer; she did her own coloring and wiping of the plates. It was at the cost of much physical strain for she actually did the manual work."[69] This recollection could date as early as an 1895 Havemeyer visit to Cassatt in France.

It is tempting to think that the final two color prints in this group, *Feeding the Ducks* and *The Album*, were done at Beaufresne in the summer of 1895. Although they are linked to *Peasant Mother and Child* in costume and in the use of monotype, they represent a change to a bucolic subject and mood, and *Feeding the Ducks* may even depict the *pièce d'eau* over which Cassatt had her studio. Once again, Cassatt draws on her recent work in oil and pastel rather than returning to the themes of her earlier color prints: *Feeding the Ducks* is based on oil sketches of the same subject (see figs. 18-1, 18-2), and *The Album* is based on a pastel (dated "'95") that uses the same model as seen in the bow of the boat in *Feeding the Ducks*. Once again, the hand of the artist is visible either in monotype accents or, as in *The Album*, in complete monotype.

Of this group of prints, only two appear to have had large editions: *The Banjo Lesson* (40) and *Peasant Mother and Child* (50). Aside from the monotype, final proofs of *Gathering Fruit* and *Feeding the Ducks* both exist today in fewer numbers than any of the other major color prints before or after. Furthermore, none of the prints carries the elaborate inscription that numbers the edition and credits a specific printer. It is most likely from the uneven size of the editions that she used different printers each time—particularly after she moved her press out of Paris. Nevertheless, impressions of these prints entered major collections in Europe and the United States, including Roger Marx, Bing, Avery, Whittemore, Pope, and artists' collections such as Theodore Robinson and J. Alden Weir.

While these prints were admired in her day and continue to be considered among her best, it is evident that they did not hold as important a place in her artistic output as did the original set of ten. The practice of printmaking never again held her entire attention as it did during the winter of 1890–1891; and thus her prints, relegated to a reproductive role, do not show the authoritative design qualities and craftsmanship of the earlier set. While they are attractive in color and subject, one is distracted by the constant comparison with her larger-scale finished work. Cassatt regretted the loss of concentration, and again in 1896 tried once more to create a series of the quality of the original ten.

Perhaps buoyed by her work on *Feeding the Ducks* and *The Album*, Cassatt announced in February 1896 a new color print to be published in *L'Estampe nouvelle*.[70] When that print, *Under the Horse Chestnut Tree* (cat. 20), appeared over a year later in October 1897, it was part of a body of work (including pastels, paintings, and three other color prints, *By the Pond*, *The Barefooted Child*, and the unfinished *Picking Daisies in a Field* [cats. 21–23]) that featured a distinctive dark-haired mother and blond, curly-haired child.

The final group of four color prints is remarkably coherent because of the repetition of the models, the distinctive drypoint technique, and the large size of three of the four plates.[71] However, while they may be considered a "set" on stylistic grounds, they were not sold or referred to as such at the time.

Since *Under the Horse Chestnut Tree* was to be distributed by the print society L'Estampe Nouvelle, it became the only print not controlled by Durand-Ruel since Cassatt had begun her formal association with that gallery in the late 1880s.[72] Durand-Ruel did, however, receive others from this group and recorded them as "mother and child" (probably both *By the Pond* and *The Barefooted Child*) to which they added "curly hair,"[73] which to this day aptly identifies the group.

The years 1896–1897 were productive ones for Cassatt; despite the loss of her mother in the fall of 1895, she was hard at work again by the following summer and continued to produce paintings and pastels steadily through 1897. Perhaps the stimulus for this activity was a second exhibition in New York to be held in January and February 1898—and her planned return to her native country for the first time in 23 years. Cassatt worked up to the last minute, delivering her larger pieces to Durand-Ruel in Paris in December 1897 to be shipped to New York for the exhibition, while she herself carried the prints and delivered them to the Durand-Ruel gallery on Fifth Avenue when she arrived. The pressure of such a deadline may account for the unfinished print, *Picking Daisies in a Field*, which is the only color print that Cassatt abandoned.

This new work, with its charming models and delicate touch, was well received by critics who acknowledged her debt to the Impressionists, but who more warmly approved her recent involvement with Japanese prints: "Then came her leaning toward those oriental workers in the land of chrysanthemums, and Miss Cassatt produced many delicately conceived etchings, drawings, and paintings, betraying her affiliations with a wonderfully decorative race. Through all the efforts, however, there were seriousness, intelligent searching, and always individuality."[74]

Ironically, Cassatt's most recent prints showed her moving away from the Japanese influence toward a more Western style of drawing and design. In contrast to her earlier color prints, this last group shows a much greater reliance on subtle drypoint hatching to create three-dimensional modeling, particularly of the flesh areas of mother and child. The Japonesque device of emphasizing outline and contour—and "flattening" form—which Cassatt had used so successfully in her earlier prints, is here found only in a compromised way. The color areas are still bold and abstract, but the figures are heavily worked in drypoint and have less of a direct impact.

Thus, in these color prints Cassatt seems to strive for the subtle modeling of flesh possible in paintings or pastels rather than the abstract linear approach more common to prints. The effect of a painting is further suggested by Cassatt's sudden adoption of the practice of signing *By the Pond* within the image rather than below, in the lower margin, which is

standard practice for prints and was her custom before and after. Furthermore, the large size of these prints suggests that Cassatt intended them to share with paintings the impact of a more monumental scale.

Both *The Barefooted Child* and *Picking Daisies in a Field* are closely related to pastels and serve the reproductive function that the color prints from 1893 to 1895 also served. But the commissioned print, *Under the Horse Chestnut Tree*, and *By the Pond* are further removed from finished works in oil or pastel, suggesting that they were to stand on their own as major works. *By the Pond* is one of the most "painterly" prints in that the aquatinted areas, particularly of the pond, are inked *à la poupée*, creating soft, brushy effects for the blue and green reflections.

As the last group of major color prints that Cassatt produced, it is fitting that they should also be the most like paintings. Throughout her career as a printmaker, she brought her experience in other media to bear on the printmaking process, often achieving the unique effects that were acknowledged even in her own day. While Cassatt's involvement with color prints ended on a bitter note—"The Durand Ruels tell me there is not enough in it, they want me to go back to pastels"[75]—her contribution was fully recognized, particularly in her own country. After her 1898 exhibition in New York, a critic summed up the response:

> She has produced a series of etchings and dry-points of great distinction, and a number of the latter printed in flat tints are among the most delightful color prints of our time. This last method, of combining an outline in dry-point with colors, applied in aquatint, she may be said to have made her own to such a degree that it would be temerarious for any one to dispute the field with her.[76]

Indeed, among Americans Cassatt had no rivals in the area she had carved out for herself. It is interesting to note that the three Americans who made and exhibited influential color prints in the 1890s chose three entirely different graphic processes: Whistler in lithograph, Arthur Wesley Dow in woodcut, and Prendergast in monotype. However, all three had access to Cassatt's color prints in Paris or the United States, and each shared with her aspects of her interest in color printing, primarily in techniques of hand-coloring of the plate and individualizing each impression. While Cassatt was not directly imitated, we must see her as a dominant figure in one of the most compelling artistic trends of her day.

NOTES

1. For example, according to Susan Hobbs, even such a noted *amateur* as Charles Lang Freer belonged to a club where members printed their own work.

2. Women particularly took advantage of this change, although usually for professional rather than hobbyist motives. For a more extensive account of the influence of the etching revival, see Peet (1988).

3. For a complete discussion of *Le Jour et la nuit* as a vehicle for reproductive prints, see Druick and Zegers, "Degas and the Printed Image, 1856–1914" in Reed and Shapiro (1985), especially p. xli.

4. Mary Cassatt to Emily Sartain, May 25, 1872, in Mathews (1984), p. 98).

5. Eliza Haldeman to Samuel Haldeman, December 21, 1861, in Mathews (1984), p. 26.

6. Segard (1913), p. 6.

7. Emily Sartain to John Sartain, February 18, 1872, in Mathews (1984), p. 93.

8. Idem. Both mezzotint and aquatint are tonal processes—that is, they create tone on the plate rather than line. However, in mezzotint the tone is produced by stippling the plate with an engraving tool that has an edge of fine teeth that dig into the plate when the tool is rocked back and forth; in aquatint, a network of fine lines is produced when acid bites the plate around tiny drops of resin that have been dusted onto it as a fine powder. The tones are not only produced in different ways but look different to the eye. The mezzotint "dots" hold ink and print black, whereas the aquatint "dots" protect the plate from the bite of the acid, causing the ink to be held in the spaces between them, and thus they print white.

9. Evariste Vital Luminais (1822–1896) was a specialist in historical genre scenes, particularly from the period of the Gauls in France. Sartain studied with him in Paris from 1872 until 1875.

10. Emily Sartain to John Sartain, May 8, 1873, in Mathews (1984), p. 120.

11. Idem.

12. Emily Sartain to John Sartain, June 17, 1874, in Mathews (1984), p. 124.

13. "*Coin de loge*. (Dessin inédit de Miss Cassatt, d'après son tableau.)" is a drawing after *In the Box* (Mr. and Mrs. Edgar Scott, Villanova, Pennsylvania). *La Vie Moderne*, May 1, 1879, p. 54. "Dans une Loge.—Composition de miss Cassatt" is a drawing after *Lydia in a Loge, Wearing a Pearl Necklace* (Philadelphia Museum of Art). *La Vie Moderne*, August 9, 1879, p. 283.

14. Edgar Degas to Félix Bracquemond (1879–1880), in *Degas Letters*, p. 54.

15. Segard (1913), p. 108.

16. See: B. S. Shapiro, *Camille Pissarro, the Impressionist Printmaker*, Museum of Fine Arts, Boston, 1973; M. Melot, "La Pratique d'un artiste: Pissarro Graveur en 1880"; *Histoire et critique des arts*, no. 2, June 1977, and Lant (1983), pp. 18–29.

17. Lant (1983), cf., pp. 19–22.

18. Edgar Degas to Camille Pissarro (1880), *Degas Letters*, p. 58.

19. Lant (1983), p. 19.

20. *New York Tribune*, April 12, 1888, p. 4, in Watrous, p. 16.

21. Segard (1913), p. 99. "C'est une recherche graphique, compliquée d'une recherche de couleurs en blanc et en noir . . ."

22. Cassatt's father mentions that she is "engaged in *etchings*" in a letter to her brother dated December 3, 1884, but it is not clear what prints she might have produced at this time. Her brother Aleck arrived with Robbie on December 29, 1884, and presumably no work in either print or painting form would have been done until after the new year.

23. Hamerton (1871), p. 80.

24. Ibid., p. 81.

25. An impression of *Gardner Held by His Mother* (Br. 113) in the New York Public Library is inscribed "Jan/88."

26. Druick and Zegers, p. lx.

27. Idem.

28. "53—Epreuves de pointe sèche faisant partie d'une serie de douze."

29. Samuel Avery, for instance, had *Bill Holding the Back of a Chair* (Br. 105), *Preparing Bill for an Outing* (Br. 106), and *On the Bench* (Br. 107), as well as two states of *Nurse and Baby Bill (No. 1)* (Br. 108) and *Nurse and Baby Bill (No. 2)* (Br. 109), printed without color. *On the Bench* was reproduced with the drypoint *The Bonnet* (Br. 137) in an article praising Cassatt's recent work in prints (Frank Linstow White, "Younger American Women in Art," *Frank Leslie's Popular Monthly*, November 1893, pp. 538, 539, and 542).

30. Although Cassatt's use of the soft-ground process is well documented, especially in her early Impressionist prints, the effect produced in these is unusual. Sue Fuller, in her article "Mary Cassatt's Use of Soft-Ground Etching" accounts for the textural quality of the lines by proposing Cassatt's use of a textured, fabriclike netting underneath the drawing.

31. See Janine Bailly-Herzberg, "Les Estampes de Berthe Morisot," pp. 215–27.

32. See Boyle-Turner, p. 26.

33. Druick and Zegers, p. lx.

34. Mary Cassatt to Berthe Morisot, April 1890, in Mathews (1984), p. 214.

35. "Mary has been quite as busy as she was last winter—but this time it is with *colored* 'eaux-forts' and not with etching." Katherine Cassatt to Alexander Cassatt, January 23, 1891, in Mathews (1984), p. 216.

36. Joseph Durand-Ruel to A. de Lostalot, November 30, 1893: "Quant aux pointes sèches editées par nous en une séries de douze numéros, nous n'en avons plus que quelques épreuves . . ." Archives Durand-Ruel, Paris.

37. Joseph Durand-Ruel to Mary Cassatt, February 16, 1892: "La vente separée de vos épreuves aurait de grands inconvenients. Tout le monde voudrait les mêmes planches et vos collections se trouveraient rapidement dépareillées, et des lors invendables." Archives Durand-Ruel, Paris.

38. Mary Cassatt to Frank Weitenkampf, May 18, 1906, New York Public Library.

39. *Rare Japanese Prints*, Kende Galleries, Inc., April 21 and 22, 1950; lots 56 to 89. This sale of works from Cassatt's collection included prints by Hiroshige, Yeisen, Hokusai, Kiyonaga, Shunjo, Shunzan, Harunobu, Utamaro, Yeishi, and Yeizan.

40. For an extensive discussion of the debate, see Chisholm, pp. 62–63.

41. Gonse, p. 78.

42. Ibid., p. 84.

43. Quoted in Louisine Havemeyer, unpublished chapter of memoirs, p. 17.

44. For example, Arthur Wesley Dow painted his woodcut blocks individually with brush and watercolor and hand-printed them to achieve the quality he saw in Japanese prints. See Frederick Moffatt, *Arthur Wesley Dow* (Smithsonian Institution Press, 1977).

45. Crabbe, p. 13.

46. *Félix Fénéon*, pp. 184–85.

47. Segard, p. 104.

48. See Schwartz, p. 70.

49. Ibid., p. 71.

50. From a 1908 letter to James Gibbons Huneker, cited in Chisolm, p. 42.

51. Jack Hillier, *The Art of Hokusai in Book Illustration*, Berkeley/Los Angeles: 1980, as cited in Floyd (March 1986), p. 107.

52. The final proof of *The Coiffure* owned by Samuel P. Avery (now in the print collection of the New York Public Library) is inscribed by Cassatt: "Study of a Nude."

53. The two pastels, *Une Caresse* and *Femme avec son enfant*, may be identified from Fénéon's description of dress fabrics in his review, "Cassatt, Pissarro," as *Baby's First Caress* ("blanche à fleurs," New Britain Museum of American Art, fig. 93) and *Hélène of Septeuil* ("écossaise," University of Connecticut Museum of Art, fig. 27), respectively. The oils, both called *Mère et enfant* in the catalogue, may have been *The Quiet Time* (Br. CR 151, formerly Durand-Ruel collection, present whereabouts unknown) and *The Child's Caress* ("lilas," Honolulu Academy of Arts, fig. 45).

54. Sue Fuller (see above) and Adelyn Breeskin supported the softground hypothesis for Cassatt's tonal areas, but a thorough examination of the documentary evidence and the prints themselves reveals that aquatint was used throughout.

55. Camille Pissarro to Lucien Pissarro, April 3, 1891, in Mathews (1984), p. 219, and Camille Pissarro to Lucien Pissarro, April 25, 1891, in Mathews (1984), p. 220.

56. Mary Cassatt to Samuel Avery, June 9, 1891, in Mathews (1984), p. 221.

57. Cassatt to Weitenkampf, New York Public Library.

58. Cassatt to Avery, in Mathews (1984), p. 221.

59. See Shapiro, p. 72.

60. Cassatt to Avery, in Mathews (1984), p. 221.

61. In Mathews (1984), p. 220.

62. Cassatt to Weitenkampf, New York Public Library.

63. The set in the Worcester Art Museum (see pp. 1–10), for which the bill of sale still exists, was purchased from Frederick Keppel on November 30, 1891, for $210.

The prints are inscribed with numbers as follows:
 1. *The Lamp* 2. *The Letter* 3. *Woman Bathing* 4. *Afternoon Tea Party* 5. *Maternal Caress* 6. *The Bath* 7. *The Coiffure* 8. *The Fitting* 9. *Mother's Kiss* 10. *In the Omnibus*

64. *The American Register*, April 11, 1891, p. 6.

65. Mary Cassatt to Joseph Durand-Ruel, February 18, 1892, Mathews (1984), p. 228.

66. Joseph Durand-Ruel to A. de Lostalot, November 30, 1893, "Miss Cassatt . . . s'occupe actuellement et d'une façon exclusive d'une nouvelle série d'impressions en couleurs . . ."

67. Ibid.

68. Mary Cassatt to Paul Durand-Ruel, January 6, 1893, as cited in Mathews (1984), p. 244. In fact, a color "facsimile-typogravure" of the central panel of the mural was indeed made from a photograph and published in the deluxe folio by William Walton, *Art and Architecture: World's Columbian Exposition* (Philadelphia: George Barrie, 1893). This type of commercial color print may have been what Cassatt wanted to prevent. For the relationship between new mechanical color printing techniques and "original" color prints, see Shapiro, p. 81.

69. Havemeyer. Unpublished manuscript, p. 16.

70. See Shapiro, p. 94.

71. *Under the Horse Chestnut Tree, By the Pond,* and *Picking Daisies in a Field* are all over 12 x 16 inches, making them among the largest prints Cassatt produced.

72. It may have been the only work by Cassatt in any medium that was not passed through the Durand-Ruel inventory in the 1890s. Even commissioned portraits were duly recorded in the Durand-Ruel stock books and presumably yielded them a percentage.

73. Durand-Ruel, N.Y., stock book, p. 292.

74. Arthur Hoebner, "'The Century's' American Artists Series—Mary Cassatt," in *The Century Magazine* 57 (March 1899), p. 741.

75. Havemeyer, unpublished manuscript, p. 17.

76. R. R., "Miss Mary Cassatt," *The Art Amateur* 38 (May 6, 1898), p. 130.

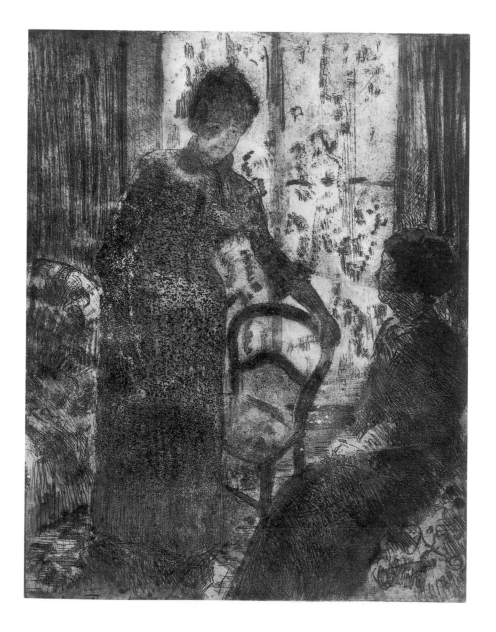

fig. 25. The Visitor, ca. 1879–1880
Br. 34
Sixth state
Softground etching, aquatint, and drypoint
Off-white, medium-weight, moderately
textured, laid paper
20½ x 15⅝ in. (520 x 396 mm) sheet
Coll.: Edgar Degas
Sterling and Francine Clark Art Institute,
Williamstown, Massachusetts

opposite:
fig. 26. *Drawing for* The Visitor,
ca. 1879–1880
Recto: pencil; verso: softground adhering
to traced lines
Off-white, smooth, wove paper
15¾ x 12³⁄₁₆ in. (400 x 309 mm) image
Coll.: Edgar Degas
The Cleveland Museum of Art, Gift of
Fifty Members of The Print Club of
Cleveland on the Occasion of the Fiftieth
Anniversary, 1966

Mary Cassatt's Color Prints and Contemporary French Printmaking

by Barbara Stern Shapiro

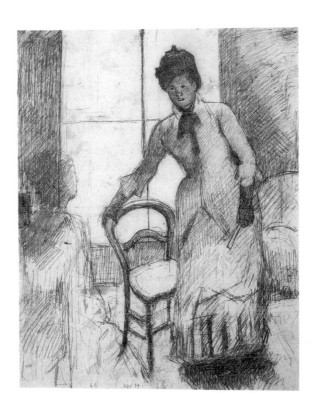

Mary Cassatt's first serious essays as a printmaker were made in the company of Edgar Degas, who had created a studio environment that attracted his artist friends. Cassatt may have learned the etching technique in Italy, where she studied art as a young student, but most likely the four initial attempts known to Breeskin (1–4) were made in Paris. Two of these tentative examples were freely copied after Paul Gavarni, the witty illustrator of fashion and manners. Both Degas and Cassatt owned many prints by Gavarni, and these personal collections may have provided the source for Cassatt's small images. (There is no record that Cassatt ever visited the Print Room at the Bibliothèque Nationale, although it is documented that Degas examined prints there.[1]) It was only after she exhibited with the Impressionists that Cassatt executed her most avant-garde prints. With Degas as an enthusiastic adviser, Cassatt went on to produce a group of etchings that would dramatically demonstrate her technical aptitude as a

printmaker. This period of close artistic contact was readily confirmed when, after Degas's death in 1917, more than 90 impressions of Cassatt's prints were found in his studio. Most of these working proofs and varying states had been executed and printed decades earlier in the 1870s.[2]

During this period Cassatt was introduced to a series of innovative printmaking methods, primarily to the possibilities of mixing and superimposing intaglio techniques: etching, drypoint, softground, and aquatint were all applied in unconventional ways and in unusual combinations to the copperplates. This included the use of various unorthodox drypoint tools, such as metal brushes, that could achieve a range of lines and tonalities. The thrust of these activities centered on a projected journal of original prints entitled *Le Jour et la nuit* (Day and Night), which was first discussed at the close of the fourth Impressionist exhibition in 1879. Its progress was recorded in letters from Degas to friends and from members of Cassatt's family.[3] It was also advertised in an article that appeared in the periodical *Le Gaulois* on January 24, 1880, listing the founders: Miss Cassatt, MM. Degas, Caillebotte, Raffaëlli, Forain, Bracquemond, Pissaro (sic), Rouard (sic), et al., and its contents were described: each *dessinateur* would be free to use any means of "reproduction" that he considered the best for his needs: etching, drypoint, aquatint, etc., even lithography! And unlike other journals, *Le Jour et la nuit* would be confined to images alone with only a brief note about each artist.[4] However, Degas's constant flirtation with experimental techniques caused many delays, and as Mary Cassatt's mother pointed out in a letter, no issue of the journal ever appeared owing to Degas's difficulty in completing a project.[5] Nonetheless, a number of significant prints were made by all the artists involved in the hopes that they would be included in future publications of this "organ of impressionism."

For the first issue, Cassatt and Pissarro and their friend Jean-François Raffaëlli joined Degas in making etchings of related format after pre-existing models: Degas adapted a pastel while Cassatt, Pissarro, and Raffaëlli translated painted prototypes into etchings.[6] Cassatt's contribution, *In the Opera Box, No. 3* (fig. 10), is a rendition in print of *Woman in a Loge*, shown in the previous Impressionist exhibition. A cache of working proofs, fully developed through several states, illustrates Cassatt's working methods: the constant adjustments to the softground, the dusting of the resin grains, the scraping of the plate, and the repeated taking of impressions that make the progressive steps she followed readily understandable. The finished plate, like those of her colleagues, was given to Salmon, a well-known professional printer, who made an edition of 50 impressions on oriental paper. The journal may have failed, but Cassatt's print as well as Pissarro's and Degas's images were shown at the fifth Impressionist exhibition in 1880. They also included preliminary states—some of which were signed and annotated—possibly marking the first time that printmakers had displayed their trial impressions. As a group the Impressionists were experiencing a crisis in solidarity and in painting direction—some

among them had even turned to offering works to the official Salon—but these few artists deliberately made highly inventive prints in order to solve their stylistic difficulties.

Cassatt mastered the "cuisine" approach and hence created striking impressionistic color and light effects in black and white. For example, in the last state of *The Visitor* (fig. 25), the shaded standing figure is dynamically silhouetted against the bright, lightly curtained window, while the seated figure, drawn in darkness, with *profil perdu*, anchors the social event. This ambitious print was made from a large plate of a size that would not be used again until the late color prints. It required a preliminary drawing (fig. 26) apparently placed twice on the plate covered at different stages with two soft, waxy grounds and involved several intricate operations with lines and tones before reaching completion. The combination of lines, hatchings, and grains on one plate is daunting. It is probably this print, Cassatt's most impressionistic etching, that reveals the close relationship to Degas with regard to composition, use of *contre-jour*, and acute diagonal perspective. Indeed, *The Visitor* appears to merge the two "Mary Cassatt" prints that Degas had prepared for *Le Jour et la nuit* (figs. 27, 28).[7] Using the same assortment of media, Degas had also transferred his image from a preliminary pencil drawing. The verso of the Degas sheet for *Mary Cassatt at the Louvre: The Etruscan Gallery* reveals traced lines in softground that adhered to the paper.[8] In all three prints—the two by Degas and one by Cassatt—there are fashionable, paired figures placed decisively in interior environments, although Cassatt has depended on a more familiar domestic setting.

It is interesting to note that at least one of Cassatt's prints from this period, *Warming His Hands* (Br. 28), was made on a daguerreotype half-plate in which the name "Schneider . . . Berlin" was stamped on the upper right corner. Both Degas and Pissarro executed prints on this same type of copper plate, possibly silvered, that may have been used first for photographic images—each made at least three prints on this kind of plate.[9] All of these impressions with the manufacturer's name inked and printed in reverse provide another documented link to the close working association of Cassatt with the two artists. On the other hand, one must point out that this print and Br. 29, possibly on a full-size daguerreotype plate, were not fully catalogued nor do they correspond in subject matter to other Cassatt prints. One can only speculate whether she traded impressions with her friends while all were working together, probably in Degas's studio, and whether these two unusual aquatints somehow entered Cassatt's oeuvre.

Nearly a decade later Cassatt turned from softground etching and coarse aquatint to drypoint, a medium that would assert itself throughout the rest of her printmaking career. Her achievements with this technique were definitely established when, in the winter of 1889 (January 23 to February 14, 1889), Durand-Ruel provided an opportunity for the artists of the "new school" to exhibit their prints. The Société de Peintres-Graveurs,

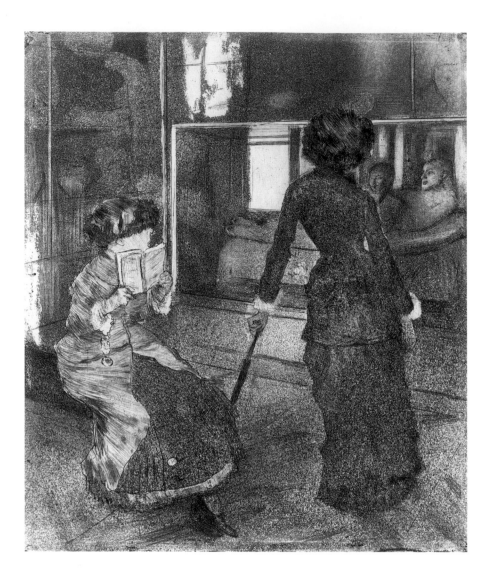

organized by her friend Félix Bracquemond and the "ingenious" Henri Guérard, centralized the disparate efforts of previous groups; by including artists of "bold talent," it sought to rise above the production of mediocre prints (mostly reproductive engravings) that were being executed for the contemporary Salons. From the outset the Society brought confidence to the artists, collectors, and dealers who attended these annual expositions. In the preface to the catalogue, Philippe Burty characterized the participants in the exhibition as committed to creating choice proofs for original prints (*belles épreuves*) without the intervention of photographic processes and without slavish copying of existing paintings.[10] Cassatt, along with Bracquemond, joined Degas, Pissarro, Redon, and Rodin, who were among the 39 French and foreign artists who submitted some 350 pictures to this first exhibition.

In a favorable review, Félix Fénéon, an eminent critic of his time, cited Mary Cassatt's two print contributions: the drypoint *Mère et Enfant*—

fig. 27. Edgar Degas (1834–1917)
Mary Cassatt at the Louvre: The Etruscan Gallery, ca. 1879–1880
Seventh state
Softground etching, drypoint, aquatint, and etching
10½ x 9⅛ (267 x 232 mm) platemark
Museum of Fine Arts, Boston, Katherine E. Bullard Fund in memory of Francis Bullard and proceeds from the sale of duplicate prints, 1984

"the delicacy of the skin in the modeling of the mother's face and the downy head of the child"—and the etching *Liseuse*—"(unfinished) with deep blacks enriched by firm hatchings."[11] He also commented on one of Degas's two entries: "Mr. Degas nonchalantly exhibits a small lithograph whose savage artistry is astounding," and he responded to Pissarro's use of *manière grise* in which sandpaper or an emery stone abraded the plate to create a delicate tone.

He, as well as other reviewers, noted the significance of this exhibition, which became the touchstone for the 1890s print revival. Paul Gauguin, for example, took immediate notice and embarked on a project of zincographs (lithographs made on a zinc plate instead of a stone)—at least three of the ten prints were made in January and February. The portfolio, with a decorative cover and printed on bright yellow paper, was available (only upon request) at the Café Volpini in the spring of 1889.[12]

Just as Degas had introduced Cassatt to the unconventional use of softground etching and aquatint, it is probable that another mentor, Marcellin Desboutin, encouraged Cassatt to perfect her handling of the drypoint medium. Today the reputation of Desboutin, a pillar at the Café Guerbois, where the Impressionists met in the early years, rests on a group of lively portraits of his well-known colleagues—all executed in drypoint. Cassatt had painted Desboutin's portrait in 1876, but she never became a member of his portrait gallery. It is worth noting, however, that Desboutin's drypoint study of Berthe Morisot (fig. 29), also executed in 1876 (and a fine example of the artist's expressive use of the technique), may have served as a model for Degas's painted portrait of Mary Cassatt holding cards made several years later (fig. 30).

Desboutin retired to Nice in 1880, but many letters testify to his frequent trips to Paris, where he spent time running to printers' studios and attending exhibitions including his own print show held in 1889 at Durand-Ruel's.[13] It is probable that during these visits he shared with Cassatt his expertise with the drypoint medium. More important, he must have introduced Cassatt to M. Leroy, "the young man who printed [Desboutin's] trial proofs at Cadart's"[14] and who later assisted her with the color prints. Desboutin's dexterity with the drypoint needle on the metal plate was eventually duplicated by Cassatt, who recognized the need for discipline and economy of line in order to achieve the full effect of a striking drypoint subject.

Perhaps it was a competitive interest in commercial success that inspired Cassatt to commit a larger number of prints to the second Exposition de Peintres-Graveurs, again held at the Durand-Ruel gallery March 6–26, 1890. A group of aquatints, which may have been executed earlier, and 12 drypoints that were planned as a set were exhibited. Published by Durand-Ruel, each drypoint subject was printed in 25 impressions. It is difficult to believe that Cassatt herself pulled 300 impressions from the plates; yet in the late fall of 1889, she wrote to Pissarro: "[I] am working at my [drypoints], & have a printing press of my own which I find a great conve-

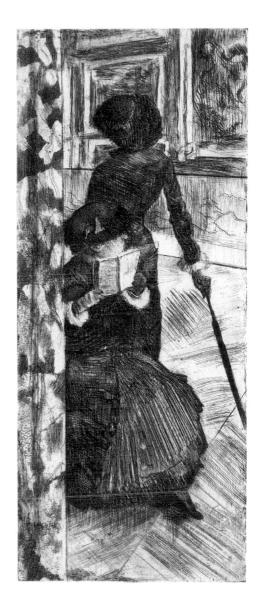

fig. 28. Edgar Degas (1834–1917)
Mary Cassatt at the Louvre: The Paintings Gallery, 1879–1880
Fifth state
Etching, softground etching, aquatint, and drypoint
12 x 5 in. (305 x 125 mm) platemark
Museum of Fine Arts, Boston, Katherine E. Bullard Fund in memory of Francis Bullard and proceeds from the sale of duplicate prints, 1984

nience, & a great pleasure, one ought to print all one's own plates only it is too hard work. . . ."[15]

In general, the second exhibition met with mixed reviews, but Mary Cassatt was singled out for praise. The critics noted the public's indifference to black-and-white images and cautioned against having successive print shows with a time lapse no greater than one year. One reviewer, M. Dargenty, commented that the gallery rooms were funereal, and that he was alone with the exception of a city guard; although he was not greatly interested in the exhibition, he was charmed by the oil paintings of Madame Bracquemond and the "jolis morceaux" of Mlle Casatt (sic).[16] M. Alfred de Lostalot also expressed reservations about spacing these black-and-white exhibitions annually yet went on to indicate that "Miss Carratt [sic] has a new series of child studies in drypoint, of deeply felt design and with rare finesse."[17] But Edmond de Goncourt was not as kind and commented sharply: "The admiration expressed in all the papers for Mlle Cassatt's etchings is enough to make you die of laughter! Etchings in which there is one little corner well executed, one corner out of a whole in which the drawing is stupidly heavy and the acid bite clumsy. Oh! truly, this is an age that makes a religion of failures; its high priest is Degas, and Mlle Cassatt is the choirboy."[18]

Perhaps the single most important event that would affect Cassatt's making of prints was not her involvement in perfecting printmaking techniques but her role as visitor and observer. She might have continued to produce only refined and appealing drypoints had there not been an exhibition of Japanese prints, held at the Ecole des Beaux-Arts in the spring of 1890, that stimulated the artist to new heights in her graphic work.

When the great collector Raymond Koechlin was persuaded by a friend to visit the Japanese print exhibition organized by Siegfried Bing at the Ecole des Beaux-Arts (April 25 to May 22, 1890), he graphically described his experience:

> It was a bolt from the blue. For two hours I went wild before these prints in vivid colors: courtesans, mother-and-child scenes, landscapes, actors—I admired all equally; catalogs and reference books that were being sold there piled up in my briefcase, and I spent the evening devouring them. The following day, surprised over the strange wonders I had described, my wife went with me, and her exultation was equal to my own.[19]

Thus, we can imagine Mary Cassatt's enthusiasm when she, too, attended the great exposition and strongly urged Berthe Morisot to visit the Beaux-Arts. "You *must* see the Japanese—*come as soon as you can*."[20]

Degas also joined in the excitement when he wrote to his friend Bartholomé, the sculptor, four days after the exhibition opened: "Dinner at the Fleury's on Saturday with Mlle Cassatt. Japanese exhibition at the

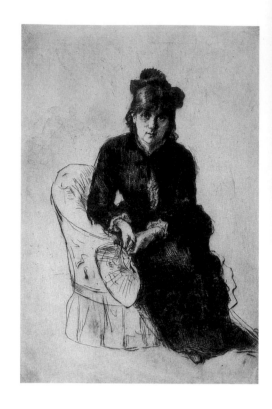

fig. 29. Marcellin Desboutin (1823–1902)
Portrait of Berthe Morisot, 1876
Second state
Drypoint
10⅜ x 6⅞ in. (263 x 176 mm) platemark
Courtesy William Weston Gallery,
London

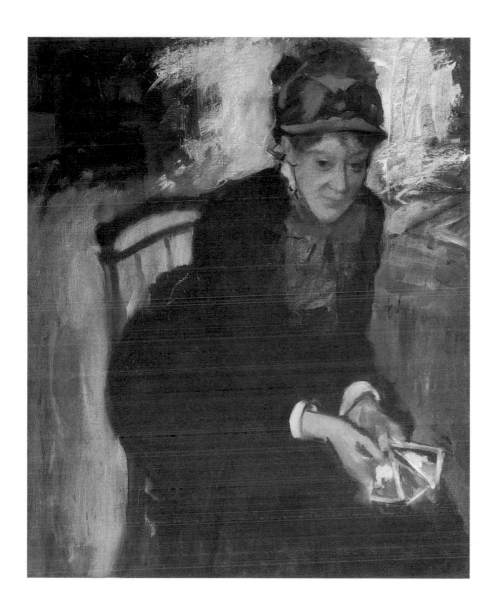

Beaux Arts. A fireman's helmet on a frog. Alas! Alas! taste everywhere."[21] (Degas's amusing comments were frequently colored with sarcasm.)

The exhibition was immense. More than 700 prints and albums were installed, including two collections that Bing had formed and mounted on three screens. A second part comprised over 350 illustrated books and selections from the collections of Bing, Philippe Burty, Antonin Proust, Edmond de Goncourt, and Louis Gonse, one of the first amateurs who acquired Japanese objects. Cassatt knew these collectors, along with other members of the organizing committee such as Roger Marx (who, before his death, assembled a major group of her prints),[22] and she must have been aware of their important holdings. She was known as a woman of cultivated taste, and both Cassatt and her family had already furnished their apartment and country home with oriental prints, porcelains, and decorative objects.[23]

fig. 30. Edgar Degas (1834–1917)
Miss Cassatt Seated, Holding Cards,
ca. 1884
Oil on canvas
28¼ x 23⅛ in. (1717 x 587 mm)
Smithsonian Institution, National Portrait Gallery, Washington, D.C., Gift of the Morris and Gwendolyn Cafritz Foundation and the Regents' Major Acquisition Fund

Other events conjoined to provide the impetus for Cassatt's color prints. Besides earlier publications by Louis Gonse (*L'Art japonais*, 1883) and Theodore Duret's writings on Japanese art in 1885, there were Bing's six volumes of *Le Japon artistique* (May 1888–April 1891) filled with articles and delightful illustrations. Through her friends Bracquemond and Degas, Cassatt also had access to the collection and library formed by Burty, who wrote for the leading journals of the day, spreading his knowledge and enthusiasm for all things Japanese. Burty provided fresh ideas and new directions for many artists and writers, and Cassatt was exposed to his expansive tastes. Félix Bracquemond had already designed a table service in 1867 using motifs from his own Manga albums of sketches by Hokusai and others, and in 1879–1880 he created another Japanese-inspired ceramic set for Haviland & Co. entitled "Fleurs et Rubans" of which Mary Cassatt owned many pieces.[24]

In his introduction to the 1890 exhibition catalogue, Bing explained that engraving as practiced in Japan was executed by means of cutting on a woodblock; although some metals were engraved, these were never inked and transferred to wood or paper. Furthermore, in Japan there was no such person as a *peintre-graveur*, for each area of the craft required its own atelier and training in special skills. Cassatt the painter was interested only interested in the entire etching experience in which she could actively participate as she had done earlier with Degas, and at no time did she consider the woodcut medium.

The ukiyo-e prints were the product of the popular school and were allied to Japanese handicrafts, such as bronze and lacquer work—the output of the common people. The subject matter was contemporary plebeian life, its shows and festivals, and the favorite courtesans of the time. Mary Cassatt chose those subjects for her color prints that could be appreciated by her own social class. The outright graphic and often erotic record of popular Japanese life held no appeal. She preferred to transform the beautiful courtesans into elegant French women who inhabited her contemporary and comfortable surroundings. Even the partially dressed models in *Woman Bathing* and *The Coiffure* were depicted with restraint and a distinctive gracefulness. Within this narrow French idiom, Cassatt was highly selective— her choice of the attractive figures traveling in the omnibus (see cat. 7) excluded the Parisian common people who would definitely have shared the cab. In his book *France: Fin de Siècle*, Eugen Weber illustrates "the new democracy of public transport, where elegant ladies and men of the world rubbed shoulders with the lower classes."[25]

In his *Chats on Japanese Prints*, written in 1915, Arthur Davison Ficke has cited several conventions that are characteristic of the Japanese woodcuts and are relevant to Cassatt's aesthetic sensibility: the Japanese artist drew his figures without shadows and made no attempt to represent the play of light and shade; the diffusion of light was almost perfectly uniform; the pattern of the object itself was the artist's sole theme, resulting in a universal flatness and denying linear perspective as Western art perceives it.[26]

Although it is known that Cassatt collected woodcuts by many of the favored Japanese artists, it was to the subjects and style of Utamaro that she most subscribed. Cassatt appropriated the theme of mother and child, which had been treated with affection by Utamaro and popularized by him as a genre in Japanese art. Her slender, languorous figures with finely rendered coiffures (there is the same degree of emphasis in depicting the hair) emulate the Utamaro figural type. The occasional sweeping color areas such as the transparent blue background of *Mother's Kiss* (cat. 11) reflect the mica-dust backgrounds that appear in many Utamaro woodcuts. Moreover, the soft, dusty palette that Cassatt studied in Utamaro's prints was essentially duplicated by her. It is important to note that the Japanese prints exhibited by Bing were already a century old and were faded to a certain degree (their pigments naturally lose color over a period of time). Even those that were preserved in a conservative manner would have shown some evidence of color change: the soft pinks, blue-grays, and deep beige to browns may have derived from the fugitive reds, blues, and purples that had lost their intensity. There was a proliferation of Japanese prints at this time ranging widely in quality and state of preservation. Mary Cassatt had every opportunity to see the very best impressions, and it was on these fine but in some measure faded prints that she based her color schemes—not on the weaker versions that were frequently exhibited.[27]

As cited by Colta Ives in *The Great Wave*, Cassatt owned a dozen Utamaro prints that were sold in 1950.[28] Another handful, inherited by members of her family, give further evidence of her interest in his prints (figs. 31 a–e). One woodcut that she acquired has been suitably compared to Cassatt's *The Coiffure*,[29] and the fact that she owned an impression can very well confirm the literal borrowings. It is interesting to compare two impressions of Utamaro's woodcut: *Takashima Ohisa Using Two Mirrors to Observe Her Coiffure*—the one belonging to Cassatt has been exposed to daylight for many years and is a shadow of its original coloration (fig. 31e); the other, from the Museum of Fine Arts, Boston, Spaulding Collection (fig. 31f), probably one of the finest impressions known of this rare print, with a cartouche from the first printing, is slightly faded but reveals the subdued palette that Cassatt would have seen. In the 1790s, the ability to mix pigments to obtain unusual and beautiful tones was at its peak, and Utamaro was able to make a choice of elegant colors; Cassatt was influenced by his distinctive palette and, in the same manner, she also made a more unique color selection in her prints.

Cassatt adopted many of the devices associated with Utamaro, but more important was the appeal of one of his great masterpieces, *The Twelve Hours in the Pleasure Quarters of the Yoshiwara*, a series of 12 prints that depicts life in the Yoshiwara from midnight until ten o'clock the following evening (the day was divided into 12 periods corresponding to two of our "hours"). Cassatt, who had already thought in terms of "sets," was obviously attracted to this unfolding of daily scenes, and in her ten color prints she used this framework to depict serene women who per-

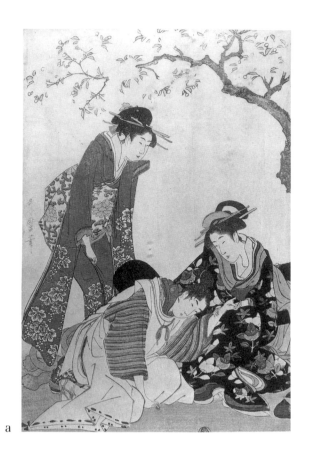

a

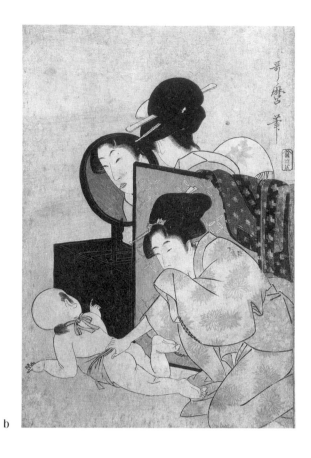

b

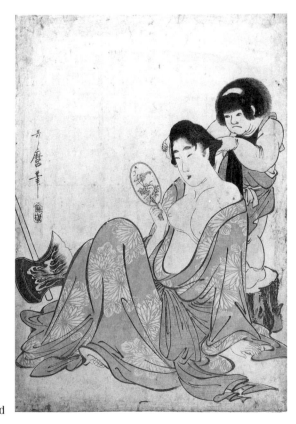

d

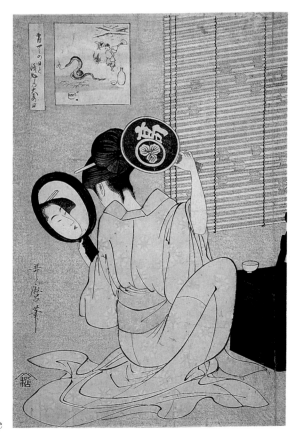

e

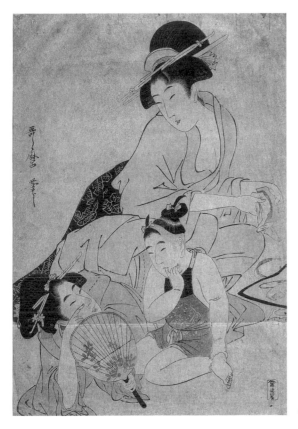

c

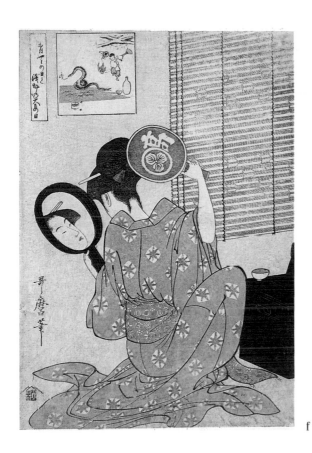

f

fig. 31a. Kitagawa Utamaro (1753–1806)
Two Beauties and a Young Man under a Cherry Tree
Color woodcut
15¾ x 10¾ in. (400 x 273 mm) sight
Museum of Fine Arts, Boston (on loan)

fig. 31b. Kitagawa Utamaro (1753–1806)
Two Courtesans and a Child
Color woodcut
15⅛ x 10¾ in. (403 x 273 mm) sight
Museum of Fine Arts, Boston (on loan)

fig. 31c. Kitagawa Utamaro (1753–1806)
Two Women and a Child
Color woodcut
16 x 11 in. (406 x 279 mm) sight
Museum of Fine Arts, Boston (on loan)

fig. 31d. Kitagawa Utamaro (1753–1806)
Kintaro Arranging Yamauba's Hair
Color woodcut
15⅝ x 11¼ in. (397 x 283 mm) sheet
Museum of Fine Arts, Boston (on loan)

fig. 31e. Kitagawa Utamaro (1753–1806)
Takashima Ohisa Using Two Mirrors to Observe Her Coiffure; Night of the Asakusa Marketing Festival
Color woodcut
16 x 11 in. (406 x 279 mm) sheet
Museum of Fine Arts, Boston (on loan)

fig. 31f. Kitagawa Utamaro (1753–1806)
Takashima Ohisa Using Two Mirrors to Observe Her Coiffure; Night of the Asakusa Marketing Festival
Color woodcut
14¼ x 9⅞ in. (361 x 251 mm) image
Museum of Fine Arts, Boston, Spaulding Collection, 1921

Mary Cassatt: The Color Prints 67

formed their domestic tasks and activities in the cultured environment that the artist knew so well.

On January 23, 1891, Mary Cassatt's mother, Mrs. Robert Cassatt, wrote to her son, Aleck:

> Mary has been quite as busy as she was last winter—but this time it is with *colored* "eaux-forts" [etchings] . . . It is very troublesome also expensive & after making the plates of which it takes 2 or 3 or 4 (according to the number of colors required), she has to help with the printing which is a slow proceeding and if left to a printer would not be at all what she wants.[30]

Mrs. Cassatt's familiarity with the procedures indicates that they were well under way before this description was written.

Letters and critical reviews written during the artist's lifetime give further testimony to their method of execution, including the small but important checklist prepared by Durand-Ruel, which clearly states that the prints were drypoints and aquatints (see fig. 2). Two or three plates were used—one for the line work and some aquatint portions and the others for various colors or patterns. They were printed using pinholes on the sheet for registration, and as in most Japanese woodcuts, the outline plate was printed last; the drypoint lines were either pale or richly dark, depending on the amount of burr that was left on the surface of the plate.

The suggestion has been made that softground etching instead of very fine aquatint was used to create the continuous-tone color areas. This idea was first proposed by Sue Fuller in an article written in 1950,[31] and subsequent attempts to duplicate a few of Cassatt's color prints with the softground technique have produced very persuasive effects.[32] Recent investigations have definitely concluded, however, that the tonal areas are the result of expert handling of the aquatint grains and that this fine aquatint combined with delicate, transparent colors makes it nearly impossible to detect the usual white "bubbles" of the grain. The use of "liquid" aquatint in Degas's and Cassatt's time to obtain delicate effects must also be considered; yet another possibility is that bitumen, a fine powdery substance favored in 19th-century printmaking, was employed instead of the conventional rosin to create the grainy surface.[33] Originally, softground etching was used to duplicate a chalk or pencil line, and only in the 20th-century has its ability to produce textures been more thoroughly investigated. What is significant about Miss Fuller's interesting experiments is that she has shown that two different techniques can have a similar appearance, and the distinction between the two becomes difficult to define visually.[34]

The color prints were planned for the third exhibition of the Peintres-Graveurs, to be held from April 4 to 30, 1891. When a resurgence of French nationalism decreed that only French-born artists would be admitted, Pissarro (born in the Danish West Indies) and Cassatt decided to

exhibit together in two small rooms at the Galeries Durand-Ruel adjacent to the main salon.

Pissarro was quite taken with Cassatt's prints and wrote to his son Lucien the day before the exhibition opened:

> It is absolutely necessary, while what I saw yesterday at Miss Cassatt's is still fresh in mind, to tell you about the [colored prints] she is to show at Durand-Ruel's at the same time as I. We open Saturday, the same day as the patriots, who, between the two of us, are going to be furious when they discover right next to their exhibition a show of rare and exquisite works. (The group now called themselves the *Société de peintres-graveurs français*).
>
> You remember the effects that you strove for at Eragny? Well, Miss Cassatt has realized just such effects, and admirably: the mat tone, subtle, delicate, without stains or smudges: adorable blues, fresh rose, etc. . . . [One must] have some copper plates, a *boîte à grain* [dust box], this is a nuisance but absolutely necessary to have uniform and imperceptible grains, and a good printer. But the result is admirable, as beautiful as Japanese work, and it's done with colored printer's ink.[35]

On April 25, 1891, just before the close of the exhibition, when Cassatt was still printing impressions, Pissarro wrote again to Lucien:

> Before leaving Paris I went to see Miss Cassatt. I watched her [print her color aquatints]. Her method is the same as ours *except* she does not use pure colors, she mixes her tones and thus is able to get along with only two plates. The drawback is that she cannot obtain pure and luminous tones, however her tones are attractive enough. We will have to make a more definitive trial of our own method to determine which is to be preferred.[36]

Pissarro's letters effectively inform us about Cassatt's methods, and since he was familiar with many printmaking techniques, his description of her procedures should be accepted. He intuitively understood that the best tools were needed to produce fine aquatints, and at no time does he mention softground etching. (His own efforts to make color etchings were not realized until 1894–1895—see pp. 78–79.) The "good printer" that Pissarro recognized was required for such an undertaking was found by Cassatt in the little-known M. Leroy. Like the Japanese who regularly noted with a stamp or mark the name of the woodcut printer, Cassatt gave an identity to her collaborator when she indicated that the final edition of each color print in the 1891 set was printed by herself and M. Leroy. This in itself was an unusual decision since credit has rarely been given to the printers in Western art.

It is from Desboutin that we first hear of Leroy (fig. 32). According to Janine Bailly-Herzberg, Desboutin "trained Leroy, the printer at the Cadart press, which specialized in etchers' work [and] they took to each other at once, as people in the same profession do."[37] By the mid-1880s, Leroy had moved to the workshop of Eudes—specialists in *taille douce* [copperplate etching]—where Desboutin continued to work with him. In early January 1890 Desboutin wrote to his friend Albert Alboize, editor of *L'Artiste*, mentioning that he had stopped by Eudes and asked Leroy to print for him "on the spot" three or four proofs of his plate with the portrait of Degas (first executed in 1876).[38]

Cassatt evidently persuaded Leroy to work with her in her studio on this difficult project whenever he was available. Her mother's letter of January 1891, written from their Paris apartment, confirms the presence of a printer, presumably Leroy. The final evidence of Cassatt's indebtedness was made by the artist in a letter to Joseph Durand-Ruel, eldest son of Paul Durand-Ruel, written February 18 [1892]: "Thanks for the offer of the money, but I don't need it now; naturally later I shall be glad of it, as I have still my promise to Leroy to fulfill of giving him an advance sufficient to start as an independent printer."[39]

Leroy brought with him an expertise in many intaglio processes, and one cannot overestimate the role that he played in the production of Cassatt's color prints. Obviously, she conceived images and knew the color effects she was trying to attain, but it was Leroy who prepared the copper plates as they became more complicated, expertly laid the aquatint grains, and printed the plates with perfect registration. *The Bath* (cat. 5), the first subject of the set, reveals the difficulties in achieving both stylistic and technical excellence; many versions, including impressions from abandoned line plates (cat. 5-VII), testify to the complexity of the artist's and printer's explorations. Cassatt may have prepared and printed the initial drypoint impressions—many of which were run through the press in order to indicate on another plate the boundaries for the aquatint areas—but it was certainly Leroy who achieved the perfect tonal results. Aquatint is one of the most fragile of etching media to control, and Cassatt would have appreciated the printer's experience and ability to "dust" the resin on the plate in its dry state or to float it on by means of a solvent. Furthermore, to register the two and three plates, overlayering the delicate aquatint areas with precision, required a skilled and practiced hand. Indeed, Pissarro, an accomplished printmaker himself, recognized the need for "imperceptible grains and a good printer."

The present authors have indicated "state" changes in the evolution of Cassatt's color prints, but this term is not applied with its traditional meaning. Cassatt used two or three plates for each image, and they were worked on individually, but also simultaneously—that is, each plate was composed of various amounts of drypoint outlines and aquatint tonal areas that were elaborated upon or reduced as the artist advanced and developed the subject. Thus, one plate might introduce color before the black-line

fig. 32. Marcellin Desboutin (1823–1902)
Portrait of the Printer, Leroy, 1875
Third state
Drypoint
11⅝ x 8¼ in. (295 x 209 mm) platemark
Bibliothèque Nationale, Paris, Cabinet des Estampes

plate was fully rendered (see, for example, *Maternal Caress*, cat. 12) and the conventional practice of creating state changes by the orderly addition or removal of work on one plate was abandoned.

We can only suggest what each plate comprised as well as the order in which the two or three plates were printed. There are overlayerings of color, selective inkings, and special wipings that can be unraveled only when examining many impressions, and frequently this must be done under high magnification. There are no printer's archives, existing plates, or documentation to aid these efforts except for two very brief and frequently quoted letters from the artist that describe her techniques. One was written to the collector and dealer Samuel P. Avery, probably in 1891,[40] and another to Frank Weitenkampf, then print curator at the New York Public Library, dated May 18, 1906.[41] Both letters provide a cursory record of Cassatt's working methods, and implicit is the role of the printer Leroy, who obviously guided the artist toward great technical achievement.

Cassatt and Pissarro took advantage of not being part of the group when they had their own small exhibitions; Cassatt included two oil paintings, two pastels, and a set of ten colored prints. Georges Lecomte wrote in a review for *L'Art dans les deux mondes* that Cassatt, who had previously exhibited drypoints summarily drawn, now attempted to complete her drawing with tinted plates. She searched for "delicious" ornamentation and submitted the exigencies of her modernist vision to the laws of earlier Japanese art: thus, she suppressed modeling, values, and aerial perspective, barely admitting a linear perspective. Lecomte stressed that, unlike the Japanese painters, Cassatt gave her figures a mobility and alert expression instead of reducing the human face to a white schema without character. He would have preferred that the postures and movements of her women had emulated a more graceful and supple Japanese type, enabling the artist better to interpret the svelte elegance of her contemporaries.[42]

In another review for *L'Art moderne*, Lecomte described both the exhibitions of the "patellistes" and the "peintres-graveurs" and succinctly summed up Cassatt's contribution in a few sentences that are timely today:

> In eight [sic] plates (drypoint and aquatint) Mlle Cassatt innovates. Intimate and worldly scenes, these [prints] in the manner of the Japanese are printed in colors. If the first, *The Bath*, is for the study of the process, a deliberate European translation of Outamaro (and the artist entitles it: *Essai d'imitation de l'estampe japonaise*), *The Letter*, the *Young Woman trying on a Dress* exemplify the work of a new art that is both charming and perfectly personal.[43]

Finally, one of the most thoughtful and lengthy critiques was written by Fénéon:

> What Cassatt did not borrow from the Japanese is any schematic formula for heads and hands or their "reserves" of white; her female

bodies, contrary to oriental customs, are tinted; they have the "coffee" tint of their male figures, but paler . . . She will create totally original works as soon as she generalizes her sympathy for those masters instead of favoring one exclusively. Today, her manner reminds us too much of Utamaro's . . . The physiognomical observation of these women and children is calm and delicate. There is no exaggeration in the way the letter writer is showing her effort in reading over her writing and her hesitation to end it, or in the way the "Young woman trying on a dress" shows a passing uneasiness and curiosity. And always, these large, beautiful, masculine hands that Cassatt likes to give her women, have decorative functions, especially when set against the bodies of naked infants, they disturb the lines, then blend with them to create unexpected arabesques.[44]

Despite the generally favorable reviews, the sales for Cassatt's color prints were moderate, and as early as May 21, Durand-Ruel was sending sets of the ten color prints to the offices in New York. There, one of the earliest purchasers was H. O. Havemeyer, who acquired a set on August 17, 1891.[45] One set each was deposited at the dealers Wunderlich, Knoedler, and Keppel & Co., from whom Mrs. Kingsmill Marrs purchased a series in November 1891. Encouraged by Sylvester Koehler, first curator of the Print Department at the Museum of Fine Arts, Boston, Mrs. Marrs was forming a unique collection of color prints (now in the Worcester Art Museum) and this was one of her "modern" acquisitions.[46]

The Durand-Ruel archives confirm that the sales of the color prints were slow, but by the second Cassatt exhibition, held in Paris in 1893, many of the collectors familiar to us today were purchasing sets in New York or Paris. An exchange of letters between Mary Cassatt and Joseph Durand-Ruel clearly describes their hopes at that time; Cassatt was willing to offer a single print from the set,[47] but Joseph Durand-Ruel, on February 16, 1892, claimed that his father would consider the selling of separate proofs as against her best interests. He further urged her not to be discouraged: "the sale of your prints has been satisfactory . . . we have sold a goodly number of them in Paris and if the series sent to America are not purchased there, we will have them returned here for an easy sale."[48]

Despite their good intentions, a study of the Durand-Ruel stock books for New York reveals that by 1893 sets were being broken up and separate proofs sold. Notations throughout, however, indicate that efforts were always made to reassemble a series; today, it is rare to find a set of prints together that were signed and/or printed at the same time.[49] The majority of the 1891 editioned prints appear on a warm off-white to cream laid paper that is medium weight or moderately thick and moderately textured. Whenever a watermark is present, it is usually one of the following in block letters: ARCHES or PL BAS, although a few examples on similar paper have the E D & Cie or D. C. Blauw watermarks. These papers, softer and more malleable, were very receptive to Cassatt's multiple printings of the

plates. All the final impressions are signed with the inscription: *Edition [*or *Série] de 25 épreuves* [possibly added later, see p. 44] *imprimée par l'artiste et M. Leroy / Mary Cassatt,* or *Imprimée par l'artiste et M. Leroy / Mary Cassatt / (25 épreuves)* and most show a small blue MC stamp in the center of the lower platemark, placed there by the artist. There are a number of impressions for each image in the set that are finished but without any inscription—some are initialed or stamped only; these may have been put aside by the artist for future sales.

Given our positive response today to Mary Cassatt's color prints, it is difficult to believe that such efforts were not officially approved in her time. There was a continuing controversy between the academicians and "modern" artists about the acceptance of color prints that were excluded in the annual Salons. The explosion of a variety of printing processes in the 1880s created an atmosphere of distrust in which the commercial success of the "chromo" industry caused the conservative artists and officials to disapprove of all attempts at color printing. Thus, a ruling issued in 1891 for the print section of the traditional Salon, in which "no work in color will be admitted," could still be addressed in 1898 despite the outpouring of posters, prints, albums, journals, and illustrated books, all printed in color.[50] Significantly, Cassatt's color prints emerge as a bridge between the bold, independent creations of an innovative artist and the uncommonly successful collaboration between the artist and a printer who would have been very familiar with the newest commercial procedures but, in this instance, directed his efforts toward making original color prints of the highest quality.

Philippe Burty, the champion of the Peintres-Graveurs, used his official position as supervisor of the Ecole des Beaux-Arts to convince the director of the Beaux-Arts, Gustave Larroumet, to purchase a selection of the prints exhibited at the second Exposition des Peintres-Graveurs. Burty's report reveals the lively discussions that took place between the critics and artists and goes beyond the introductions that he wrote for both exhibitions in 1889 and 1890. He commented on the artists' commitment to showing only "original" prints of a personal conception that avoided any reproductive representations after paintings unless they were the first states or initial thoughts on the subject. More important, Burty briefly described the status of the various printmaking media in his day:

> *Engraving* plays a characteristic role in the general life of the people and even though it has been assaulted by photographic processes, it will remain for a long time; *etching*, more rapid, attaches itself to the expressive effects of color, to the movements of beings or landscapes and offers a territory of action that stimulates the modern workshops; *drypoint*, formerly a secondary means of expression beneath etching, has become a distinct art—steelfacing has gained for it a relative duration of life. The painter can almost use the sharp point in the manner of a pencil on paper, printing light accents for

flesh and modeling the velvety blacks of a colorist's brush. One looks for the intellects who work not only with the half-forgotten processes of *aquatint* and *la manière noire* [mezzotint] but also with the seductive "engravings" in color where the "sanguine" can be mistaken for the pencils on blue paper of Boucher or the water-colors of Demarteau; *lithography*, so brilliantly advanced by the romantic masters, is reworked with a new vigor and the young artists have learned to print varied proofs obtaining striking depths; finally, the *woodblock*, under the burin of skillful masters, offers here [strokes] without rival. Our printmakers search for the tricks at hand which will link color with line.[51]

Burty submitted to the director a list of works from the exhibition that were distinguished by exceptional quality. Dated March 26, this list included A. Besnard, M. and F. Bracquemond, John Lewis-Brown, Mary Cassatt, J. Chéret, Delauney, Robert Goff, H. Guérard, N. Goeneutte, A. Lepère, H. Rivière, H. Somm, Ph. Zilcken, and G. Jeanniot. The price to be paid totaled 1,250 francs and the decision to acquire these prints was ratified by decree on April 9, 1890.

A second note from Burty, dated April 15, proposed that two prints by Pissarro should be added and that all these newly acquired works must be made easily accessible to the public at the Musée du Luxembourg. Unfortunately, Burty's sudden death on June 3, 1890, not only eliminated one of the great champions of contemporary printmaking but delayed the acquisition for the state. The final vote was not agreed upon until April 27, 1891 (during the third Exposition des Peintres-Graveurs), when 50 works were chosen from the 112 accepted that would constitute the nucleus of the future Print Room of the Musée du Luxembourg. The prints of many of the artists cited above, including Mary Cassatt, were acquired, and it was the pioneering efforts of Philippe Burty that contributed to the richness of the Print Room at the Bibliothèque Nationale, where, after the artists' deaths, their "contemporary" prints were stored.

At the same time that Burty was striving for the triumph of the *belle épreuve* (or fine original print), the last of a series of articles on color printing appeared in the *Gazette des Beaux-Arts*, February 1890.[52] Baron Roger Portalis applauded the work of the 18th-century artists Janinet and Debucourt but preferred to call attention to the unexpected processes and inventions that the modern artists could apply to their knowledge of techniques. He suggested that three great events dominated color printmaking in the 19th century: the invention of lithography that extended into chromolithography; the renaissance of wood-engraving and, by extension, the immense development of relief engraving or chromotypography; and the invention of photography, including the photogravure and photographic printing in colors or *photochromie*. To these processes Portalis added etching in color from superimposed plates, which he considered to be of less importance but whose creative development he predicted.

For the most part, Portalis's article was devoted to the reproductive use of new color processes for book illustration and in the publishing of fine color facsimiles. A few paragraphs touched on the execution of original prints in color by artists of talent such as Bracquemond, Gaujean, Guérard, Lewis-Brown, and Lalauze in which a first plate was used for black and other plates were etched for color. But the thrust of Portalis's thesis was that there were many intriguing printing processes involving photographic means that were replacing traditional print techniques for the reproduction of art and were creatively competing for the artists' attention.[53] See, for example, the deluxe volumes of book illustrations for the writer Octave Uzanne, printed around 1882 and 1883, including the extraordinary *L'Histoire des quatre fils Aymon* of 1883, illustrated by Eugène Grasset. All were produced by the photo-color-relief process in which flat aquatint-like areas of fresh and transparent colors were achieved photographically.[54]

It is against this background where original and reproductive prints coexisted that Mary Cassatt produced her ten color drypoint and aquatints. By this time, she would have seen the color lithographs of John Lewis-Brown printed between 1883 and 1890 (each with three to five colors), and she would already know Bracquemond's early color etching, *Au Jardin d'acclimatation*, 1873 (fig. 33), in which separate plates for each color of aqua-

fig. 33. Félix Bracquemond (1833–1914)
At the Jardin d'Acclimatation, 1873
Color etching and aquatint
7⅜ x 8 in. (187 x 200 mm) platemark
Museum of Fine Arts, Boston, Frederick Keppel Memorial Fund, Gift of David Keppel, 1913

tint—green, orange, and yellow—were overprinted by one line plate in black etched over gray aquatint. This experimental print was shown at the fourth Impressionist exhibition in 1879 when Mary Cassatt exhibited with the Impressionists for the first time. Bracquemond's color method derived from the one introduced about 1720 by Jakob Christoffel Le Blon (1667–1741), who printed from three plates with the three primary colors, red, blue, and yellow, occasionally adding a black plate for tone or contour. This system was notably practiced by Philibert-Louis Debucourt (1755–1832); in his greatest color print, *La Promenade Publique*, 1792, Debucourt used multiple color plates and added aquatint for shading to the fourth, black plate. In the prints that followed, he either printed them in black only or in color from a single plate using a rag stump or dauber to ink the several colors (*à la poupée*).[55] Given all the publications, notices, reproductions, and exhibitions of 18th-century works, as well as notable private collections, Mary Cassatt would have been aware of the finest color prints and illustrated books and would have observed the range of excellent results that could be obtained with these traditional color processes.[56]

At the same time, many of her contemporaries were exploring these color etching methods: Henri Guérard, co-organizer with Bracquemond of the Société de Peintres-Graveurs exhibition in 1889 was preoccupied with printing in color. One can find in the Bibliothèque Nationale numerous "assembled" compositions in which Guérard played with different inks to create infinite luminous effects. Some were colored by hand using the etched lines merely as a vague support, and one small print dated 1881, *Le Polichinelle*, is a three-color etching that distinctly shows three beveled platemarks. Several of his essays in color were shown in the 1889 exhibition.

Other artists' work probably known to Cassatt included Henri Detouche, whose pedantically drawn color etching *Au théâtre* (fig. 34) used hand-wiped plate tone to create flesh tones; this print of a subject that had appealed to Cassatt earlier is dated 1886, well before Cassatt's efforts in color. Eugène Delâtre, the son of the "impressionist printer" Auguste, made his own prints as well as continuing his father's workshop tradition.[57] His color etchings were often created by just using one extra plate to achieve rich coloristic effects. Jean-François Raffaëlli, Degas's friend and, apparently, a member of Cassatt's circle, produced a color etching in 1889 using the conventional three-plate method and was delighted when Boussod, Valadon and Co. published six of his plates in color in 1893. Lesser-known artists whose experimentations might have interested Cassatt but clearly did not inspire her included Richard Ranft, Emile-Alfred Dezaunay, and Marie Gautier.

In December 1891, the same year that Cassatt exhibited her color prints, Charles Maurin registered his patent for an unusual system of color printing—a hybrid process somewhere between lithography and monotype printed on a zinc plate with oil-based colors.[58] He soon abandoned this "watercolor-quality" process, however, and reverted to conventional color

etching. His themes of women owe a debt to Degas and Cassatt (see fig. 35), and even his aquatint technique may have been influenced by Cassatt's technical expertise. Yet in an article written in 1901, Maurin was credited with having revived color etching! The author, Gabriel Mourey, boldly stated: "Indeed, since Debucourt no one employed it [etching in colors], and it was not till 1891 that M. Charles Maurin—for to him, I believe, the honour exclusively belongs—essayed to revive it. . . . About the same time MM. Raffaëlli, Bracquemand (sic)—Louis Legrand, Eugène Delâtre, Charles Houdard, Lepère, and Richard Ranft—to name a few among many—tried their hands at the new work."[59] It is both curious and amusing that in the course of this two-part article, written a quarter of a century before Mary Cassatt's death, the author made no mention of her great color series, although he was apparently aware of the color work of most of her contemporaries.

Cassatt's two friends and mentors, Pissarro and Degas, expressed varying attitudes toward color. In spite of his enthusiasm for Cassatt's work, Pissarro did not launch his color prints until 1894; the lack of an adequate printing press dampened his desire to attempt such complicated work even though he had conveyed the hope of making a series with Cassatt: "market scenes and peasants in the fields." On January 3, 1894, Pissarro wrote to Lucien that "the press I bought from Delâtre has been installed in the large studio; I am waiting for ink to make some prints. We tried to print

fig. 36. Camille Pissarro (1830–1903)
Church and Farm at Eragny-sur-Epte,
1894–1895
Color etching
6³⁄₁₆ x 9¾ in. (158 x 248 mm) platemark
Museum of Fine Arts, Boston, Ellen
Frances Mason Fund, 1934

with oil color, the effect is astonishing. It gives me the urge to do more etchings."[60] A little over a year later, on January 18, 1895, Pissarro noted:

> I received my colored plates after having had them steel-faced. I will send you soon a fine impression of my *Little Peasant Girls in the Grass* and a *Market* in black, retouched with tints; I think some excellent things can be made in this way. . . . It has no resemblance to Miss Cassatt, it involves nothing more than retouching with colors, that is all. I have already gotten some fine proofs; it is very difficult to find just the right colors.[61]

Pissarro did manage to acquire a press and found good-quality copper plates (many of which were given by the family to the Bibliothèque Nationale, where they can be studied) but did not use the "good printer" that he thought was so essential for unusual results. His handful of color prints, unlike Cassatt's, often comprise an elaborate sequence of preparatory drawings and printed impressions. For *Church and Farm at Eragny-sur-Epte* (fig. 36), he made two drawings and developed the black-and-white etching through six states before attempting a series of color "editions." Four heavy copper plates were used: a key plate for outline and three plates for red, yellow, and blue. These were printed according to the traditional method of superimposing the plates to achieve a variety of color effects. Some impressions are strong and especially well balanced in tonality, but others are failures owing to the poor registration of the plates, which causes a lack of color harmony. One can only speculate whether a professional printer such as Leroy could have achieved more successful results, but this kind of collaboration would have been against the artist's temperament and beyond his finances.

Pissarro's other significant exploration into color printing (see also his monotypes, cat. 19) took place with Lucien when the two collaborated on a portfolio of woodcuts entitled *Travaux des champs*. Although the first series was published in 1895, it was discussed as early as 1886 and frequently referred to as their "Manga." Camille made the initial drawings and Lucien transferred them to the blocks and engraved and printed them. The project was planned as a series of illustrations dealing with aspects of country life, but only six woodcuts were issued during Camille's lifetime.

The two multicolored prints, *The Weeders* and *Women Weeding the Grass* (fig. 37), owe much to Japanese color woodcuts in composition and technique, but they also correspond to Camille's efforts with color etchings—most of the color printing by both father and son was executed during the course of 1894. Five or six blocks, one for each primary color, were applied directly or overlaid to create additional hues; all were contained and offset by pronounced black outlines. Although conceived as a set and highly inventive like Mary Cassatt's color prints, they bear no resemblance to hers in style or coloration—Pissarro always preferred to use "pure colors." They are closer to the "cloisonniste" principles practiced by Gauguin and

fig. 37. Camille Pissarro (1830–1903) and Lucien Pissarro (1863–1944)
Women Weeding Grass,
from "Travaux des Champs," 1895
Color woodcut
6¾ x 4½ in. (171 x 114 mm) image
Museum of Fine Arts, Boston, Gift of Robert P. Bass, 1982

Mary Cassatt: The Color Prints 79

Emile Bernard[62] but also resemble medieval stained-glass windows, for which Pissarro had an affection.

Degas, on the other hand, never attempted color etching (with the exception of a handful of experimental impressions that he printed in color from one of Pissarro's plates in 1879), yet he was not unmindful of Cassatt's work, especially its subject matter. He was most complimentary toward her color prints in the April 1891 exhibition and was especially attracted to *Woman Bathing* (fig. 38).[63] Soon after her exhibition, on July 6, 1891, he indicated to a friend: "I am hoping to do a suite of lithographs, a first series on nude women at their toilette. . . ."[64] Like Cassatt's print, Degas's focused on the back of a model who performed her private ritual (fig. 39). But stylistically, Degas favored a more sculptural effect, as if he were compelled to extract the figure out of the lithographic stone. Degas had expressed an earlier interest in the theme of women "bathing, washing, drying themselves," yet Cassatt's exhibition must have prompted him to undertake this subject in prints. Although he greatly admired and collected Japanese woodcuts and also attended the splendid 1890 exhibition, he was not interested in the linear and luminous effects that had appealed to Cassatt.

Nevertheless, on September 26, 1890, five months after the close of the Japanese exhibition, Degas set forth on a trip through the countryside of Burgundy, paying visits to friends along the way. With Albert Bartholomé (the same companion to whom he had written the amusing comment about Bing's exhibition) as driver of the tillbury, Degas collected images that he put down on plates in the studio of the artist Georges Jeanniot, whose home was the final destination. These landscape monotypes differ dramatically from the body of Degas's work—is it possible that these abstractions in oil colors were inspired, ironically, by the poetic landscape woodcuts of Hokusai and Hiroshige? Two years later, in September 1892, Durand-Ruel exhibited about 20 of Degas's "imaginary" landscapes, now richly covered with pastel and/or gouache, and in a letter written on November 30, 1892, Mary Cassatt commented succinctly: "At Durand Ruels there has been an exhibition of a series of landscapes in pastel by Degas, not from nature. I prefer his landscape when used as background for his figures—"[65] Yet, Cassatt may have been tempted by Degas's vivid autumnal colors (fig. 40) when she made her color print *The Banjo Lesson* (cat. 16), with its partial monotype inking and her two versions of the monotype *The Album* (cat. 19).

Another major occurrence that had a significant effect on both Cassatt and Degas was the Exposition Générale de la Lithographie. Held at the Ecole des Beaux-Arts from April 26 to May 24, 1891, it overlapped with the third exhibition of the Peintres-Graveurs. Both artists were included among the almost 1,000 lithographs, many lent by members of the organizing committee. Cassatt had given permission to Alexis Rouart to show one example, *Au théâtre* (number 994 in the exhibition), but Degas, who had not contributed, was represented by a single, minor work lent by the printer A.

fig. 38. Mary Cassatt
Woman Bathing, 1890–1891
Fourth state
Drypoint and aquatint
14¹⁵⁄₁₆ x 10⁹⁄₁₆ (379 x 270 mm)
platemark
National Gallery of Art, Washington, D.C., Gift of Chester Dale, 1963

Bouvenne. Degas was irritated that his permission had not been sought, but the two exhibitions may have caused him to begin his major series of lithographs of nudes. Cassatt, however, was not attracted to the processes of lithography, and with the exception of one minor transfer lithograph executed about 1904 (*Sara Wearing Her Bonnet and Coat*), she pursued her unique command of drypoint and aquatint.

This conjunction of exhibitions barely indicates the rapid tempo of printmaking activity that was taking place in the late 1880s and early 1890s before the so-called "revolution" of color lithography, and indeed, Mary Cassatt's color prints were executed at a most fortuitous time in her career and in the annals of printmaking: we have already noted the 1889 Café Volpini exhibition that included ten zincographs on yellow paper by Gauguin and hand-colored zincographs by Bernard as well as the series of Expositions des Peintres-Graveurs held at the Galeries Durand-Ruel. Mention should also be made of the print sections of the official Paris Salon, the Blanc et Noir exhibitions that took place in both Paris and London, and the numerous attempts to launch albums of original prints such as the first *L'Estampe originale* issued in May 1888 and then revived in 1893.[66]

Another point to consider with respect to Cassatt's color series was the revival of the decorative arts. Douglas Druick has repeatedly emphasized the significance of the dissemination of the decorative arts for the middle classes with Jules Chéret's highly suggestive and lively posters as well as his theater programs, book covers, invitations, and other works on paper pointing the way.[67] Although Cassatt was not interested in making her art accessible to a broad public (despite her democratic comments to the contrary), she intended that the color prints be a commercial success. She may have agreed with Durand-Ruel to sell the ten prints as a series or portfolio of images, and she must have also assumed that they would be exhibited as a group—as important decorative objects for the home similar to the porcelains, the Persian vases, old silver, Japanese woodcuts, and other objets d'art that amateurs like herself and her parents had accumulated. The fact that the color prints were published in a relatively small edition of 25 signifies that the artist pictured them in only a few homes, to be appreciated by knowledgeable collectors. In his memoirs George Biddle recalled seeing such a display as he walked "down the long corridor (of Cassatt's country home), pausing to look at dry points and colored aquatints along the wall, then . . . out through the cold glass-covered veranda where hung the Utamaros and one or two Hokusais."[68]

On December 5, 1893, Camille Pissarro wrote to Lucien: "Miss Cassatt has at this moment a very beautiful exhibition of paintings at Durand-Ruel's. She is decidedly very capable."[69]

For her second exhibition at the Galeries Durand-Ruel, held from November 27 to December 16, 1893, Cassatt assembled a large number of works: 17 paintings, 14 pastels, a set of 10 color prints plus 2 more made for this exhibition, and some 40 etchings and drypoints, many shown in

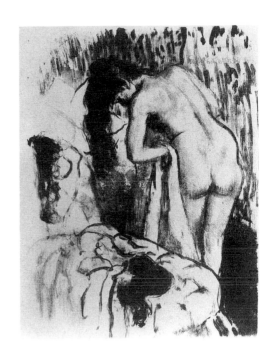

fig. 39. Edgar Degas (1834–1917)
Nude Woman Standing, Drying Herself,
1891–1892
Fourth state
Lithograph
13 x 9⅝ in. (330 x 245 mm) image
Museum of Fine Arts, Boston, Katherine
E. Bullard Fund in memory of Francis
Bullard and proceeds from the sale of
duplicate prints, 1984

proofs and duplicate impressions. There was a small catalogue with an introduction by André Mellerio, a writer and editor, who made thoughtful observations about Cassatt's work and recognized that "her native distinction never abandoned her." He added that her "drypoints heightened with color were an absolutely original work for which Miss Cassatt took special care in the printing done in her own studio."[70] In a small note, an American, Eleanor B. Caldwell, reported back: "They [the paintings and prints] are all so beautiful in their impression of light and color! The French were wild over her, and half the pictures were sold when I visited the gallery. I enclose a sympathetic tribute to her, written by André Mellerio, which I know will interest you."[71]

For the most part, the reviews were favorable, although some separated out the color prints for special comment. In *La Chronique des arts et de la curiosité*, M. de Lostalot stated at the end of an enthusiastic review that the success of the color prints seemed less complete, and since, to him, the qualities of draughtsmanship had not changed, he attributed these results to the process used:

> The angles of the lines in the drawing seem too sharp; there is a lacking of proportion between the contour lines and the colors that they contain. To tell the truth, we do not believe that an artist whose aesthetic sentiments find their principal expressive resources in design can succeed in assimilating completely the technique of an art where the charm of color plays the principal role.[72]

And, once again, Edmond de Goncourt could not resist writing a biting comment in his diary: "Saturday 2 December 1893. Exposition de Miss Cassatt. Attempts at coloring plates in the manner of Japanese impressions, interesting attempts but still very incomplete."[73]

Of greater interest is his entry made several weeks later, Wednesday, January 10, 1894, when de Goncourt recorded that Félix Bracquemond visited him and talked about working on an etching that he hoped to "push" to a dozen colors and with the "grains" equally colored to make tinted plates. The artist felt that these works would be beautiful only if they were expensive, for one could not be economical, and that the colors would be satisfying only if they were dark and light tints—adding that the sensation of color was a new one for Western eyes, something that had not been fully explained. These observations, made by Bracquemond so soon after Cassatt's important exhibition, clearly reveal the effect her color prints had on the well-known printmaker and teacher.

The Cassatt exhibition sold well and many of the works shown at that time have found their way into major public institutions. Degas and the brothers Alexis and Henri Rouart, who were lenders to the exhibition, purchased prints along with Bing, Henri Béraldi, and Mellerio, as well as Roger Marx.

The two new color prints that Cassatt made for this special showing

were *The Banjo Lesson* (cat. 16) and *Gathering Fruit* (cat. 15), both executed in connection with a large mural project. (see p. 48). Preliminary sketches, finished oils and pastels, and prints record her efforts for almost all of 1892 until the panel was sent to Chicago in 1893. When M. de Lostalot requested an etching from Cassatt to accompany an article in the *Gazette des beaux-arts*, he was informed by the gallery that she was much too busy with a new series of impressions in colors [!] and did not have time to make a special plate for the journal.[74]

The Banjo Lesson was published in 40 impressions, which in itself is surprising: it would have been necessary to have the plate steel-faced in order to protect the fragile drypoint for such a large edition, and it is difficult to accept that during this productive year, Cassatt could have had time to print the plates herself as she had done previously in 1889. Unlike the set of ten, there is no indication as to the printer; however, she knew the Delâtres—both father and son—and may have called upon their print-shop services. It is also possible that the stated edition was not completed —a frequent practice—since we have not located nearly that number of impressions.

In this print, with drypoint lines and a pale aquatint tone that seems to have been "vaporized" onto the surface of the plate, Cassatt introduced monotype inking for much of the color areas so that each impression reveals different painterly strokes of the pigments. The copper plates may have been professionally printed, but the special wiping and monotype painting of the pink, royal blue, and deep yellow inks on the smooth areas of the plate were surely executed by the artist.

For the most part, both *The Banjo Lesson* and *Gathering Fruit* are found on a slightly thin, cool, off-white, laid paper with the Adriaan Rogge or VanderLey watermarks. There are occasional impressions on the heavier-weight laid paper with the ARCHES watermark similar to those used for the earlier color prints. These later prints do not carry an inscription by Cassatt but bear her signature and often the blue MC stamp on the lower platemark, placed there during her lifetime.

About 1894 to 1895 Mary Cassatt prepared two more color prints in anticipation of the major exhibition of her work planned by Durand-Ruel for his New York galleries. *Feeding the Ducks* (cat. 18) and *Peasant Mother and Child* (cat. 17) (number 49 in the 1895 exhibition catalogue) were executed at this time. The latter image evolved from an elaborate sequence of printed impressions, and various types of inkings were attempted before the finished impression was accepted. Durand-Ruel inquired as to the size of the print edition, and a note in the stock books says that "Miss Cassatt proposes not to make more than fifty impressions."[75] Again, not nearly that number of impressions has been found. The delicate "liquid-type" aquatint surface permitted a freer, more painterly surface for the color and accentuated the inky, monotype-like plate tone. The colors are strong and "tart" in their juxtaposition, and in one final state, Cassatt has added touches of pigment to the sheet as accents on the woman's dress.

A few years later, the artist employed the same models—a mother with black hair and her blond curly-headed child—to create three more color prints. *Under the Horse Chestnut Tree*, *By the Pond*, and *The Barefooted Child* (see cats. 20–22) were all executed about 1896. The first print (cat. 20) was published in a journal, *L'Estampe nouvelle*, that was announced on February 15, 1896 but that did not come into existence until October 1897. Mary Cassatt's contribution, *Femme et enfant dans l'herbe*, appeared alone in the first issue in an edition of 45 impressions. Some were given to the founding members, others were deposited in the Society's archives and at the Bibliothèque Nationale, and ten were permitted for commerce.[76] The journal, whose vice president was Roger Marx, continued until June 1908, and Mary Cassatt offered another print for the February 1904 issue—a drypoint in black and white, *The Crocheting Lesson*, printed in 50 impressions, plus 7 trial proofs.

Mary Cassatt was nearly 50 when she celebrated her most important exhibition at the Galeries Durand-Ruel in 1893. More than half the works shown were her prints, for she·was one of the few Impressionist artists who was a "born printmaker." Although she made prints only sporadically, she was deeply committed to the medium and greatly cared about their disposition. Essentially, all the color prints, genuinely recognized for their inventiveness, were completed in the early 1890s—the beginning of the greatest period of printmaking in 19th-century France. Thus, it is surprising and regrettable that Cassatt did not participate in or express interest in the numerous workshops, societies, and publishing enterprises that were form-

fig. 40. Edgar Degas (1834–1917)
Landscape, 1890–1892
Pastel over monotype in oil colors
10 x 13⅜ in. (254 x 340 mm) platemark
Museum of Fine Arts, Boston, Gift of
Denman W. Ross, 1909

ing for the creation and dissemination of original prints. One publication, called *L'Estampe originale*, with its first album containing ten prints, appeared on March 30, 1893, nearly eight months before Cassatt's exhibition in November of the same year. It was published under the direction of André Marty and with the support of Roger Marx, who wrote the preface, and its intent was to include prints of great originality by artists of aptitude, embracing all graphic techniques and artistic tendencies. Innovations in color and process were encouraged, which should have appealed to Cassatt, but she made no contribution (nor did Degas, whose printmaking activity had ceased after his bather lithographs) to any of the albums, the last of which appeared in 1895.[77] Pissarro was persuaded to offer two prints, but neither was in color.

Roger Marx believed that these albums represented the "avant-garde" of French art, and it was this track that Cassatt avoided; she may have enjoyed encouraging certain young artists, but she had no intention of aligning herself with them. Indeed, the artists that she later joined for *L'Estampe nouvelle* were of much less stature and far more conventional in their approach to technique and subject matter.

L'Estampe originale spawned a number of publications and periodicals that contain many of the prints we identify as representing the best in French printmaking. But they all came too late for Cassatt, who turned away from "the color revolution" and the young "radicals" who participated in it. Even Ambroise Vollard, whom Cassatt thought very clever, could not tempt either her or Pissarro to contribute to his *Albums des peintres-graveurs* in 1896. Perhaps the entrepreneurial nature of the gallery owner, who was a friend of both artists, held no appeal for them. Like Pissarro, she was not about to make color prints on demand.

One can readily describe the printmaking environment in which Cassatt's color drypoint and aquatints made their appearance, but this discussion diminishes the impact that her inventions had on the artists and collectors in her day and in subsequent years. Because of her determined individualism, she pursued a concept that she had created, and she strived for the proper means to express it. There were no direct disciples of Mary Cassatt—her methods were too complicated and probably too expensive to duplicate—but many artists today try to unravel her techniques and acknowledge their appreciation for her extraordinary color prints.[78]

We may strain to find related prints and procedures from which Mary Cassatt might have drawn her great color series, but in vain. One can posit a context but no more, for just as other artists have, on rare occasions, strayed from the established conditions and artistic milieu of their time, so one can propose that Cassatt took a highly original step in her color printmaking enterprise. Although there are precedents for her subject matter of women and children and women in domestic scenes, the particular style of her prints is unique and the technical processes wholly inventive. It is safe to say that Cassatt's color prints, especially the set produced in 1891, represent a major contribution to the field of printmaking.

N O T E S

1. Lethève, p. 109. Degas, among other well-known artists, was first recorded as visiting the Print Room in 1853.

2. *Catalogue de collection Edgar Degas: Estampes, anciennes et modernes*. Sale catalogue. Hotel Drouot, Paris. November 6–7, 1918. Under the entry for Mary Cassatt (lot nos. 16–58) are listed 87 impressions plus 13 working proofs from plates, for the most part "unfinished."

3. See *Degas Letters* and Reed and Shapiro, pp. 168–169, cat. no 51.

4. In his research for a book on Monet, Charles Stuckey came across a most telling and important description of *Le Jour et la nuit*. This was cited in his "Recent Degas Publications," and in Boggs et al., p. 219.

5. Reed and Shapiro, p. 169.

6. For Degas, Cassatt, and Pissarro, see Reed and Shapiro, p. 169, and for Raffaëlli, see pp. xli–xlii and notes 44 and 51.

7. Richards, pp. 268–277.

8. For further discussion of the "Mary Cassatt" images, see Reed and Shapiro, pp. 168–197.

9. See *Pissarro* (London: 1980), p. 196, note 5, and Reed and Shapiro, p. 98.

10. For a discussion of Philippe Burty and the notion of the "belle épreuve," see Douglas Druick and Peter Zegers, "Degas and the Printed Image, 1856–1914," in Reed and Shapiro, pp. lx–lxi.

11. Félix Fénéon, "Les Peintres-Graveurs," *La Cravache*, February 2, 1889, reproduced in *Félix Fénéon*, pp. 139 and 141.

12. Douglas Druick in the foreword to *The Prints of the Pont-Aven School: Gauguin and His Circle in Brittany* (Washington, D. C.: 1986), p. 13, and Richard Brettell and Françoise Cachin et al., *The Art of Paul Gauguin* (Washington, D. C.: 1988), pp. 130–132.

13. I am grateful to Janine Bailly-Herzberg for bringing to my attention the correspondence between Desboutin and Albert Alboize. Arsène and Ann Bonafous-Murat have kindly assisted me in assembling information on the printer M. Leroy.

14. Cited in Melot, under "Marcellin Desboutin," p. 101, nos. 219–221.

15. Mathews (1984), p. 213.

16. G. Dargenty, pp. 98–99.

17. de Lostalot, p. 82.

18. de Goncourt, vol. 17, p. 19 (Thursday, March 13, 1890).

19. Raymond Koechlin, "Recollections of a Veteran Amateur of Far Eastern Art" (originally published in 1930), trans. by H. Bartlett Wells, reprinted in *Essays on Japanese Art: Presented to Jack Hillier* (London: 1982), p. 179.

20. Mathews (1984), p. 215. Morisot responds to her friend Stéphane Mallarmé in May 1890: "Wednesday I shall go to Miss Cassatt to see with her those marvellous Japanese prints at the Beaux-Arts." See *Berthe Morisot: The Correspondence with her family and her friends,*" ed. by Denis Rouart, trans. by Betty W. Hubbard (new edition) (London: 1987), p. 174. At the end of the year, after recovering from an illness, she wrote to her sister: "You ask me what I am doing. My attempts at colour prints are disappointing, and that was all that interested me" (p. 179).

21. *Degas Letters*, p. 146, no. 132.

22. *Collection des estampes modernes composant la collection Roger Marx*, Hotel Drouot, sale catalogue, April 27 to May 2, 1914. Under CASSATT (Mary), lot nos. 248–312. Marx assembled more than 130 impressions, many of which were working proofs that are prized today for their help in understanding Cassatt's working methods. He owned only two prints by Pissarro and eighteen prints plus two monotypes by Degas. A small collector's mark, "R Mx" in an oval, is usually found in the corner of each sheet.

23. Shapiro (1978), no. 55. As early as 1883, the Cassatt family received a porcelain tea service that Mary Cassatt had admired. It was believed to be a "Japanese tea and coffee set," but it is now considered to be blue-and-white Chinese export.

24. Shapiro (1978), no. 59.

25. Weber (1986), p. 73.

26. Ficke (1958), p. 37.

27. Money Hickman, Research Fellow in Asiatic Art, has offered many interesting observations concerning Mary Cassatt and Japanese prints.

28. See Ives (1974), p. 54, note 4 for mention of the auction of a group of Cassatt's Japanese woodcuts at the Kende Galleries, Inc., New York, 1950.

29. Ives (1974), p. 54, example illustrated has a different cartouche than the impression owned by Cassatt in which the vignette, described as "Night of the Asakusa Marketing Festival," is from an earlier printing.

30. Mathews (1984), p. 217.

31. Fuller (1950), pp. 54–57.

32. In 1975 Sue Fuller joined Janet Ruttenberg as artist and Donn Steward as etcher and printer to reproduce examples of Cassatt's color prints in softground. One set of proofs for *The Coiffure* is in the Print Room of The New York Public Library and another for *In the Omnibus* is at The Metropolitan Museum of Art. I am grateful to Mrs. Ruttenberg, who generously lent some working proofs of her own prints using softground etching to the Boston Museum for study and examination, and to both women, who kindly met with me to discuss their theories.

33. In a visit to his studio in June 1987, Aldo Crommelynck made this interesting suggestion.

34. Although superficially there are great similarities between aquatint and softground color areas, under high magnification subtle differences can be detected. In the more transparent softground color areas of Mrs. Ruttenberg's prints, there is evidence of the paper fibers—minute, irregular strokes—that were pressed into the softground covering on the plate. When these areas are printed in layers or in deeper tonalities, they produce a "grainy" effect that, to the naked eye, resembles aquatint.

Miss Fuller evidently did not have the opportunity to examine the preliminary working proofs of the *Portrait of George Moore*, for example, which reveal a decided use of aquatint; the print is not "a pure soft-ground etching" as she states in her article, p. 55, but through printing, burnishing, and wiping, it gives such an appearance.

35. For the letter as published, see *Pissarro, Lettres* (1950), p. 228, dated April 3, 1891. See also *Correspondance de Camille Pissarro*, ed. by Janine Bailly-Herzberg, vol. 3 1891–1894 (Paris: 1988), p. 55 and note 1, p. 56.

36. *Pissarro, Lettres* (1950), p. 235.

37. Bailly-Herzberg (1972), p. 497.

38. See Marcellin Desboutin letters to Albert Alboize, January 7, 1890 (Carton no. 33, Graveurs) at the Bibliothèque d'Art et d'Archéologie de l'Université de Paris.

39. Mathews (1984), p. 228. Despite Cassatt's good intentions, there is no mention of this M. Leroy in the 1892 or 1893 commercial directory, suggesting that Leroy never did set up his own workshop.

40. This letter had always been incorrectly dated "1903" until questioned by Mathews (1984), pp. 221–222. Avery, to whom the letter was addressed, died in 1902, and the content of the letter surely indicates a

much earlier date. It was left to George Avery, then acquired by Mary Benson (a collector of autograph letters), and finally given to the Brooklyn Museum in 1919.

41. Quoted in Sweet (1966), pp. 121–122.

42. Lecomte (April 18, 1891), p. 261.

43. Lecomte (April 26, 1891), p. 137.

44. For the entire review, see Félix Fénéon, "Cassatt, Pissarro," *Le Chat noir*, April 11, 1891, reprinted in Halperin, *Oeuvres* (1970), pp. 184–186. I appreciate the assistance of Chantal Sloan in translating the relevant passages.

45. Mme Caroline Durand-Ruel Godfroy and Mlle France Daguet made available all the records in the Durand-Ruel Archives pertaining to Cassatt's color prints. This information on acquisitions is listed in the stock book of the "Maison Durand-Ruel, New York" (December 1891–1893), pp. 340–341.

46. For a full description of Mrs. Marrs's initiative in collecting color prints and Sylvester Koehler's guidance, see Riggs (1977–1978), pp. 3–13.

47. Entire letter quoted in Mathews (1984), pp. 227–228. Letter should be dated February 14 or 15, 1892, since Joseph Durand-Ruel's response was written February 16, 1892 (see below).

48. Durand-Ruel Archives. Letter from Joseph Durand-Ruel to Mary Cassatt 5–218, 219.

49. The following sets of the color prints are known: H. O. Havemeyer—now dispersed among the descendants; Mrs. Marrs's set—now Worcester Art Museum; on October 28, 1916 Paul J. Sachs acquired a set which he gave in the same year to The Metropolitan Museum of Art; the Art Institute of Chicago was given a set in 1932 by Mr. and Mrs. Martin A. Ryerson, who purchased it in 1922; The New York Public Library acquired a set from Samuel P. Avery; the National Gallery of Canada, Ottawa, has recently received a bequest from Guy M. Drummond of Montreal, whose grandfather Sir George Drummond purchased the prints before his death in 1910; and, finally, according to records in the Bibliothèque Nationale, 21 prints on deposit at the Musée d'Art Moderne were transferred to the Cabinet des Estampes in 1963. These had come from the Musée des Arts Decoratifs, where they were offered as a gift in 1932. The color prints form a group, although the impression of *Mother's Kiss* (not in good condition) has been replaced in the portfolios by an impression acquired from the dealer Guiot in 1936.

50. For further information on the color-printing processes, see Phillip Dennis Cate, "Printing in France, 1850–1900: The Artist and New Technologies," *Gazette of The Grolier Club*, Numbers 28/29, June/December 1978, pp. 57–73, and Cate and Hitchings (1978).

51. Burty's letter is published in full by Distel (1894), pp. 8–13. The information on Burty's efforts for the State has been paraphrased from this article. Juliet Wilson Bareau has kindly sent me copies of the original correspondence and certificates of payment (Archives Nationales, Paris. Liasse F 21 2077): on June 20, 1890, Mary Cassatt received 120 francs for 12 drypoints (in one frame), "Etudes de femmes et enfants," and one aquatint, "Etude de femme."

52. Portalis (1890), pp. 118–128.

53. See also P. D. Cate, "The 'revolutionary intrigue' among 19th-century printmakers," *Art News*, March 1978, pp. 77–84.

54. Cate (1978), p. 5.

55. Carlson and Ittmann et al. (1984), p. 290.

56. With the revival of collecting interest in 18th-century color prints, there must have been exhibitions that Mary Cassatt would have seen, but none are known by name. Any event, however, triggered publicity, such as the discovery in 1878 of a portfolio of color proofs by Janinet. John Ittmann kindly brought this information to my attention.

57. I appreciate Sinclair Hitchings showing me the extensive Auguste and Eugène Delâtre archive at the Boston Public Library—there are some documents and numerous color proofs to be studied.

58. *Charles Maurin*, exh. cat. with essay by P. D. Cate, Lucien Goldschmidt, Inc. (New York: November 1978), p. 8.

59. Mourey (1901), p. 7. See both Mourey articles in this volume for a detailed commentary with illustrations on French color etching in the last decade of the 19th century, pp. 3–14 and pp. 94–103. The author makes interesting comments even though it is historically inaccurate to jump from Debucourt to Charles Maurin with regard to color etching.

60. *Pissarro, Lettres* (1950), p. 324.

61. *Pissarro, Lettres* (1950), p. 363.

62. Brettell and Lloyd (1980), pp. 66–75.

63. Degas purchased three prints including *La Toilette* on December 18, 1893, according to the Durand-Ruel stock books

(Livre de "Reçu en dépôt," Maison Durand-Ruel, Paris).

64. For a discussion of Degas's lithographs, see Reed and Shapiro (1984), p. lxii and pp. 220–222.

65. Mathews (1984), p. 240.

66. For a discussion of the print environment in 1889 see the long, descriptive essay by Henri Béraldi, *Les Graveurs du XIXe siècle* (Paris: 1889), pp. 255–271.

67. The revival of the decorative arts is cited in Druick and Zegers (1981), pp. 96–97, and in Druick's foreword to *The Prints of the Pont-Aven School* (1986), p. 13.

68. Biddle (1939), p. 220.

69. *Pissarro, Lettres* (1950), p. 319.

70. André Mellerio, "Miss Cassatt," introduction to *Exposition* (1893), p. 8.

71. Caldwell (1895), pp. 4–5.

72. de Lostalot (1893), p. 299.

73. de Goncourt, *Journal*, Monaco reprint 1957, vol. 19, p. 195, and for the entry on Bracquemond's visit, dated Wednesday, January 10, 1894, p. 214.

74. Archives Durand-Ruel (6–428). Joseph Durand-Ruel to Monsieur A. de Lostalot, November 30, 1893. It is interesting to note that Durand-Ruel mentions the disposition of some earlier drypoint plates: "Quant aux pointes sèches éditées par nous en une série de douze numéros, nous n'en avons plus que quelques épreuves, les planches ayant également été détruites."

75. Archives Durand-Ruel (2–20), May 1, 1895, and Stock Book Durand-Ruel, New York, p. 291.

76. Bailly-Herzberg (1985), p. 355.

77. There was an important precedent for the 1893 publication when a group of artists issued on May 1, 1888, *L'Estampe originale* comprising 150 original prints; evidently, only one album with loose prints appeared. Roger Marx considered the 1893 *L'Estampe originale* as a continuation of the earlier project. See Bailly-Herzberg (1985), pp. 355–357, for a listing of both journals.

78. Clifford S. Ackley brought to my attention Jacques Villon's obvious interest in Cassatt's color aquatints. In 1899 Villon "executed his first color aquatints under the supervision of the master printer, Eugène Delâtre." See *Jacques Villon: master of graphic art (1875–1913)* (Boston: 1964), p. 13. It is known that Mary Cassatt was a professional friend of Delâtre's, but he did not work on her 1891 color prints.

The Catalogue

Use of the Catalogue

The catalogue entries describe all of Mary Cassatt's color prints in as many states as it was possible to discover. Most but not all of these states are illustrated.

The word "state" is used broadly in this catalogue because of the complex procedures Mary Cassatt followed in making her color prints. Traditionally, a "state" has indicated any stage in the development of the print at which impressions are taken, changing only with the addition or removal of work on a single plate. In this catalogue, however, the word is used to illustrate any changes that have taken place on one, two, or all three plates that Cassatt employed for her color prints. Thus, if work changes on one plate but not on the other two, a state change is noted.

The catalogue entries are in chronological order as established by the authors. However, the 1891 set of ten prints is ordered to the 1891 Durand-Ruel exhibition. Dimensions are given in inches and millimeters; height precedes width. Measurements are given for platemarks and for sheet size. The platemarks were newly measured for this catalogue. Platemarks often vary due to the degree of dampness of the paper and/or to printing pressure.

The plates are listed in the order in which the work was designed on each plate; this does not mean, however, that they were necessarily printed in this sequence. For example, in *The Fitting* (cat. 9), Plate II was printed first, then Plate III, and finally Plate I, which contained all the drypoint linework and much of the aquatint areas.

Titles are given in English; alternative titles are also recorded.

The summary of the design on each plate is based on the final state.

Reproductions in the catalogue are numbered as follows:

The color prints are identified by their catalogue number (Arabic) and state number (Roman, e.g., cat. 5-iv for *The Bath*, fourth state; if more than one version of a state is reproduced, an abbreviated reference to the location of the particular version follows the state number, e.g., cat. 5-xvi (LC) for *The Bath*, sixteenth state, at the Library of Congress.

Related material (e.g., paintings, pastels, drawings, prints by Mary Cassatt or other artists) is identified as a figure (fig.) by the catalogue number (Arabic) of the color print to which it is related and a second number (Arabic) indicating its sequence in the entry.

The following abbreviations are used for frequently cited references:

Br. CR Breeskin, Adelyn. *Mary Cassatt, A Catalogue Raisonné of the Oils, Pastels, Watercolors, and Drawings*, Washington, D.C.: 1970.

Br. Breeskin, Adelyn. *The Graphic Work of Mary Cassatt, A Catalogue Raisonné*, New York: First edition, 1948; Washington, D.C.: Second edition, 1979.

Lugt Lugt, Frits. *Les Marques de collections de dessins et d'estampes*, Amsterdam: 1921; *Supplément*, The Hague: 1936.

A census of collections of Cassatt's prints has been compiled based on impressions known to the authors. Abbreviations are as follows:

Achenbach	Achenbach Foundation for Graphic Arts, The Fine Arts Museums of San Francisco
Addison	Addison Gallery of American Art, Andover, Massachusetts
AIC	The Art Institute of Chicago
Amon Carter	Amon Carter Museum, Fort Worth, Texas
Amsterdam	Rijksprentenkabinet, Rijksmuseum
ANG	Australian National Gallery, Canberra
BAA	Bibliothèque d'Art et d'Archéologie (Fondation Doucet), Paris
Berlin	Staatliche Museen Preussicher Kulturbesitz, Kupferstichkabinett, Berlin
BMA	Baltimore Museum of Art
BN	Bibliothèque Nationale, Cabinet des Estampes, Paris
BPL	Boston Public Library, Print Department
Brooklyn	The Brooklyn Museum
Bryn Mawr	Bryn Mawr College, Pennsylvania
CAM	Cincinnati Art Museum
Carnegie	Museum of Art, Carnegie Institute, Pittsburgh
Christie's	Christie's Fine Art Auctioneers, New York
Clark	Sterling and Francine Clark Art Institute, Williamstown, Massachusetts
CMA	The Cleveland Museum of Art
Corcoran	The Corcoran Gallery of Art, Washington, D.C.
Delaware	Delaware Art Museum, Wilmington
Dresden	Staatliche Kunstsammlungen Dresden, Kupferstichkabinett, German Democratic Republic
Fitchburg	Fitchburg Art Museum, Massachusetts
Fogg	Fogg Art Museum, Harvard University, Cambridge, Massachusetts

Grand Rapids	Grand Rapids Art Museum, Michigan
Hill-Stead	Hill-Stead Museum, Farmington, Connecticut
Hirschl & Adler	Hirschl & Adler Galleries, New York
Hom	Mr. and Mrs. Jem Hom
Indianapolis	Indianapolis Museum of Art
Johnson	R. Stanley and Ursula Johnson Collection
Kansas	Spencer Museum of Art, University of Kansas, Lawrence
LACMA	Los Angeles County Museum of Art
LC	Library of Congress
McNay	Marion Koogler McNay Art Museum, San Antonio, Texas
MFA	Museum of Fine Arts, Boston
MIA	The Minneapolis Institute of Arts
MMA	The Metropolitan Museum of Art, New York
MOMA	Museum of Modern Art, New York
Munich	Staatliche Graphische Sammlung, Munich
NGA	National Gallery of Art, Washington, D.C.
NGC	The National Gallery of Canada, Ottawa
NMWA	The National Museum of Women in the Arts, Washington, D.C.
NYPL	New York Public Library
Oberlin	Allen Memorial Art Museum, Oberlin College, Ohio
Oklahoma	Oklahoma Arts Center, Oklahoma City
Oregon	Oregon Art Institute, Portland Art Museum
Payson	Joan Whitney Payson Gallery of Art, Portland, Maine
Petteys	Chris Petteys Collection
PMA	Philadelphia Museum of Art
Prouté	Archives Paul Prouté, S.A.
Rogers	Lauren Rogers Museum of Art, Laurel, Mississippi
St. John's	St. John's Museum of Art, Wilmington, North Carolina
Saint Louis	The Saint Louis Art Museum
Santa Barbara	The Santa Barbara Museum of Art, California
Shelburne	Shelburne Museum, Vermont
Smith	Smith College Museum of Art, Northampton, Massachusetts
Sotheby's	Sotheby's, New York
Terra	Terra Museum of American Art, Chicago
Toledo	The Toledo Museum of Art
Virginia	Virginia Museum of Fine Arts, Richmond
Weil	Weil Brothers Collection, Montgomery, Alabama
Weston	William Weston Gallery, London
Worcester	Worcester Art Museum, Massachusetts
Yale	Yale University Art Gallery

Collectors

The following names, listed alphabetically, represent those collectors who most actively acquired Mary Cassatt's prints. Within the catalogue entries, collectors are noted as follows:

Avery
Samuel Putnam Avery (1822–1904) Lugt 41
Barrion
G. Alfred Barrion (1842–1903) Lugt 76
Hartshorne
Robert Hartshorne (d. 1945) Lugt Supplément 2215b
Lucas
George Aloysius Lucas (1824–1909) Lugt 1681; Supplément 1695c
McVitty
Albert Elliott McVitty (1876–1948) Lugt Supplément 1862c
Roger Marx
Roger Marx (1859–1913) Lugt 2229; Supplément 1800b
Vollard
Ambroise Vollard (1868–1939) not in Lugt
Whittemore
Harris G. Whittemore (1865–1927) Lugt 1342; Supplément 1384a

For the most part, these collectors were personal friends of Mary Cassatt and purchased works by her in other media. They were also interested in the prints of other nineteenth-century French artists and acquired many examples, probably with Cassatt's active encouragement.

M C
Mary Cassatt (1844–1926) Lugt 604

This blue stamp was placed during Cassatt's lifetime on the lower center platemark of many impressions of her color prints. When it appears on impressions without the full inscription, it often indicates that these examples were given to friends or relatives. It is regularly found on the set of ten and more sporadically on the later color prints; it was apparently abandoned for the prints executed after 1895.

Inscriptions

Cassatt did not include the name of the printer on the prints made after 1891. Most impressions of the later prints were signed in the lower right margin by the artist.

1
Nurse and Baby Bill (No. 2),
ca. 1889–1890

Breeskin 109
Softground etching and aquatint
8⅝ x 5½ in. (220 x 140 mm) platemark

On the Bench (fig. 1-3), *Nurse and Baby Bill (No. 1)* (see cat. 2), and *Nurse and Baby Bill (No. 2)* (cat. 1-ii) are all derived from sketches Cassatt did both in pastel (*Baby Bill in Cap and Shift*, fig. 1-1) and in pencil (*Baby Bill and His Nurse No. 2*) (fig. 1-2). Although Breeskin considered this to be the second version of the theme, the relative simplicity of the image with aquatint tone on the background rather than on the figure itself suggests that it was the first. According to Breeskin, *Nurse and Baby Bill (No. 2)* was printed in an edition of 25, but the authors have located only a few monochrome impressions and one in color (cat. 1-ii). Cassatt's first experiments in color (cats. 1-4) were each executed on a single plate.

Description of the states

I First state, on one plate (not illustrated)

The design of the nurse and child is sketchily drawn in softground with a textural effect, which was probably created by an aquatint grain that is most visible in the hair. Softground tone forms horizontal bands at the top and bottom of the image.

One impression is known: NYPL (Avery, inscribed "first state," printed in gray-black)

II Second state, on one plate

Softground lines are unchanged from the first state, and aquatint, possibly in liquid form, irregularly covers the background area, the horizontal band at the lower edge has been lightened.

The LC impression, the only one known in color, is printed with gray-brown ink for the lines of the figures, and deep blue for the background. Monochrome impressions are known at: Achenbach (sepia); BMA (inscribed to Mr. Lucas, dark gray); BN (dark gray)

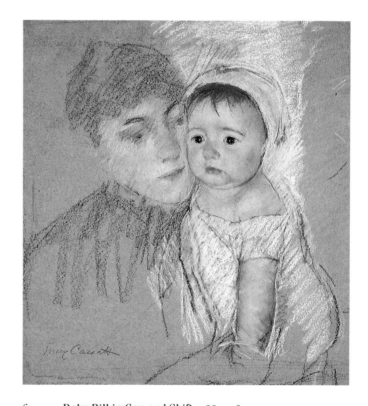

fig. 1-1. **Baby Bill in Cap and Shift**, 1889–1890
Pastel on paper
16⅞ x 15⅛ in. (429 x 384 mm)
Hunter Museum of Art, Chattanooga,
Tennessee, Gift of Benwood Foundation

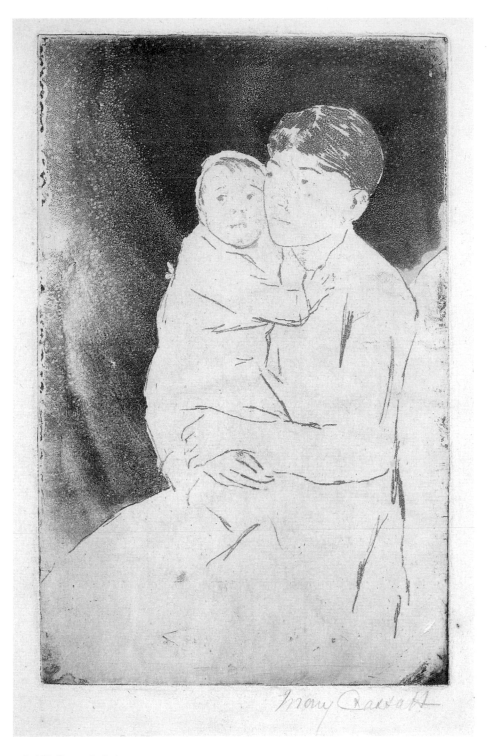

cat. 1-II Second state

cat. 1-II Second state
Softground etching and aquatint on one plate
Off-white, thin, moderately smooth, laid paper
13¾ x 8⅜ in. (349 x 213 mm) sheet
Watermark: DERLE
Signed lower right: "Mary Cassatt"
Library of Congress, Washington, D.C., Pennell Fund
Committee, 1949

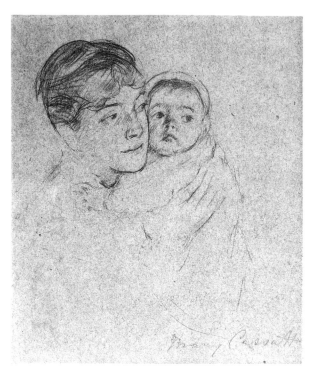

fig. 1-2. *Drawing for* Baby Bill and His
Nurse (No. 2)*,* 1889–1890
Black crayon
Gray-blue, wove paper with some
discoloration
7½ x 5⅝ in. (190 x 142 mm) sheet
Signed lower right: "Mary Cassatt"
Coll.: Avery
The Miriam and Ira Wallach Division of
Art, Prints and Photographs,
The New York Public Library
[exhibited in Williamstown]

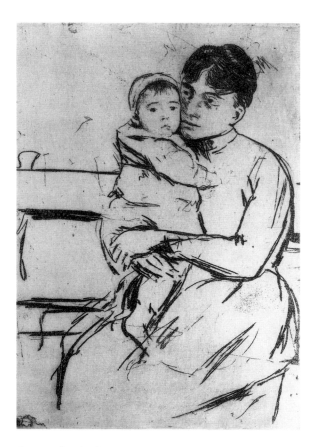

fig. 1-3. On the Bench, 1889–1890
Br. 107
Aquatint and softground etching
Off-white, medium-thin, moderately
textured, laid paper
7¼ x 5½ in. (184 x 140 mm) platemark
15⅜ x 9⅜ in. (391 x 238 mm) sheet
Library of Congress, Washington, D.C.

2
Nurse and Baby Bill (No. 1)
ca. 1889–1890

Breeskin 108
Softground etching and aquatint
7⅜ x 5⅝ in. (187 x 136 mm) platemark

This simple study is another experimental print in which Mary Cassatt explored the results that could be achieved using textured softground etching lines and aquatint—possibly a liquid aquatint. The plate was altered four times, and only a few impressions give evidence of its development. These bear a strong resemblance to Degas's prints of 1879–1880 when he was searching for unusual effects and used experimental means to achieve them. In the fourth state, the aquatint was contained by a "stop-out" varnish noted in the uncolored background area, which reads as a positive shape. The pale colors—green, brown, and minute pink accents—were all daubed onto a single plate (*à la poupée*) and lightly wiped before printing.

Description of the states

I First state, on one plate

Softground lines define the composition, including a horizontal line indicating a bench at left. Baby's features and hand are blurred. There is an overall background plate tone in the form of a twill-like pattern caused by printing on the screen side of the wove paper.

This unique impression, printed in a gray-black ink, is located at: NYPL (Avery)

II Second state, on one plate (not illustrated)

Baby's features and hands are redefined and nurse's hair more heavily shaded with different and/or additional softground work. There is now a vertical line at right behind the nurse. Only a light plate tone is now visible in the background.

This one known impression is printed in a light brown ink: NYPL (Avery, inscribed "1st state")

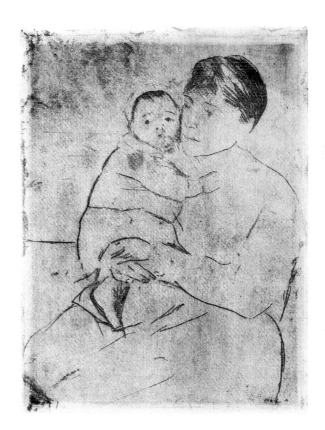

cat. 2-1 First state

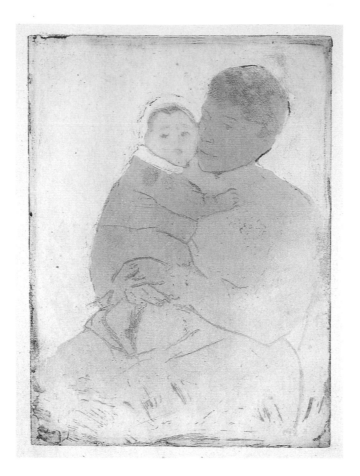

cat. 2-IV Fourth state

III Third state, on one plate (not illustrated)

The line work is completed but an irregular aquatint tone covers the background and the nurse's hair in part. Although Breeskin has reproduced an impression of this state, the authors have not located it—probably in a private collection (formerly Hartshorne).

IV Fourth state, on one plate

The aquatint background is scraped away and a light aquatint now covers the figures—the contours of the figures clearly show that "stop-out" was used to protect the background. The nurse's dress is printed in light green; the infant's dress and the line work are in gray except for the white cap and collar. Printed touches of pink decorate the lips and eye-brows on the infant's face.

Only one impression is known: MFA

cat. 2-I First state
Softground etching and aquatint on one plate
Dark cream, medium-weight, slightly textured, laid paper
11⅛ x 9¹/₁₆ (282 × 230 mm) sheet
Watermark: fragment of VanderLey
Coll.: Avery
The Miriam and Ira D. Wallach Division of Art, Prints and Photographs, The New York Public Library
[not exhibited]

cat. 2-IV Fourth state
Softground etching and aquatint on one plate
Off-white, thin, moderately smooth, laid paper
13⅞ x 8¼ in. (352 x 209 mm) sheet
Watermark: DERLE
Museum of Fine Arts, Boston, Gift of Mr. and Mrs. Peter A. Wick, 1958

3
Hélène Held by Mathilde,
ca. 1889–1890

Breeskin 126+
Softground etching and aquatint
7½ x 6 in. (190 x 152 mm) platemark

Another experimental color print, *Hélène Held by Mathilde*, is related to *Nurse and Baby Bill (nos. 1 and 2)* but is known in only one state and one impression. It is more openly a mirror of the finished pastel, *Hélène of Septeuil* (fig. 3-2) than is the related drypoint, *Hélène of Septeuil* (fig. 3-1), which is of a slightly different composition.

Description of the states

Only known state, on one plate

Figures of the woman and child are drawn in softground with aquatint added on dresses and background.

Only one impression is known: private collection, Florida. It is printed in gray and gray-brown with touches of color throughout, all delicately inked *à la poupée:* flesh tones, blue eyes and dress on child, and somewhat pale orange for the background tone.

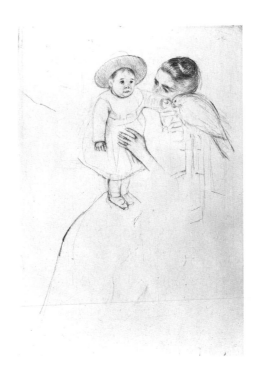

fig. 3-1. Hélène of Septeuil, 1889–1890
Br. 134
Drypoint
9⅜ x 6³/₁₆ in. (238 x 157 mm) platemark
Coll.: Avery
The Miriam and Ira D. Wallach Division
of Art, Prints and Photographs,
The New York Public Library

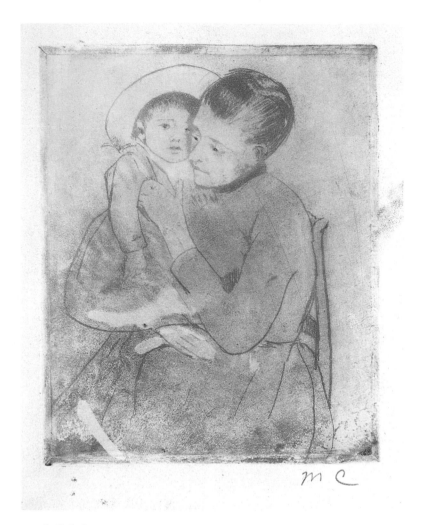

cat. 3 Only known state

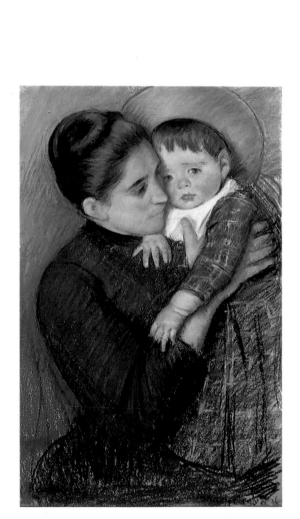

fig. 3-2. **Hélène of Septeuil**, ca. 1890
Pastel on paper
25 x 16 in. (635 x 406 mm)
University of Connecticut Museum of Art,
Louise Crombie Beach Collection

cat. 3 Only known state
Softground etching and aquatint on one plate
Cream, wove paper
7⅛ x 6 in. (189 x 153 mm) platemark
Private Collection, Florida

4
A Portrait of the Artist's Mother,
ca. 1889–1890

Breeskin 122
Softground etching and aquatint
9¹⁵/₁₆ x 7¹/₁₆ in. (252 x 179 mm) platemark

Based on the large oil portrait of her mother (fig. 4-1), this was the most complex design Cassatt had yet attempted in a color print. The process differs from the previous three woman-and-child experiments in that a more traditional softground etching process was used, with hatching to create the dark tone of the dress—as can be seen in both the drawing (fig. 4-2) and the first state of the print (cat. 4-i). Cassatt soon began reworking the tonal areas, however, ending up with a dense aquatint over the dress and a lighter, atmospheric tone over the background.

Description of the states
?I First state, on one plate (not illustrated)

Softground sketch of figure. Described by Breeskin, 1948 and 1979, but not confirmed.

I First state, on one plate

Figure sketched in softground and with light aquatint grain added to background areas.
(whereabouts unknown)

II Second state, on one plate

Aquatint tone reworked, dark spot in upper right lessened, tone around mother's head evened out. There is still evidence of hatching now mostly covered by the aquatint grain. A vase of flowers is added in softground.
One impression is known: NGA (Whittemore)

III Third state, on one plate

Aquatint again reworked so that some areas, such as the flowers, face, and shawl are lightly bitten, while the dress is heavily etched. The aquatint patterns are

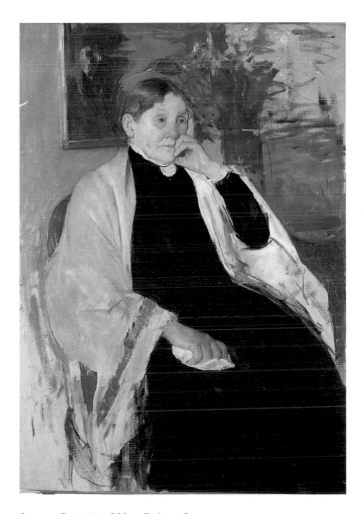

fig. 4-1. Portrait of Mrs. Robert S. Cassatt, ca. 1889
Oil on canvas
38 x 27 in. (965 x 686 mm)
The Fine Arts Museums of San Francisco, Museum purchase, William H. Noble Bequest Fund, 1979
[exhibited in Washington and Boston]

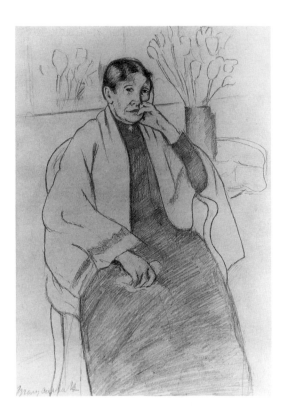

fig. 4-2. *Drawing for* A Portrait of the
Artist's Mother, ca. 1889
Pencil on pink-tan paper
9½ x 6⅝ in. (241 x 168 mm)
Private Collection, Maine

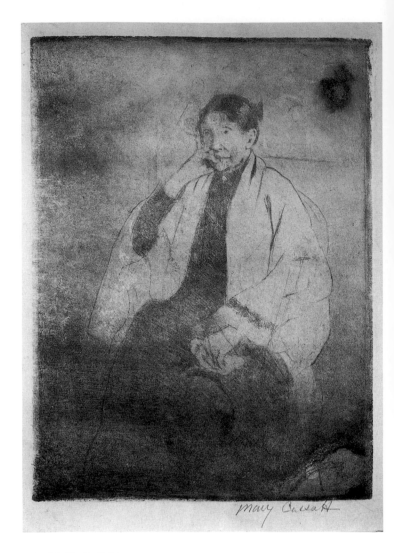

cat. 4-I First state

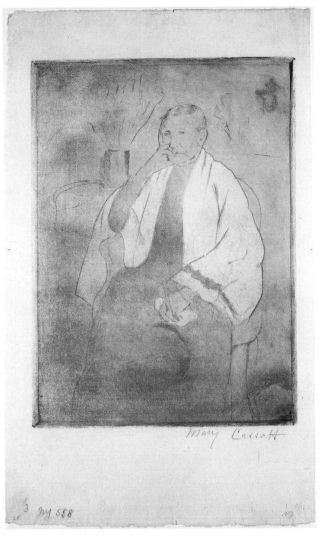

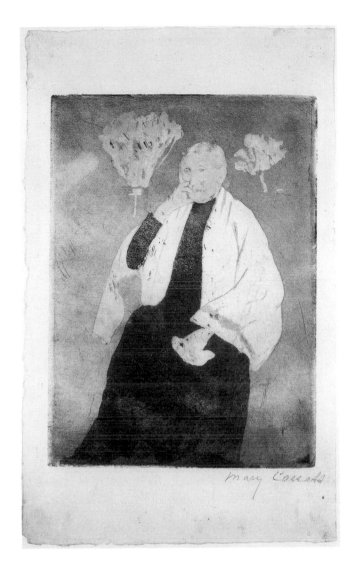

cat. 4-II Second state

cat. 4-III Third state

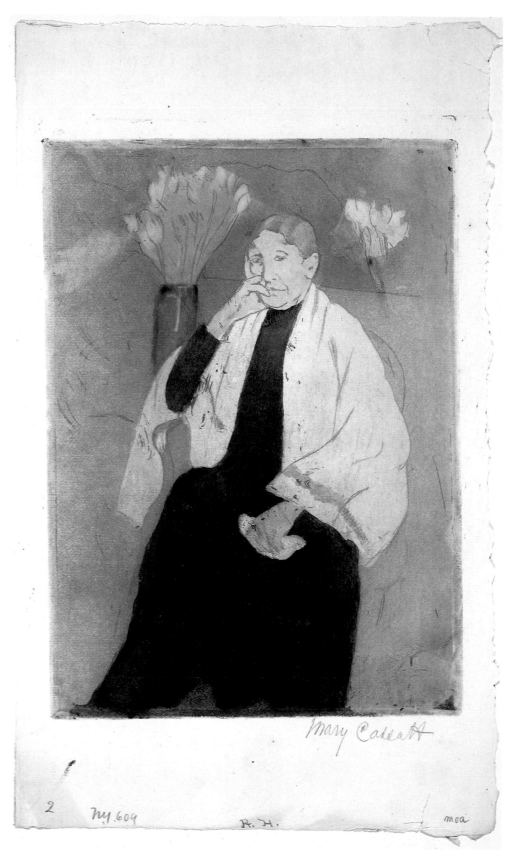

Mary Cassatt

cat. 4-IV Fourth state

carefully "stopped-out," and the subject is printed in light brown and brown-black.

One impression is known: NGA (Whittemore)

IV Fourth state, on one plate

Additional softground lines are added to reinforce the face, hand, flowers, and other details of the background. The dress is again printed darkly and projects against the pale shawl and light brown background. Touches of yellow and green are added *à la poupée* to the color impression.

There are two known impressions in color: NGA (Hartshorne) and Carnegie. Two printed in brown: Sotheby's 1977, lot 56, and Addison.

cat. 4-I First state
Softground etching and aquatint on one plate
(whereabouts unknown)

cat. 4-II Second state
Softground etching and aquatint on one plate
Off-white, moderately thin, slightly textured, laid paper
14¹⁵⁄₁₆ x 8¼ in. (380 x 210 mm) sheet
Watermark: Neptune in armorial shield
Signed lower right: "Mary Cassatt"
Coll.: Whittemore
National Gallery of Art, Washington, D.C., Rosenwald Collection, 1949.5.468

cat. 4-III Third state
Softground etching and aquatint on one plate
Off-white, moderately thin, slightly textured, laid paper
13¹⁵⁄₁₆ x 8⁷⁄₁₆ in. (354 x 215 mm) sheet
Watermark: Neptune in armorial shield
Signed lower right: "Mary Cassatt"
Coll.: Whittemore
National Gallery of Art, Washington, D.C., Rosenwald Collection, 1949.5.467

cat. 4-IV Fourth state
Softground etching and aquatint on one plate
Off-white, medium-weight, slightly textured, laid paper
13⅞ x 8⅜ in. (352 x 213 mm) sheet
Watermark: VanderLey
Signed lower right: "Mary Cassatt"
Coll.: Hartshorne
National Gallery of Art, Washington, D.C., Rosenwald Collection, 1946.21.90

5
The Bath, *1890–1891*

(also called *The Baby's Bath*, *The Child's Bath*, *The Tub*)
Breeskin 143
Drypoint, softground etching, and aquatint
12⅝ x 9¾ in. (321 x 247 mm) platemark

The design for *The Bath* grew out of a long series of related works. In a painting, *The Child's Caress* (fig. 5-1), we see the two models: a sturdy, dark-haired woman wearing an off-white dress with a blue pattern assumes a playful pose with a pudgy young girl with

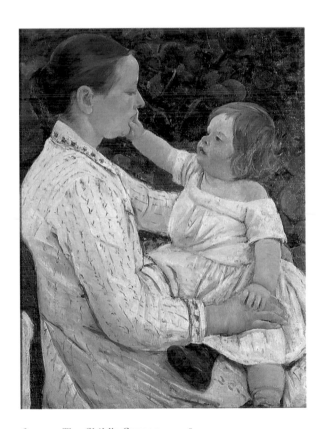

fig. 5-1. The Child's Caress, ca. 1890
Oil on canvas
26 x 21 in. (660 x 533 mm)
Honolulu Academy of Arts, Wilhelmina
Tenney Memorial Collection

disheveled hair. These two are mirrored in a drypoint (*The Caress*, Br. 140) and captured in other poses in drypoints, *Quietude* (Br. 139) and *Mother Marie Dressing Her Baby After Its Bath* (fig. 5-3). The tub appears in this last print as well as in a drawing, *Baby with Left Hand Touching a Tub, Held by Her Nurse* (fig. 5-2). Another drawing shows the composition close to final (Br. CR 801) and preparatory to the drawing actually used for *The Bath* (fig. 5-4). Once this drawing has been established, however, there are no further changes to the composition.

From the earliest states of the drypoint, Cassatt has begun inking the plate *à la poupée* with two different colors of ink: black and sanguine (cat. 5-ii). This device, which is found on only one earlier drypoint, is used frequently throughout the set of ten to distinguish flesh tones from the black of other compositional lines. In the fourth state (cat. 5-iv), Cassatt has added aquatint for the background and dress to this same plate. Her method of coloring *à la poupée*—black for hair, sanguine for faces, yellow for the dress, and blue dots on the collar—may indicate that she was approaching this print as she had earlier color experiments: with all the colors on the same plate.

She soon moved, however, to the more complex process of using two plates, one for the tonal areas and the other for drypoint lines (cat. 5-vi). Once she had taken this step, she experimented extensively to bring the print to a satisfactory conclusion, eventually producing 17 identifiable states. The restless adding and subtracting of lines and tone even continue into the inking of the final state in which she alternates between blue and green for the water in the tub.

Description of the states

I First state, on one plate (not illustrated)

Plate I: The mother, child, and tub are indicated in drypoint worked over softground outlines as in the second state, but before minor details such as the mother's left cuff, the fingers of the child's right hand, and the fuller treatment of the hair for both. Printed in black and sanguine for the contour lines around the mother's face and child's body, creating a flesh-colored tone.

Two impressions are known: Amsterdam; NGA (Vollard, 1943.3.2737)

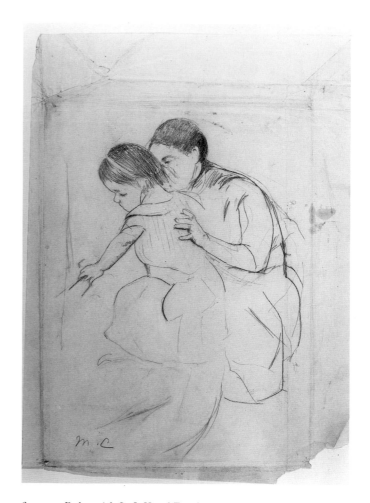

fig. 5-2. **Baby with Left Hand Touching a Tub**, 1890–1891
Br. CR 799
Pencil and charcoal on cream, wove paper
9⅞ x 7¼ in. (251 x 184 mm)
Courtesy Sotheby's 1980, lot 727

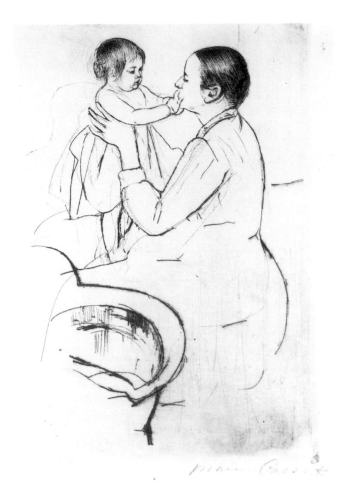

fig. 5-3. **Mother Marie Dressing Her Baby After Its Bath**, ca. 1890
Br. 142
Drypoint
Off-white, thin, slightly textured, laid paper
9¾ x 6⅝ in. (248 x 168 mm) platemark
8¼ x 13¾ in. (210 x 349 mm) sheet
Watermark: VanderLey
Signed lower right: "Mary Cassatt"
Library of Congress, Washington, D.C.

overleaf:
fig. 5-4. *Drawing for* The Bath 1890–1891
Recto: Graphite and black crayon
Verso: Pale softground lines overlaid with black
Dark cream, thin, smooth, wove paper
13⅜ x 10⅝ in. (344 x 270 mm) sheet including folds
Signed lower right: "Mary Cassatt"
Coll.: Whittemore
National Gallery of Art, Washington, D.C., Rosenwald Collection, 1948.11.49

II Second state, on one plate

Plate I: The drypoint design of the first state is slightly enhanced with lines for the cuff at the mother's left wrist, the child's fingers defined, and the hair of both more completely shaded. Printed in black and sanguine.

Three impressions are known: BMA; PMA (McVitty, printed in black only); private collection, New York (inscribed "état")

III Third state, on one plate (not illustrated)

Plate I: The drypoint of the second state is further worked to show the top line of the tub, which is now extended to the bevel at left. A light aquatint tone is added to the plate, especially noted on the background and floor.

One impression: NYPL (Avery) is printed in black and sanguine and incorrectly inscribed by Cassatt "1st state." Another impression in the BAA (printed in black only) is a third state with partial tone.

IV Fourth state, on one plate

Plate I: The background tone is incompletely burnished, leaving a fine, grainy tone on the tub, on the baby's body, and in some triangular shapes in the background above the tub. Aquatint is now added to the mother's dress and printed in yellow.

Two impressions are known: NGA (Vollard, with touches of blue added to the dress collar and cuffs); NGA (Vollard, 1943.3.2736)

V Fifth state, on one plate (not illustrated)

Plate I: Similar to the fourth state, but with drypoint lines of the dress reinforced to define folds. The lines and aquatinted dress are both printed in black and on the same plate; the overall grainy tone is still easily detectable.

Only one impression is known: MMA (Roger Marx, inscribed "état")

VI Sixth state, on two plates

Plate I: The composition is the same as the fifth state, but most of the lines and the dress are printed in yellow with the exception of the hair and eyes of the mother and child, which are printed in black.

Plate II: Sketchy drypoint lines correspond to

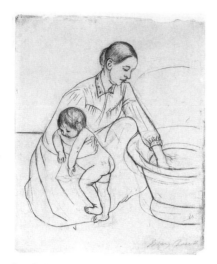

fig. 5-4

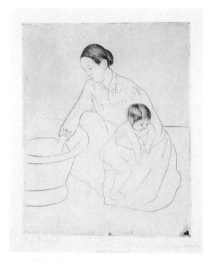

cat. 5-II Second state

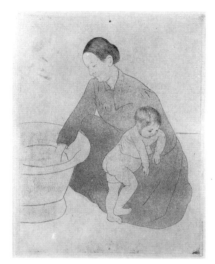

cat. 5-VIII Eighth state

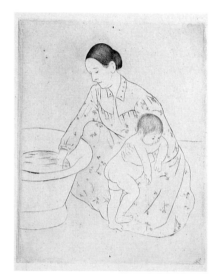

cat. 5-IX Ninth state

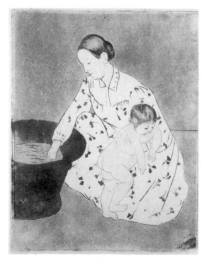

cat. 5-XV Fifteenth state

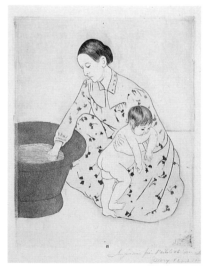

cat. 5-XVI (NGA) Sixteenth state

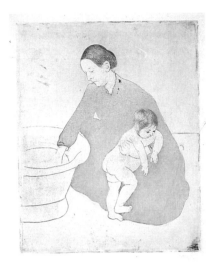

cat. 5-IV Fourth state

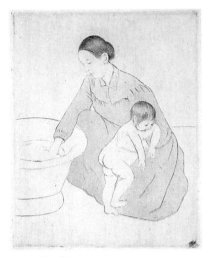

cat. 5-VI Sixth state

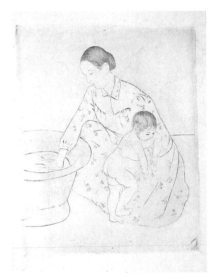

cat. 5-XI Eleventh state

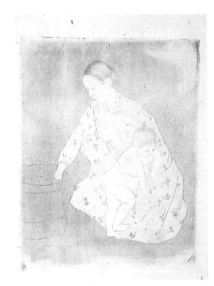

cat. 5-XII Twelfth state

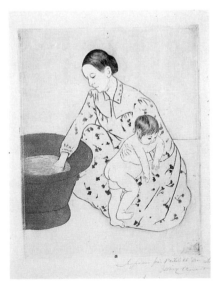

cat. 5-XVII (LC) Seventeenth state

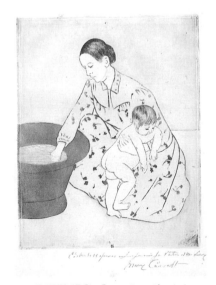

cat. 5-XVII (PC) Seventeenth state

those on plate I with the addition of faint flowers on the dress and a few lines to indicate water in the tub. This plate is printed overall in sanguine, which becomes brown as it extends partially into the mother's hair.

The only impression known, in a private collection, shows double platemarks but no registration holes at the top and bottom of the sheet. The duplicate drypoint lines on the two plates do not align, thus creating a slightly blurred effect.

This marks the first time that Cassatt has introduced the idea of working from multiple plates.

VII Seventh state, on two plates (not illustrated)

Plate I: The lines and aquatint remain unchanged from the fifth state, printed in yellow with the exception of the mother's and child's hair, which is printed, for the most part, in black; some yellow lines extend into the hair of both figures. The overall grainy tone on the tub and the child's body as well as the triangular marks in the upper left background that were noted in the fourth state are difficult to detect when printed in yellow.

Plate II: The drypoint lines again roughly duplicate the lines on plate I but do not match those that were on plate II in the sixth state, suggesting that the lines on plate II were either reworked or redrawn on a new plate. Numerous small amendments and additions on the tub and dress confirm this proposal. Registration holes were drilled on both plates and used (the paper is pierced at the top and bottom within the platemark). Plate II is printed only in black.

One impression is known: NGA (Vollard, 1943.3.2738)

VIII Eighth state, on one plate

Plate I: Remains unchanged from the fifth state, but a small wedge-shaped area between the mother's knee and tub as well as minute areas around the contours of the mother's dress and child's body are now filled in with tone. The plate is printed only in black but more lightly than the fifth state. The registration holes are printed but not pierced.

A unique impression is known: private collection

IX Ninth state, on two plates

Plate I: Unchanged from the eighth state, including small areas of tone, but as in the seventh state, the plate is printed in yellow with the exception of the mother's hair, which is printed in black.

Plate II: The drypoint lines appear to be similar to the seventh state, but with a small floral pattern that is applied in drypoint, softground, and roulette in a different pattern from the final state. There are some drypoint lines and also some roulette work in the water of the tub. This plate is printed in black with sanguine just on the face and body of the child.

Only one impression is known: private collection

X Tenth state, on two plates (not illustrated)

Plate I: Softground lines seem to overlay the original drypoint lines as if Cassatt wanted to reinstate the linear design on plate I through a softground transfer method. The aquatint tone on the dress is apparently burnished and a floral design, different from the pattern on plate II of the ninth state, is added to the dress now on plate I in drypoint and softground. There is an overall tone on the background and tub that may be from a twill pattern of paper etched in a softground process—the scratchy lines at the lower left and upper right seem drawn in softground. The tone on the water in the tub is burnished to produce a few white ripples.

Plate II: The aquatint tone for the dress is now placed on plate II and printed in yellow; some previous drypoint lines, also printed in yellow, are still visible on the contours of the tub.

One impression is known: NGA (Vollard, 1943.3.2739)

The tenth state marks the point in the development of this print in which the work is finally separated onto the two plates as they will be carried out to the final, editioned state.

XI Eleventh state, on two plates

Plate I: The scratchy lines at lower left and upper right, executed in softground, are burnished, leaving only faint traces. The flowers of the dress are slightly altered with the addition of drypoint and aquatint touches over the softground pattern; more ripple lines are added in drypoint to suggest water in the tub. The plate is printed in black with sanguine for the mother's profile and the child's body; for the first time, the tub, its contour lines, and the water are printed in blue.

Plate II: The aquatint of the dress seems to be re-bitten to create a darker tone. Printed in yellow with no previous drypoint lines visible on the tub.

Two impressions are known: NGA (Vollard, 1943.3.2741); Sotheby's 1980, lot 728 (printed unevenly)

XII Twelfth state, on two plates

Plate I: A new aquatint tone is applied to the background and to the tub with some "stop-out" work and burnishing at the bottom and the upper right of the print. There are small amendments made to the floral pattern on the dress including additional stems and enlargements of the flowers throughout. Again, ripples in the tub are created by a light burnishing. The plate is printed in black and sanguine for the mother's profile and child's body.

Plate II: Unchanged from the eleventh state and printed in yellow

One impression is known: NGA (Vollard, 1943.3.2740)

XIII Thirteenth state, on two plates (not illustrated)

Plate I: Most of the aquatint tone on the background is burnished out, but not completely removed, leaving a triangular area of aquatint between the mother's arm, bodice, and knee. The drypoint pattern of the hair on both the mother and child is intensified, creating highlights through a greater means of contrasts. Fresh drypoint work is now on the major contours and on many of the fold lines of the dress, including a more noticeable vertical line added to the left of the neckline of the dress yoke. The plate is printed in black, sanguine for the faces and bodies of the mother and child, and lightly inked in blue for the tub and water.

Plate II: Remains unchanged from the eleventh state, printed in yellow

Only impression known is: Fogg (Paul J. Sachs)

XIV Fourteenth state, on two plates (not illustrated)

Plate I: Similar to thirteenth state, but with the aquatinted triangular wedge between the mother's arm, bodice, and knee burnished. Printed in black, sanguine, and a more intense blue for the tub and water. Some of the burr appears to be removed from the dress and contour lines.

Plate II: Remains unchanged from the eleventh state, printed in yellow

Two impressions known are: BN; Sotheby's 1980, lot 729

XV Fifteenth state, on one plate

Plate I: Again, the background is reaquatinted, perhaps in an attempt to produce a dramatic and even tone on the floor and wall. The tub is rebitten so that it now prints darker than the water, the flowers on the dress are rebitten and are now in the final configuration. The plate is printed darkly in black.

Plate II: Not printed

One impression is known: private collection

XVI Sixteenth state, on two plates

Plate I: The aquatint background noted in the fifteenth state was burnished out unequally, leaving slightly more tone on the wall than on the floor. The vertical drypoint line at the left of the neckline of the dress yoke is strengthened and the hair of the mother is altered, probably by burnishing. The clamp marks that appear regularly in the lower corners of the plates throughout the set of ten are not inked in the MFA impression.

Plate II: Remains unchanged from the tenth state, printed in yellow

Two impressions are known: MFA (Mathilde X); NGA (1943.3.2760)

XVII Seventeenth state, on two plates (editioned state)

Plate I: Similar to the previous state, but with a new aquatint tone added to water in the tub, which is now lightly burnished again to indicate ripples. Delicate drypoint hatching is added to emphasize the mother's jaw line, printed in sanguine; mother's hair is darkened with additional drypoint. Unlike the sixteenth state, the background is now lightly inked to pick up a fine aquatint tone. The water in the tub is printed in either blue or green.

Plate II: Remains unchanged from the tenth state, printed in yellow

Final state impressions known are: AIC; BAA; BN; CMA (signed only); Indianapolis; LC; McNay; MFA (initialed only); MMA; NGA (Chester Dale); NGC (2); NMWA; NYPL; private collection (initialed only); private collection, Boston; private collection, Maine; Sotheby's 1981, lot 82; St. John's; Worcester

Summary of the design on each plate

Plate I: Drypoint of mother and child, line of floor; printed in black and sanguine. Aquatint of flowers on dress printed in black, tub and water printed in blue (water sometimes printed in green). Light aquatint for background and figure of baby (printed in sanguine).

Plate II: Aquatint of mother's dress, printed in yellow.

cat. 5-II Second state
Drypoint on one plate
Cream, medium-weight, moderately textured, laid paper
17 x 11⅞ in. (432 x 300 mm) sheet
Inscribed lower left: "Bain d'enfant"; lower right: "state" and signed "To Mr. Lucas with my best/compliments/Mary Cassatt"
The George A. Lucas Collection of the Maryland Institute, College of Art, on indefinite loan to the Baltimore Museum of Art

cat. 5-IV Fourth state
Drypoint and aquatint on one plate
Off-white, moderately thick, moderately textured, laid paper
16⅞⁄₁₆ x 11⅜ in. (417 x 289 mm) sheet
Watermark: ARCHES
Coll.: Vollard
National Gallery of Art, Washington, D.C., Rosenwald Collection, 1943.3.2735

cat. 5-VI Sixth state
Drypoint and aquatint on two plates
Cream, heavy-weight, moderately textured, laid paper
17 x 11¾ in. (432 x 300 mm) irregular sheet
Private Collection

cat. 5-VIII Eighth state
Drypoint and aquatint on two plates
Off-white, medium-weight, slightly textured, laid paper
17⅜ x 11⅛ in. (441 x 282 mm) sheet
Watermark: Adriaan Rogge and other letters in part
Private Collection

cat. 5-IX Ninth state
Drypoint and aquatint on two plates
Pale blue, medium-weight, slightly textured, laid paper
18½ x 12⅛ in. (470 x 308 mm) sheet
Watermark: ornate initials intertwined
Private Collection

cat. 5-XI Eleventh state
Drypoint and aquatint on two plates
17 x 11 in. (433 x 279 mm) sheet
Gray-white, medium-weight, moderately textured, laid paper
Coll.: Vollard
Watermark: large crown with fleur-de-lys
National Gallery of Art, Washington, D.C., Rosenwald Collection, 1943.3.2741
[not exhibited]

cat. 5-XII Twelfth state
Drypoint and aquatint on two plates
Cream, medium-weight, moderately textured, laid paper
17¼ x 11 in. (438 x 280 mm) sheet
Watermark: large crown with fleur-de-lys
Coll.: Vollard
National Gallery of Art, Washington, D.C., Rosenwald Collection, 1943.3.2740
[not exhibited]

cat. 5-XV Fifteenth state
Drypoint and aquatint on one plate
Cream, medium-weight, smooth, wove paper
14⁹⁄₁₆ x 10⅞ in. (370 x 278 mm) sheet
Private Collection

cat. 5-XVI (NGA) Sixteenth state
Drypoint and aquatint on two plates
Off-white, moderately thick, smooth, wove paper
14⅜ x 10⅞ in. (365 x 375 mm) sheet
National Gallery of Art, Washington, D.C., Rosenwald Collection, 1943.3.2760
[not exhibited]

cat. 5-XVII (AIC) Seventeenth state
[not illustrated]
Drypoint and aquatint on two plates
Off-white, medium-weight, moderately textured, laid paper
17 x 11⅝ in. (430 x 295 mm) sheet
Watermark: fragment of ARCHES
Inscribed lower right: "Imprimée par l'artiste et M. Leroy/Mary Cassatt/(25 épreuves)"
The Art Institute of Chicago, The Mr. and Mrs. Martin A. Ryerson Collection, 1932
[exhibited in Williamstown]

cat. 5-XVII (MMA) Seventeenth state
[illustrated on page 46]
Drypoint and aquatint on two plates
Cream, moderately thick, moderately textured, laid paper
17 x 12 in. (432 x 305 mm) sheet
Inscribed lower right: "Edition de 25 série Imprimée par l'artiste et M. Leroy/Mary Cassatt"
The Metropolitan Museum of Art, New York, Gift of Paul J. Sachs, 1916
[exhibited in Washington]

cat. 5-XVII (Worcester) Seventeenth state
[illustrated on page 1]
Drypoint and aquatint on two plates
Cream, moderately thick, moderately textured, laid paper
17¹/₁₆ x 11⁷/₈ in. (433 x 300 mm) sheet
Inscribed lower right: "Edition de 25 épreuves Imprimée
par l'artiste et M. Leroy/Mary Cassatt"
Worcester Art Museum, Bequest of Mrs. Kingsmill Marrs,
1926
[exhibited in Boston]

cat. 5-XVII (LC) Seventeenth state
Drypoint and aquatint on two plates
Off-white, medium-weight, moderately textured, laid paper
16½ x 12⅛ in. (418 x 308 mm) sheet
Inscribed lower right: "Imprimée par l'artiste
et M. Leroy/Mary Cassatt/(25 épreuves)"
Coll.: Roger Marx; Hartshorne
Library of Congress, Washington, D.C., Pennell Fund,
1946

cat. 5-XVII (PC) Seventeenth state
Drypoint and aquatint on two plates
Cream, medium-weight, moderately textured, laid paper
16⁷/₈ x 11¼ in. (429 x 299 mm) sheet
Inscribed lower right: "Edition de 25 épreuves
Imprimée par l'artiste et M. Leroy/Mary Cassatt"
Coll.: Havemeyer
Private Collection, Boston

6
The Lamp, *1890–1891*

(also called *L'Abat-Jour*)
Breeskin 144
Drypoint, softground etching, and aquatint
12¾ x 9¹⁵/₁₆ in. (323 x 252 mm) platemark

Although listed second in Cassatt's exhibition cata-
logue of 1891, *The Lamp* was probably not the second
to be executed. The relative simplicity of the state
changes, compared to *The Bath*, shows that she was no
longer groping for technical mastery but was able to
achieve the effects she wanted with comparative ease.
Also unlike *The Bath*, the composition is independent
of related drawings, paintings, or drypoints. Although
the subject is familiar in Cassatt's work, this interpreta-
tion of a woman "at home" is unique and may reflect
the common Japanese device of showing a woman's
neck from behind, highlighting this oriental symbol
of beauty.

The only related drawing is that used for the print
(fig. 6-1) and the drypoint derived from it by transfer
(cat. 6-i) shows a correspondence in part to the recto of
the drawing. Like other drawings for the set of ten, this
sheet was folded over the plate and there is a definite
reworking of many of the lines, but only some were ac-
tually offset onto the copper plate. The next known
state leaps to the use of three plates (cat. 6-ii). Aquatint
has been placed on all three plates, and Cassatt has
used her method of "painting" each one to arrive at the
large number of actual colors. She has taken extraordi-
nary care to prevent the contiguous colors on the same
plate from bleeding into one another, as, for example,
the wall, dress, and fan.

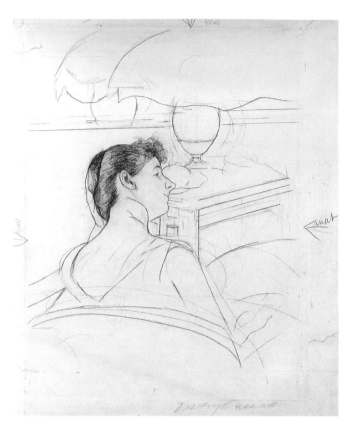

fig. 6-1. *Drawing for* The Lamp,
1890–1891
Recto: graphite and black chalk;
verso: black offset lines
Off-white, smooth, wove paper
15⅛ x 12 in. (384 x 305 mm) irregular
sheet
Yale University Art Gallery, New Haven,
Connecticut, Bequest of Edith Malina K.
Wetmore

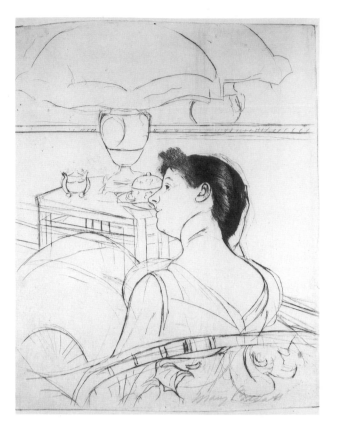

cat. 6-I First state

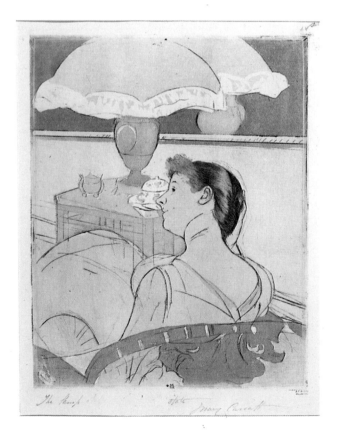

cat. 6-II Second state

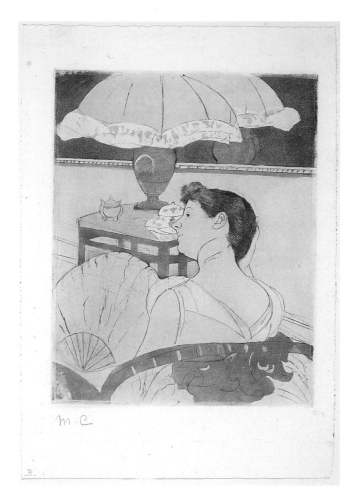

cat. 6-III Third state

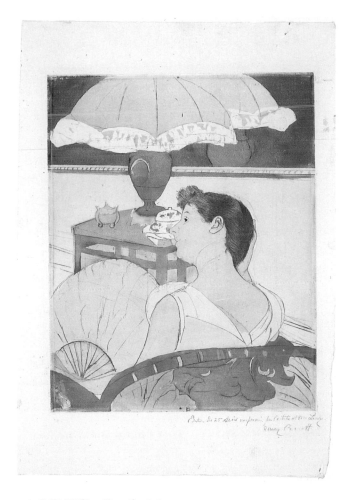

cat. 6-IV (AIC)a Fourth state

Description of the states

I First state, on one plate

Plate I: The composition is drawn in drypoint and printed in black with rich burr showing, especially on the woman's hair. There are remnants of pale soft-ground lines that correspond to lines on the related drawing. However, the lines offset onto the verso of the drawing are of a dry, black substance atypical of the brown, greasy material traditionally used for soft-ground. This substance is also found on the verso of other drawings for the set of ten prints (see, for example, cats. 7 and 8) and must therefore be a variant type of the conventional softground coating. The registration holes are pierced (now covered with tape), suggesting that this sheet was used for transferring the design to another plate.

One impression is known: NGA (Hartshorne)

II Second state, on three plates

Plate I: The drypoint is the same as in the first state, with the addition of aquatint for the floral design of the chair, printed in brown along with the woman's hair and other drypoint lines.

Plate II: Aquatint is applied for tonal areas, including the flesh tones, the pink pattern of the chair, the table, and the objects on top: the lamp, lampshade (which is partially "stopped-out" to create a decorative border), and the "silver" mirror with its reflection of the lamp.

Plate III: Aquatint is applied for the dress, the fan (including the area behind the spokes of the handle), and the wall, which becomes part of the floor below the diagonal baseboard at left.

Two impressions are known: CMA (initialed only); NYPL (Avery)

III Third state, on three plates

Plate I: Similar to the first state, but drypoint lines are added to the back of the chair at the lower right corner, to the spokes of the fan, and to its body to suggest vertical folds. A horizontal drypoint line enhances the mirror frame.

Plate II: Unchanged from the second state
Plate III: Unchanged from the second state
One impression is known: NGA

IV Fourth state, on three plates (editioned state)

Plate I: Unchanged from the third state
Plate II: The aquatint for the flesh tone along the back neckline is burnished in part so that it no longer overlaps the color aquatint of the dress.
Plate III: Remains unchanged from the second state

The known impressions are: AIC (2); BN; Brooklyn (inscribed *à M. Leroy*); Fitchburg; LC; McNay; MFA; MMA; NGA; NYPL; private collection, Maine (no impression or stamp); St. John's (printed without plate III): Terra; Worcester

Summary of the design on each plate

Plate I: All drypoint lines with the addition of aquatint for the chair arm and its wooden rim as well as its decorative floral pattern.

Plate II: Aquatint for the flesh areas, the pink floral pattern of the chair, the table, the tea set, the lamp and shade, the mirror and its reflection, printed in different shades of gray, blue, and green.

Plate III: Aquatint for the dress in varying shades of light gold and green, for the fan, wall, baseboard, and the extension that reads as the floor.

cat. 6-I First state
Drypoint with softground etching on one plate
Off-white, medium-weight, smooth, wove paper
12½ x 10 in. (318 x 254 mm) sheet
Signed lower right in image: "Mary Cassatt"
Coll.: Hartshorne
National Gallery of Art, Washington, D.C.,
Rosenwald Collection, 1946.21.85

cat. 6-II Second state
Drypoint and aquatint on three plates
Cream, medium-weight, slightly textured, laid paper
17⅜ x 11⅛ in. (441 x 283 mm) sheet
Inscribed lower margin:
"The Lamp, state/Mary Cassatt"
Watermark: crown with fleur-de-lys
Coll.: Avery
The Miriam and Ira D. Wallach Division of Art, Prints and Photographs, The New York Public Library

cat. 6-III Third state
Drypoint and aquatint on three plates
Off-white, moderately thick, moderately textured, laid paper
17¼ x 11⅞ in. (438 x 302 mm) sheet
Initialed lower left: "M.C."
National Gallery of Art, Washington, D.C.,
Rosenwald Collection, 1943.3.2762

cat. 6-IV (AIC)a Fourth state
Drypoint and aquatint on three plates
Off-white, medium-weight, moderately textured, laid paper
17 x 11⅞ in. (432 x 302 mm) sheet
Inscribed lower right: "Edition de 25 serie Imprimée par
l'artiste et M. Leroy/Mary Cassatt"
Coll.: Potter Palmer
The Art Institute of Chicago, Bequest of Mrs. Gordon
Palmer, 1985

cat. 6-IV (AIC)b Fourth state
[not illustrated]
Drypoint and aquatint on three plates
Off-white, medium-weight, moderately textured, laid paper
17⅛ x 12 in. (435 x 305 mm) sheet
Inscribed lower right: "Imprimée par l'artiste et
M. Leroy/Mary Cassatt/(25 épreuves)"
The Art Institute of Chicago, The Mr. and Mrs. Martin A.
Ryerson Collection, 1932
[exhibited in Williamstown]

cat. 6-IV (MMA) Fourth state
[illustrated on page 46]
Drypoint and aquatint on three plates
Cream, moderately thick, moderately textured, laid paper
17⅛ x 12 in. (435 x 305 mm) sheet
Inscribed lower right: "Edition de 25 serie Imprimée par
l'artiste et M. Leroy/Mary Cassatt"
The Metropolitan Museum of Art, New York, Gift of
Paul J. Sachs, 1916
[exhibited in Washington]

cat. 6-IV (Worcester) Fourth state
[illustrated on page 2]
Drypoint and aquatint on three plates
Cream, moderately thick, moderately textured, laid paper
17¼ x 11¾ in. (438 x 300 mm) sheet
Inscribed lower right: "Edition de 25 épreuves Imprimée
par l'artiste et M. Leroy/Mary Cassatt"
Worcester Art Museum, Bequest of Mrs. Kingsmill Marrs,
1926
[exhibited in Boston]

7
In the Omnibus, *1890–1891*

(also called *En Bateau Mouche, Interior of Tramway
Crossing a Bridge, The Tramway*)
Breeskin 145
Drypoint and aquatint
14⅜ x 10½ in. (384 x 267 mm) platemark

In the Omnibus is unique in showing major composi-
tional changes in the drawing stage. The drawings
used for the color prints do not ordinarily serve as ve-
hicles for creative problem solving but tend to serve
only the purpose of transferring a finished idea to the
plate; further changes then are made on the plate itself.
But in this case, not only does the preliminary drawing
(fig. 7-1) show two alternate figures (a standing wom-
an and a seated man), which were not transferred to
the plate (see verso of fig. 7-1), but Cassatt has drawn
in pencil on an early state (cat. 7-i) to work out a land-
scape design as an addition to a later state.

In the Omnibus is also unusual in subject mat-
ter—this is a theme that does not appear again in her
work—and in its relation to contemporary printmak-
ing outside the Impressionist circle. It has obvious ties
to Daumier's omnibus paintings and lithographs, but it
also seems to have been derived from a contemporary
print shown in the Salon of 1887, *Un coin d'omnibus* by
Delance-Feurgard (fig. 7-2).*

*The authors thank Brent Benjamin for pointing out this parallel.

Description of the states

I First state, on one plate

Plate I: The image is sketched in drypoint out-
lines except that the hair of the two women is shaded;
printing is uneven.
One impression is known: NYPL

II Second state, on one plate

Plate I: Further development in drypoint: hand
and dress of child, extra lines in window frames, and
top lines of car are redrawn diagonally.
One impression with a landscape view penciled in
is at the NGA (Roger Marx). In that impression there

fig. 7-1. *Drawing for* In the Omnibus, 1890–1891
Recto: pencil and black chalk
Verso: gray-black lines, possibly offset
from a smoked plate
Dark cream, thin, smooth, wove paper
17⅞ x 10¾ in. (454 x 273 mm) irregular
sheet
Signed lower right: "Mary Cassatt"
Coll.: Whittemore,
National Gallery of Art, Washington,
D.C., Rosenwald Collection, 1948.11.51a, b

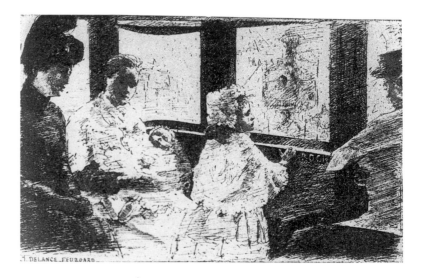

fig. 7-2. Mme J. Delance-Feurgard
**Un Coin d'omnibus (A Corner of the
Omnibus)**
Salon de 1887, Catalogue illustré
(Paris: Librairie d'Art, Ludovic Baschet,
éditeur, 1887), p. 341

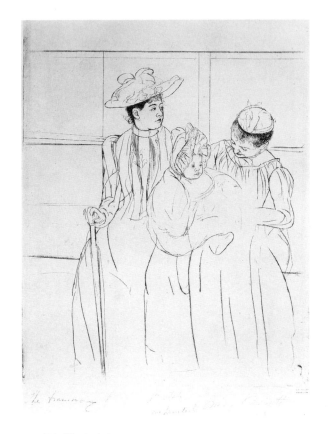

cat. 7-I First state

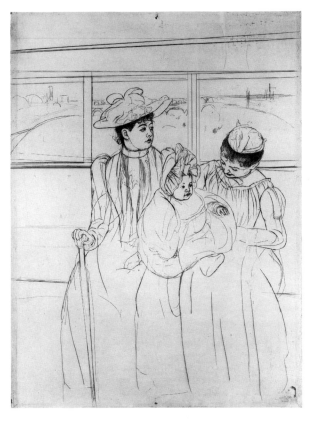

cat. 7-II Second state

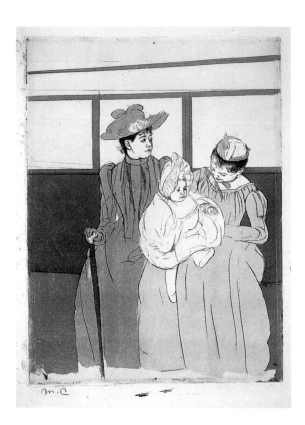

cat. 7-III Third state

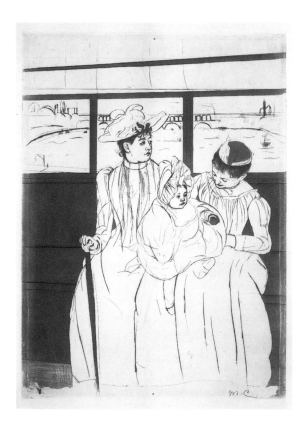

cat. 7-IV Fourth state

are pierced holes and two platemarks, suggesting that this sheet may have been used to transfer lines to another plate; a second impression without the drawing and without pierced holes or two platemarks is at the BAA.

III Third state, on two plates

Plate I: Aquatint is added for the bench, its platform, and the frame of the omnibus interior, all printed in blue and gray-brown. Some key drypoint lines and some aquatint on the flower decoration of the woman's hat at left are reinforced.

Plate II: Aquatint is added for women's dresses printed in brown and pink, as well as for the hat of woman at left and trim on the hat of woman at right.

Three impressions are known: NGA (Vollard); NYPL (incorrectly annotated by Cassatt as "2nd state"); and Oregon

IV Fourth state, on one plate

Plate I: Additional drypoint strokes define baby's shoe, cuff on seated woman's dress, edge of skirts, and horizontal lines that demarcate interior seats; touches of aquatint added to hat of woman at right, to child's ball, and to wedge by arm of figure at left. Aquatint at the lower left of image is scraped to indicate floor. Scenic view in background is drawn in drypoint and a few pale lines describe ceiling. There are pierced holes and two platemarks, suggesting that this sheet was also used for transfer.

Plate II: Not printed

One impression is known: NGA (Vollard)

V Fifth state, on three plates (not illustrated)

Plate I: Similar to the fourth state, but a horizontal band in pale gray aquatint is added unevenly to the floor.

Plate II: Remains unchanged from the third state

Plate III: Soft gray aquatint now shades ceiling of bus, and the background scene, including the barge, is lightly colored in green, gray, and brown in part. A very pale yellow and/or pale blue aquatint tone colors the sky and water.

Two impressions, private collection and NGA (Vollard 1943.3.2764), appear unfinished before additions of some aquatint areas in the panoramic view; the barge at left that is noticeable in the private collection impression is not fully inked in the NGA impression.

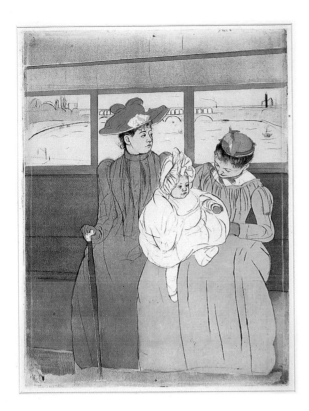

cat. 7-VI Sixth state

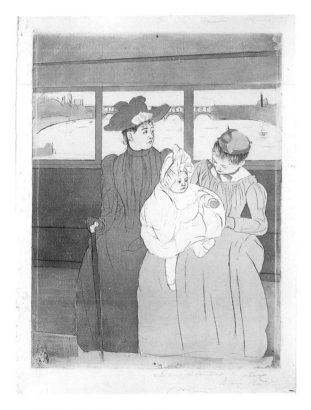

cat. 7-VII (BPL) Seventh state

VI Sixth state, on three plates

Plate I: The gray floor is reaquatinted to refine the line of skirts, and the shadow of the previous line can be detected.

Plate II: Unchanged from third state

Plate III: Unchanged from fifth state

One impression records this small change: MFA (with the barge at left remaining uninked)

VII Seventh state, on three plates (editioned state)

Plate I: Unchanged from sixth state

Plate II: Unchanged from third state

Plate III: Gray ceiling of omnibus, bridge, and shoreline are reaquatinted to darken tone (a patch of aquatint at upper right corner is irregularly etched and appears in all final impressions). The green and gray shoreline at right and the green and brown areas at left that merge are inked *à la poupée*. The barge at left is inked in all impressions.

The known impressions are: AIC; Amon Carter; BAA (signed but not inscribed); BN (2, one inscribed *à M. Leroy*); BPL (Roger Marx and Hartshorne); Brooklyn; Bryn Mawr; Carnegie; LC (signed but not inscribed); McNay; MMA; NGA (2); NGC (2); NYPL; Payson; Petteys; private collection, Boston; private collection, Maine (with MC stamp only); private collection, New York; St. John's (not inscribed); Santa Barbara; Terra; Worcester

Summary of the design on each plate

Plate I: Black drypoint lines of figures (red lips and baby's blond hair inked *à la poupée*) and landscape outlines; aquatint for the medium blue of interior; gray-brown of interior frame and lower platform of seat; gray umbrella; yellow-green on both women's hats; child's ball; and gray aquatint on floor of omnibus.

Plate II: Aquatint for the woman's pink dress; woman's brown dress and hat; red bow at neck and red hatband plus green and pink of hat; child's ball possibly reaquatinted.

Plate III: Aquatint for the flesh tones; gray color added to the ceiling of omnibus; green trees in background landscape; yellow to brown on shoreline and gray on barge and bridge; pale yellow or blue tone in water and sky.

cat. 7-I First state
Drypoint on one plate
Off-white, medium-weight, moderately textured, laid paper
17½ x 10⅞ in. (445 x 276 mm) sheet
Watermark: VanderLey
Inscribed lower margin: "The tramway 1st state/one printed/Mary Cassatt"
Coll.: Avery
The Miriam and Ira D. Wallach Division of Art, Prints and Photographs, The New York Public Library

cat. 7-II Second state
Drypoint with pencil additions on one plate
Off-white, medium-weight, smooth, wove paper
15 x 11½ in. (381 x 292 mm) sheet
Coll.: Roger Marx; Hartshorne
National Gallery of Art, Washington, D.C., Rosenwald Collection, 1946.21.93

cat. 7-III Third state
Drypoint and aquatint on two plates
Off-white, moderately thick, moderately textured, laid paper
17 x 11⅞ in. (432 x 302 mm) sheet
Initialed lower left in pencil: "M. C."
Coll.: Vollard
National Gallery of Art, Washington, D.C., Rosenwald Collection, 1943.3.2753

cat. 7-IV Fourth state
Drypoint and aquatint on one plate
Dark cream, moderately thick, smooth, wove paper
18 x 12⅜ in. (457 x 314 mm) sheet
Initialed lower right within image: "M. C."
Coll.: Vollard
National Gallery of Art, Washington, D.C., Rosenwald Collection, 1943.3.2752

cat. 7-VI Sixth state
Drypoint and aquatint on three plates
Off-white, moderately thick, moderately textured, laid paper
17⅛ x 11⅝ in. (435 x 290 mm) sheet
Watermark: fragment of ARCHES
Initialed lower left: "M. C."
Museum of Fine Arts, Boston, Gift of William Emerson and Charles Henry Hayden Fund, 1941
[exhibited in Boston]

cat. 7-VII (AIC) Seventh state
[not illustrated]
Drypoint and aquatint on three plates
Off-white, medium-weight, moderately textured, laid paper
17⅛ x 11⅞ in. (430 x 300 mm) sheet
Inscribed lower right: "Imprimée par l'artiste et M. Leroy/Mary Cassatt/(25 épreuves)"
The Art Institute of Chicago, The Mr. and Mrs. Martin A. Ryerson Collection, 1932
[exhibited in Williamstown]

cat. 7-VII (MMA) Seventh state
[illustrated on page 47]
Drypoint and aquatint on three plates
Cream, moderately thick, moderately textured, laid paper
17 x 11⅞ in. (432 x 302 mm) sheet
Watermark: fragment of ARCHES
Inscribed lower right: "Edition de 25 série Imprimée par l'artiste et M. Leroy/Mary Cassatt"
The Metropolitan Museum of Art, New York, Gift of Paul J. Sachs, 1916
[exhibited in Washington]

cat. 7-VII (BPL) Seventh state
Drypoint and aquatint on three plates
Cream, moderately thick, moderately textured, laid paper
17 x 12⅞ in. (432 x 302 mm) sheet
Inscribed lower right: Imprimée par l'artiste et M. Leroy/Mary Cassatt/(25 épreuves)
Coll.: Roger Marx; Hartshorne
Boston Public Library, Print Department

cat. 7-VII (Worcester) Seventh state
[illustrated on page 3]
Drypoint and aquatint on three plates
Cream, moderately thick, moderately textured, laid paper
17⅛ x 11⅞ in. (435 x 302 mm) sheet
Inscribed lower right: "Edition de 25 épreuves Imprimée par l'artiste et M. Leroy/Mary Cassatt"
Worcester Art Museum, Bequest of Mrs. Kingsmill Marrs, 1926
[exhibited in Boston]

8
The Letter, *1890–1891*

Breeskin 146
Drypoint and aquatint
13⅝ x 8⁵/₁₆ in. (345 x 211 mm) platemark

With the exception of one known related drawing (fig. 8-1), there are no other works leading up to *The Letter*; more important, the known states jump from a single-plate preliminary drypoint to a fairly complete three-plate colored image. The final state, like *The Lamp*, shows two basic colorations for the flowers on the wallpaper: red and blue. The best loved of all the color prints, it may have been the last done, judging from the supreme confidence with which Cassatt created the composition and used the medium.

Description of the states

I First state, on one plate

Plate I: The subject is defined in drypoint with rich burr. The smocking pattern nearly disappears as aquatint is applied to this plate, but as the color work progresses the floral design of the dress will be detected under subsequent layers. Although this first state was printed from one plate, the pierced holes and two platemarks (see upper left corner) suggest that it was used for transferring.

A unique impression is known: MMA (Roger Marx)

II Second state, on three plates

Plate I: Outline plate now includes aquatint for the brown desk and pink bodice.
Plate II: Aquatint etched for flesh tones and beige flowers on dress.
Plate III: The dress and desktop are aquatinted and printed in blue. The bodice, printed in a deep pink, has smocking lines that are altered from the first state. The hair is lightly printed.
These changes are found on one impression: NGA (McVitty)

fig. 8-1. *Drawing for The Letter,*
1890–1891
Recto: black crayon and pencil
Verso: offset lines from ground plate
(possibly smoked and unsmoked ground)
Cream, thin, smooth, wove paper
13¾ x 9¹/₁₆ in. (349 x 230 mm) sheet
Signed lower right: "Mary Cassatt"
The Cleveland Museum of Art, Bequest of
Charles T. Brooks, 1941

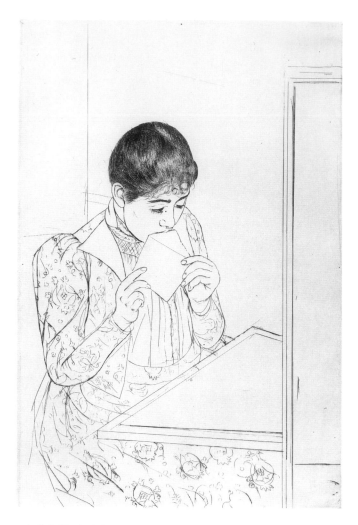

cat. 8-I First state

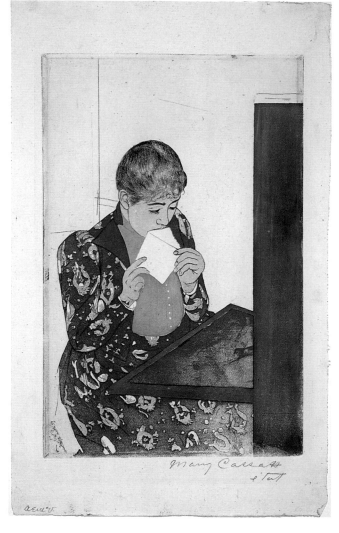

cat. 8-II Second state

122 *The Letter*

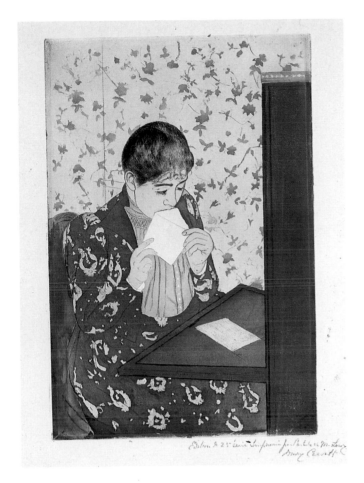

cat. 8-IV (NGC) Fourth state

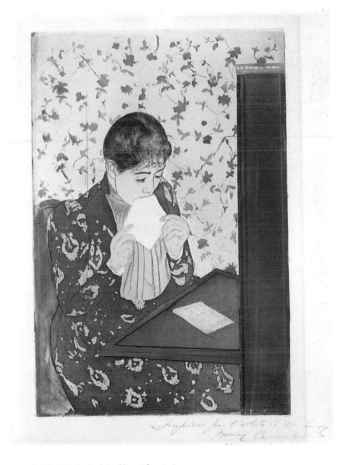

cat. 8-IV (St. John's) Fourth state

III Third state, on three plates (not illustrated)

Plate I: Unchanged from second state

Plate II: Unchanged from second state

Plate III: A few minor amendments are made to the blue aquatint, especially around the flower pattern on the bottom and sides of the model's dress near the desk; these may have been achieved by a localized painting of the aquatint called "spit bite." The hair that is darkly printed in this state is probably the result of manipulating the ink.

On the NYPL impression, Cassatt has written that three impressions were printed; this probably includes the earlier impression (NGA) and one at the BAA in which the overall coloration is much darker. Thus, all three impressions or working proofs reveal slight differences but were probably considered the same state by Cassatt.

IV Fourth state, on three plates (editioned state)

Plate I: Additional lines define the side of the desk and small chair, which is printed in tones ranging from plum to brown.

Plate II: Pale aquatint tone of gray background and "brass" molding at top of desk are added.

Plate III: Another layer of fine aquatint evens the blue dress and desktop and alters minutely the decorative dress pattern; a floral wallpaper design in shades of blue and green or red and green inked *à la poupée* was added. The "white" sheet of stationery is created by scraping away an area of aquatint that held blue ink. The pink bodice, now light in color, is printed *over* two sets of smocking pattern lines—this subtle inking and printing can be detected only under high magnification.

The drop-leaf desk that served as a model for the print is still in the possession of the artist's family, and the writing surface reveals a blue felt that probably inspired Cassatt to attempt this deep coloring.

Impressions known of this final state are: AIC; BAA; BN (2); Bryn Mawr; Corcoran; LC; McNay; MFA (initialed only); MMA; NGA (3, one initialed only); NGC (2, one signed but not inscribed); NYPL; PMA; private collection, Maine; private collection, New Orleans; private collection, New York; St. John's; Worcester

Some impressions of the last state reveal certain variations other than in color: the MFA sheet was printed unevenly, leaving an unsuccessful desktop, as well as a gray tone on the wallpaper. One impression

at the NGA (1963.10.251) and another at Worcester show touches of blue pigment on the dress, probably applied by the artist, where the aquatint did not print fully.

Summary of the design on each plate

Plate I: Drypoint outlines, including one set of smocking lines on bodice; brown desk and brown chair; and pink bodice.

Plate II: Overall gray background tone; beige dress pattern; and flesh tones all in aquatint as well as "brass" molding.

Plate III: Blue dress and blue desk in aquatint; blue drypoint smocking pattern on bodice; and blue or red flowers with green leaves in background.

cat. 8-I First state
Drypoint on one plate
Off-white, medium-weight, smooth, wove paper
13⅝ x 9⅛ in. (346 x 232 mm) sheet
Coll.: Roger Marx
The Metropolitan Museum of Art, New York,
Gift of Arthur Sachs, 1916

cat. 8-II Second state
Drypoint and aquatint on three plates
Off-white, medium-weight, slightly textured, laid paper
13½ x 10¾ in. (343 x 273 mm) sheet
Watermark: Fortuna on globe with block letters
Inscribed lower right: "Mary Cassatt/état"
Coll.: McVitty
National Gallery of Art, Washington, D.C.,
Rosenwald Collection, 1950.1.40

cat. 8-IV (NGC) Fourth state
Drypoint and aquatint on three plates
Off-white, moderately thick, moderately textured,
laid paper
17 x 12 in. (432 x 305 mm) sheet
Inscribed lower right: "Edition de 25 série Imprimée par
l'artiste et M. Leroy/Mary Cassatt"
The National Gallery of Canada, Ottawa, Bequest of Guy
M. Drummond, Montreal, 1987

cat. 8-IV (AIC) Fourth state
[not illustrated]
Drypoint and aquatint on three plates
Off-white, medium-weight, moderately textured, laid paper
15⅝ x 12 in. (396 x 305 mm) sheet
Inscribed lower right: "Imprimée par l'artiste et
M. Leroy/Mary Cassatt/(25 épreuves)"
The Art Institute of Chicago, The Mr. and Mrs. Martin A.
Ryerson Collection, 1932
[exhibited in Williamstown]

cat. 8-IV (MMA) Fourth state
[illustrated on page 47]
Drypoint and aquatint on three plates
Cream, moderately thick, moderately textured, laid paper
17 x 11⅞ in. (432 x 302 mm) sheet
Watermark: fragment of ARCHES
Inscribed lower right: "Edition de 25 série Imprimée par l'artiste et M. Leroy/Mary Cassatt"
The Metropolitan Museum of Art, New York, Gift of Paul J. Sachs, 1916
[exhibited in Washington]

cat. 8-IV (St. John's) Fourth state
Drypoint and aquatint on three plates
Off-white, moderately thick, moderately textured, laid paper
17 x 12 in. (432 x 305 mm) sheet
Inscribed lower right: "Imprimée par l'artiste et M. Leroy/Mary Cassatt/(25 épreuves)"
St. John's Museum of Art, Wilmington, North Carolina

cat. 8-IV (Worcester) Fourth state
[illustrated on page 4]
Drypoint and aquatint on three plates
Cream, moderately thick, moderately textured, laid paper
17¹/₁₆ x 11⅞ in. (432 x 300 mm) sheet
Inscribed lower right: "Édition de 25 épreuves Imprimée par l'artiste et M. Leroy/Mary Cassatt"
Worcester Art Museum, Bequest of Mrs. Kingsmill Marrs, 1926
[exhibited in Boston]

9
The Fitting, *1890–1891*

(also called *Young Woman Trying On a Dress*)
Breeskin 147
Drypoint and aquatint
14¾ x 10⅛ in. (377 x 256 mm) platemark

There is only one work by Cassatt directly related to *The Fitting*: a drawing (fig. 9-2) that, from the orange-brown residue on the back of the paper, suggests that it was used in a softground transfer process. However, there are no corresponding drypoint lines in the first state of the print that match the softground lines of the drawing nor do the measurements of the folds of the drawing sheet match the measurements of the plate-mark. We propose that either the softground was used as a faint guide, allowing Cassatt to develop the design with the drypoint needle directly on the plate, or more likely, it was transferred to another but abandoned plate.

The dress that is being fitted can be seen on the same model in *Woman Holding a Zinnia* (1892, fig. 9-1), perhaps offering pictorial evidence that Cassatt had clothes made for her models so that they would appear in the latest fashions.

The Fitting is an excellent example of Cassatt's different color combinations; the inking and printing of the lines, patterns, and stripes produced unique color-ations, and clearly the artist found each impression acceptable.

Description of the states

I First state, on one plate

Plate I: Drypoint partially indicates two figures. There is no evidence of the softground lines that ap-pear on the verso of the drawing, which had been ex-tensively reworked on the recto.
One impression is known: NGA (Hartshorne)

II Second state, on one plate

Plate I: Head of standing figure is altered—tilted forward and to the left; burnished shadow of drypoint confirms its original position. There is more definition in drypoint of the seated figure, including her hair, and additional decorative work on dress of standing model.

fig. 9-2. *Drawing for* The Fitting,
1890–1891
Recto: graphite over black chalk
Verso: pale softground adhering to traced
lines
Cream, thin, smooth, wove paper
19½ x 11¾ in. (495 x 298 mm) irregular
sheet
Initialed lower right within image: "M. C."
National Gallery of Art, Washington,
D.C., Rosenwald Collection, 1954.12.7

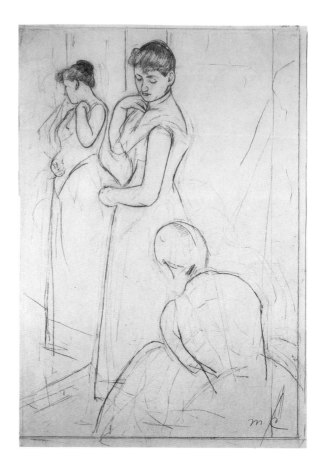

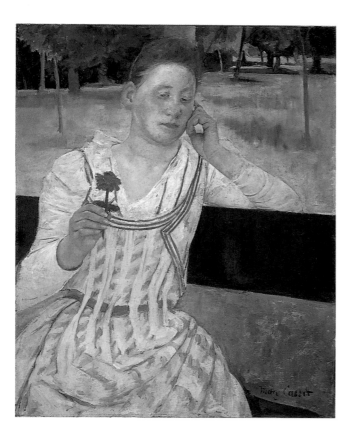

fig. 9-1. Woman Holding a Red Zinnia, 1892
Oil on canvas
28¾ x 23¾ in. (730 x 603 mm)
National Gallery of Art, Washington,
D.C., Chester Dale Collection, 1963

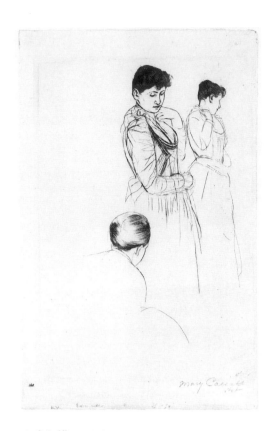

cat. 9-I First state

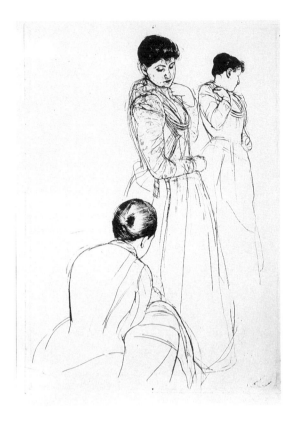

cat. 9-II Second state

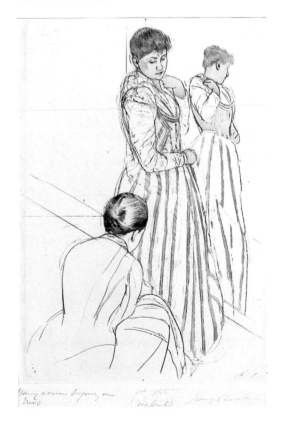

cat. 9-III Third state

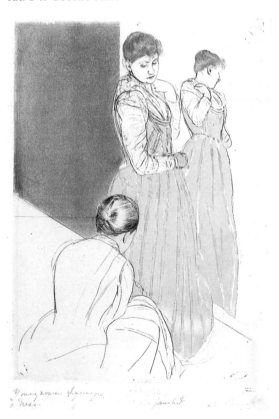

cat. 9-IV Fourth state

Although sheet is pierced at top and bottom, there is no apparent sign that two plates were used; still, this impression may have acted as a guide for transfer of aquatint areas.

One impression is known: MMA (Roger Marx)

III Third state, on two plates

Plate I: First set of gray stripes on dress of standing figure are introduced.

Plate II: Aquatint is added for flesh tones and for pink bodice of standing figure and her reflection. The coloring of her hair and facial features is executed by selective inking—*à la poupée.*

One known impression: (NYPL)

IV Fourth state, on two plates

Plate I: Similar to the third state, but aquatint tone covers background at left and is printed in gray.

Plate II: Aquatint flesh tones, bodice, and new panels of the long skirt of the standing figure are all printed in pink.

The NYPL impression was inscribed by Cassatt as "only proof" but incorrectly annotated by her as "2nd state." The NGA (McVitty 1950.1.42) impression is a variant in which all aquatinted flesh areas of both figures were inked and printed.

V Fifth state, on two plates

Plate I: There is additional drypoint on the dress sleeves of standing figure and the introduction of stripes on seamstress's dress. Drypoint indicates linear carpet pattern and baseboard molding—lines drawn in mirror demarcate wall and floor. Hair of dressmaker is more fully rendered and some drypoint lines are reincised.

Plate II: Remains unchanged from fourth state

An unusual impression (AIC), printed in dark green-brown, may have been a printer's proof.

VI Sixth state, on three plates

Plate I: Aquatint wall area, printed in gray in the fourth and fifth states, is probably scraped down and a new decorative background pattern is created by "stopping out" the floral design with varnish. New horizontal lines at left and right indicate a baseboard molding printed in ocher. The decorative wall pattern adjoins a new baseboard at left and extends ocher color onto

baseboard at right. Dress stripes on standing figure with their edges refined are reaquatinted over the old stripes and printed in tones of soft gray. Drypoint lines on the seamstress's dress become stripes and both dress and stripes are aquatinted—selective wiping and inking colored the dress in different shades of brown.

Plate II: An aquatinted floral pattern on rug (with its reflection in mirror) is introduced. Sleeves on dress of standing figure are delicately aquatinted and "stopped-out" to create a fine decorative pattern—printed in a pale pink, it can often be detected only in a raking light.

Plate III: A light aquatint tone printed in ocher covers the entire plate.

Two impressions (Brooklyn—inscribed but not signed, and NGC—inscribed and signed) show the rug pattern printed in ocher; two impressions (CMA—signed, and BN—MC stamp only) have a red and green rug pattern, and the hair of the standing figure and her reflection are colored burnt orange.

VII Seventh state, on three plates (editioned state)

Plate I: Unchanged from sixth state

Plate II: Unchanged from sixth state, but floor pattern is now always printed in various hues of red and green.

Plate III: Floor color is reaquatinted to intensify rug area. It is printed in gray and frequently wiped in a different manner as noted in the mirror image at right, where the pale background color meets the gray floor. There is some slight burnishing near the ocher, but now gray, baseboard at right.

Impressions located are: AIC (2, one initialed only); BN; Carnegie; CAM (MC stamp only); LC; McNay; MFA (initialed only); MMA; NGA; NGC; private collection, New Orleans; NYPL; private collection at PMA; private collection, Philadelphia; private collection, New York; private collection (initialed only); St. John's; Shelburne; Smith; Sotheby's 1980, lot 73 (initialed only); Sotheby's 1981 (inscribed *à M. Leroy*); Worcester.

Summary of the design on each plate

Plate I: All drypoint line work, including fine lines of floor pattern and decorative work on sleeves of standing figure; gray stripes reaquatinted (in sixth state) over old stripes; brown dress of seamstress and its stripes; decorative dark ocher background pattern plus baseboards.

Plate II: Aquatint flesh tones; pink aquatinted bodice, skirt, and eventually sleeves on standing figure and her reflection; aquatint carpet pattern printed in yellow, then in red and green.

Plate III: Overall pale tone (usually yellow) on mirror and wall under decorative pattern; gray floor color.

The majority of the work was executed on plate I, but the printing order was plate II, plate III, then plate I.

cat. 9-I First state
Drypoint on one plate
Off-white, medium-weight, slightly textured, laid paper
17⅛ x 10½ in. (435 x 267 mm) sheet
Watermark: shield with HP in block letters
Inscribed lower right: "Mary Cassatt/état"
Coll.: Hartshorne
National Gallery of Art, Washington, D.C.,
Rosenwald Collection, 1946.21.79

cat. 9-II Second state
Drypoint on two plates
Off-white, medium-weight, smooth, wove paper
16¼ x 12½ in. (413 x 318 mm) sheet
Coll.: Roger Marx
The Metropolitan Museum of Art, New York, Gift of
Arthur Sachs, 1916

cat. 9-III Third state
Drypoint and aquatint on two plates
Off-white, medium-weight, moderately textured, laid paper
17⅜ x 10⅞ in. (435 x 276 mm) sheet
Watermark: VanderLey
Inscribed lower margin: "Young woman trying on/a dress
1st state/(one printed) [over erasure of] (only proof)/Mary
Cassatt"
Coll.: Avery
The Miriam and Ira D. Wallach Division of Art, Prints
and Photographs, The New York Public Library

cat. 9-IV Fourth state
Drypoint and aquatint on three plates
Off-white, moderately thick, moderately
textured, laid paper
17¼ x 12 in. (437 x 305 mm) sheet
Inscribed lower margin: "Young woman trying on/a dress
2nd state/(one printed) [over erasure of] (only proof)/Mary
Cassatt"
Coll.: Avery
The Miriam and Ira D. Wallach Division of Art, Prints
and Photographs, The New York Public Library

cat. 9-V Fifth state
Drypoint and aquatint on two plates
White, medium-weight, smooth, wove paper
18 x 12⅛ in. (457 x 308 mm) sheet
The Art Institute of Chicago, John H. Wrenn
Memorial Collection, 1942

cat. 9-VI (CMA) Sixth state
Drypoint and aquatint on three plates
Off-white, medium-weight, moderately textured, laid paper
16¾ x 12⅜ in. (425 x 314 mm) sheet
Signed lower right: "Mary Cassatt"
The Cleveland Museum of Art, Bequest of Charles T.
Brooks, 1941
[exhibited in Washington and Boston]

cat. 9-VI (NGC) Sixth state
Drypoint and aquatint on three plates
Off-white, moderately thick, moderately textured,
laid paper
17⅛ x 12 in. (440 x 305 mm) sheet
Inscribed lower right: "Serie de 25 épreuves Imprimée par
l'artiste et M. Leroy/Mary Cassatt"
The National Gallery of Canada, Ottawa, Bequest of Guy
M. Drummond, Montreal, 1987
[exhibited in Williamstown]

cat. 9-VII (AIC) Seventh state
[not illustrated]
Drypoint and aquatint on three plates
Off-white, medium-weight, moderately textured, laid paper
17¼ x 11¾ in. (437 x 298 mm) sheet
Inscribed lower right: "Imprimée par l'artiste et
M. Leroy/Mary Cassatt/(25 épreuves)"
The Art Institute of Chicago, The Mr. and Mrs. Martin A.
Ryerson Collection, 1932
[exhibited in Williamstown]

cat. 9-VII (MFA) Seventh state
Drypoint and aquatint on three plates
Cream, moderately thick, moderately textured, laid paper
18⅞ x 12⅛ in. (481 x 309 mm) sheet
Initialed lower left: "M. C."
Museum of Fine Arts, Boston, Gift of William Emerson
and Charles Henry Hayden Fund, 1941

cat. 9-VII (MMA) Seventh state
[illustrated on page 46]
Drypoint and aquatint on three plates
Cream, moderately thick, moderately textured, laid paper
17 x 12 in. (432 x 305 mm) sheet
Watermark: fragment of ARCHES
Inscribed lower right: "Edition de 25 serie Imprimée par
l'artiste et M. Leroy/Mary Cassatt"
The Metropolitan Museum of Art, New York, Gift of Paul
J. Sachs, 1916
[exhibited in Washington]

cat. 9-VII (Worcester) Seventh state
[illustrated on page 5]
Drypoint and aquatint on three plates
Cream, moderately thick, moderately textured, laid paper
16½ x 12⅛ in. (421 x 306 mm) sheet
Watermark: MBM
Inscribed lower right: "Edition de 25 épreuves Imprimée
par l'artiste et M. Leroy/Mary Cassatt"
Worcester Art Museum, Bequest of Mrs. Kingsmill Marrs,
1926
[exhibited in Boston]

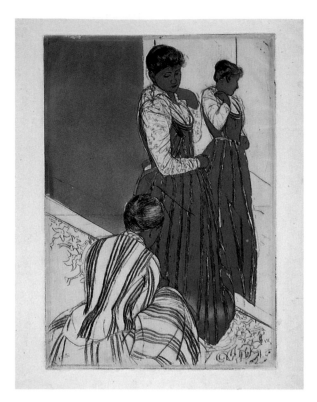

cat. 9-V Fifth state

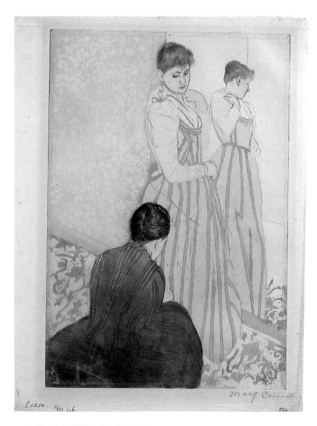

cat. 9-VI (CMA) Sixth state

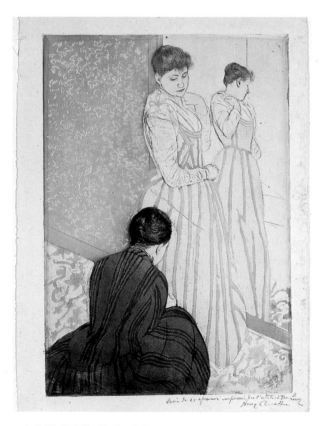

cat. 9-VI (NGC) Sixth state

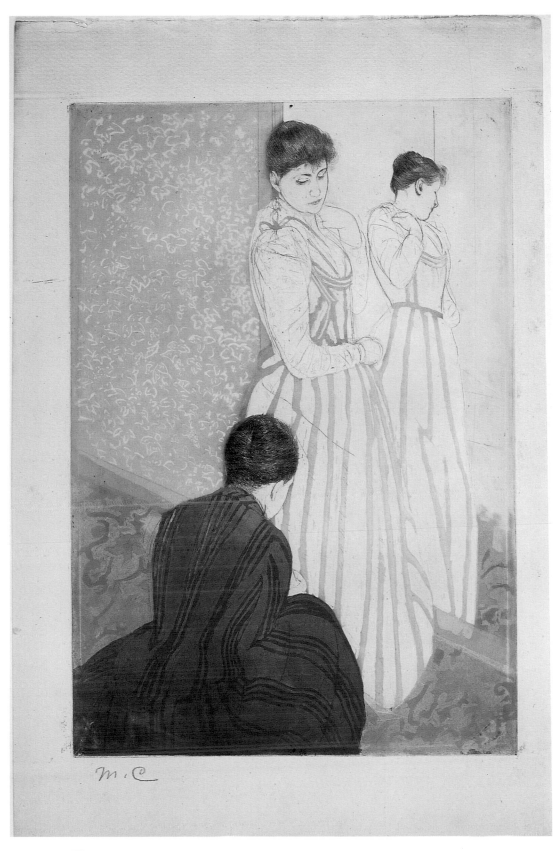

cat. 9-VII (MFA) Seventh state

10
Woman Bathing, *1890–1891*

(also called *The Toilette, Femme debout à sa toilette*)
Breeskin 148
Drypoint and aquatint
14½ x 10⅜ in. (368 x 263 mm) platemark

Cassatt's interest in the theme of the toilette comes in the later 1880s, possibly in response to Degas's series of "bathers" in pastel and monotype. Degas's *The Washbasin* (fig. 10-2), for instance, is a possible source for the composition of *Woman Bathing*. An oil sketch, *Sketch of a Young Woman at Her Toilette* (fig. 10-1), may have served to work out the preliminary design, but, curiously, no drawings have survived.

The known states are few, showing Cassatt arriving at the final composition with a minimum of changes to the plates. Although the basic palette of the final state is constant, Cassatt remixes the blue of the rug and wall to achieve a different effect for each proof, and she varies the color on the rug's floral pattern by inking it *à la poupée*.

Description of the states

I First state, on one plate

Plate I: Drypoint outlines only, drawn over softground lines as described by Breeskin, 1948 and 1979.

McVitty sale, 1949, present whereabouts unknown

II Second state, on one plate

Plate I: The design is sketched in drypoint with aquatint on washstand, mirror frame, and baseboard. There is no evidence of softground lines. Printed in black.

One impression is known: NGA (Hartshorne)

III Third state, on three plates

Plate I: Drypoint lines added to complete the stripes on the back of the skirt and to indicate a floral rug design. Many horizontal lines on front of cabinet are suppressed by selective inking and wiping; aquatint added to flower pattern on pitcher and rug. Drypoint is printed in black except for the woman's hair and body

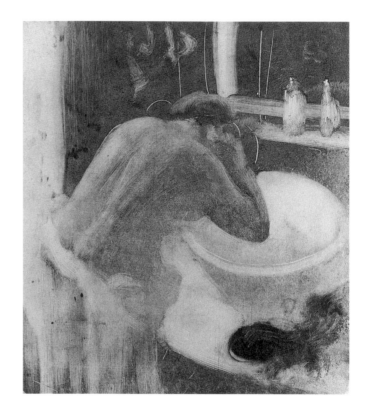

fig. 10-1. Edgar Degas (1834–1917)
The Washbasin, 1879–1883
Monotype on paper
12¼ x 10¾ in. (311 x 273 mm) platemark
Sterling and Francine Clark Art Institute,
Williamstown, Massachusetts

opposite left:
fig. 10-2. *Sketch for* A Young Woman at Her Toilet
Oil on canvas
(whereabouts unknown)

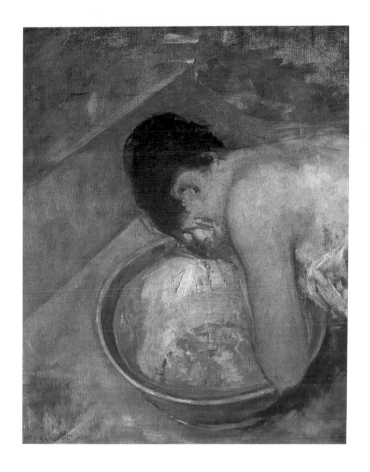

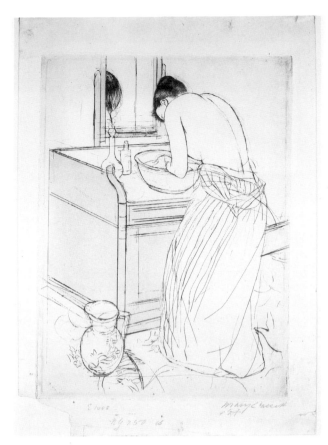

cat. 10-II Second state

and inked *à la poupée* in green and light brown for the floral patterns.

Plate II: Aquatint added for areas of flesh, basin, pale yellow tone of pitcher as well as for the pink stripes of the woman's skirt.

Plate III: There is aquatint for the rug, wall, top of cabinet, mirror, bottles, water in basin, and the green stripes of the woman's skirt.

One impression is known: NGA (Note: Breeskin records a colored state preliminary to this, but it cannot be confirmed and may be an altered description of this impression)

IV Fourth state, on three plates (editioned state)

Plate I: Similar to third state with some extra drypoint lines in folds of skirt reinforced and some new horizontal lines added in lower part of front and side of cabinet (possibly replacing lines visible in first state).

Plate II: Unchanged from third state

Plate III: Similar to third state with one of the diagonal green stripes near the center back of the skirt

eliminated. Aquatint is bitten in various stages to create different degrees of tone for rug, cabinet top, bottles, and water in the basin, all printed in blue.

Final proofs are known in: Achenbach (initialed only); AIC; BN; Brooklyn; Bryn Mawr; CAM; Johnson; Lauren Rogers; LC; McNay; MFA (initialed only); MMA; NGA (2); NGC (2); NYPL; private collection, Maine (MC stamp only); private collection, Palo Alto; private collection, Ohio; St. John's; Sotheby's 1985, lot 17 (inscribed *à M. Leroy*); Worcester

Summary of the design on each plate

Plate I: Drypoint design with aquatint on cabinet, mirror frame, baseboard, floral pattern of pitcher and rug.

Plate II: Aquatint for flesh, basin, background tone of pitcher, and pink stripes of skirt.

Plate III: Aquatint printed in blue for rug, wall, reflection of background in mirror, cabinet top, bottles, and water in basin, and printed in green for stripes of skirt.

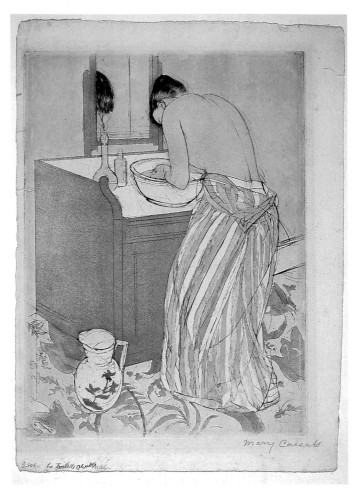

cat. 10-III Third state

cat. 10-IV (Achenbach) Fourth state
Drypoint and aquatint on three plates
Dark cream, moderately thick, moderately
textured, laid paper
18⅞ x 12¼ in. (479 x 311 mm) irregular sheet
Initialed lower left: "M. C."
The Fine Arts Museums of San Francisco, Achenbach
Foundation for Graphic Arts purchase and William H.
Noble Bequest Fund, 1980
[exhibited in Washington and Boston]

cat. 10-IV (Worcester) Fourth state
[illustrated on page 6]
Drypoint and aquatint on three plates
Cream, moderately thick, moderately textured, laid paper
17¹/₁₆ x 11¾ in. (435 x 299 mm) sheet
Inscribed lower right: "Edition de 25 épreuves Imprimée
par l'artiste et M. Leroy/Mary Cassatt"
Worcester Art Museum, Bequest of Mrs. Kingsmill Marrs,
1926
[exhibited in Boston]

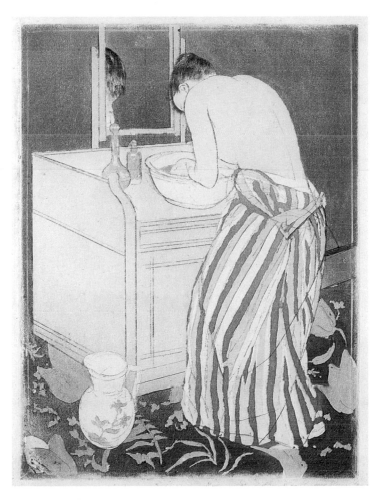

cat. 10-IV (PC) Fourth state

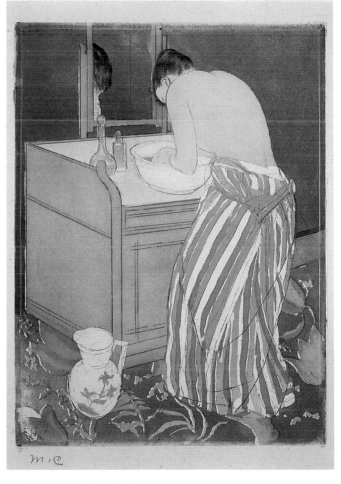

cat. 10-IV (Achenbach) Fourth state

11
Mother's Kiss, *1890–1891*

(also called *After the Bath*, *Mother and Child*, *The Kiss*)
Breeskin 149
Drypoint and aquatint
13¾ x 9 in. (349 x 229 mm) platemark

Mother's Kiss is more like *The Bath* (cat. 5) than any other print from the set of ten and was probably done immediately afterward. Composed from two plates, it also was developed more tentatively. Furthermore, the first drypoint design—which may have been drawn directly onto the plate, since there is no transfer drawing known for it—was burnished down, and Cassatt started again with a slightly different placement of the figures, showing the same willingness to rework radically the plate that is evident in *The Bath*. It is related to a number of drawings (fig. 11-1, and Br. CR 808) as well as to a finished pastel, *Baby's First Caress* (fig. 11-2).

Description of the states

I First state, on one plate

Mother and child sketched in drypoint are close but not identical to the final design. Drypoint is subsequently removed, leaving a faint impression of the original lines: the woman's head and child's lower foot can be seen in proofs of later states.

One impression is known: NGA

II Second state, on one plate

The drypoint composition is essentially redrawn, but less of the design is completed, with only an indication of the mother's dress and remnants of the floral design that is visible in the first state.

One impression, whereabouts unknown, was sold: Sotheby's 1980, lot 733

III Third state, on one plate

Plate I: The drypoint design is extended to indicate the mother's figure and dress and to complete the child's body. The floral pattern on the dress is added in

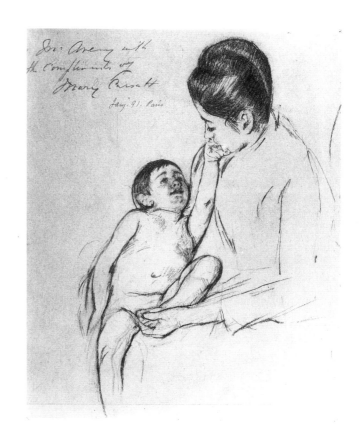

fig. 11-1. The First Caress, 1890–1891
Black chalk
Buff, thin, smooth, wove paper
11 x 9 in. (280 x 229 mm) sheet
Inscribed upper left: "Mr. Avery with/the compliments of/Mary Cassatt/("Jany '91–Paris" in another hand)
Coll.: Avery
The Miriam and Ira D. Wallach Division of Art, Prints and Photographs, The New York Public Library

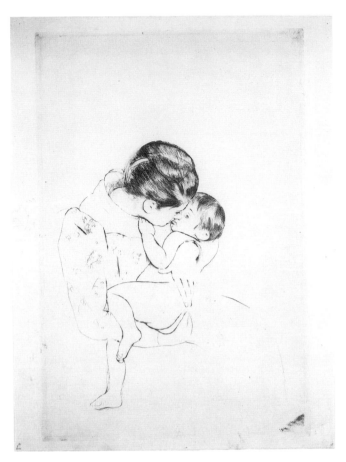

cat. 11-I First state

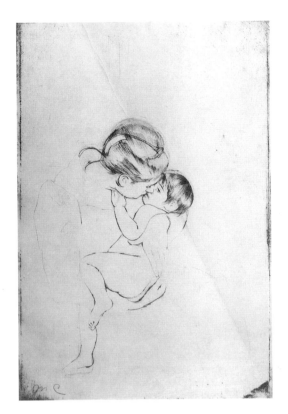

cat. 11-II Second state

drypoint and aquatint, which also creates the flesh tones.

Three impressions are known: BAA; MFA (printed in black only); NYPL (printed in black and flesh color, inscribed "only state" and "only proof" [erased]). In this impression the flesh color is inked *à la poupée* and lightly wiped over the drypoint contours, especially on the child.

IV Fourth state, on two plates

Plate I: The floral design is slightly altered to extend the pattern to the whole dress, and the delicate forms are elaborated. The aquatint flesh tone seen on plate I in the third state is removed. The drypoint lines are reinforced, especially around the mother and the child's hands, and the hair of the child is slightly altered.

Plate II: The aquatint of the flesh areas is redrawn and etched on a second plate.

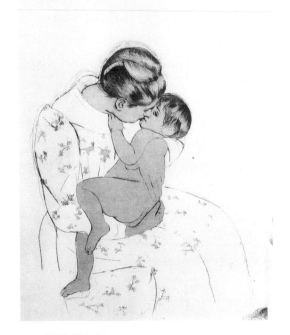

cat. 11-III Third state

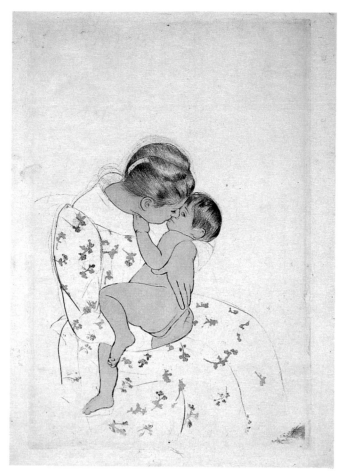

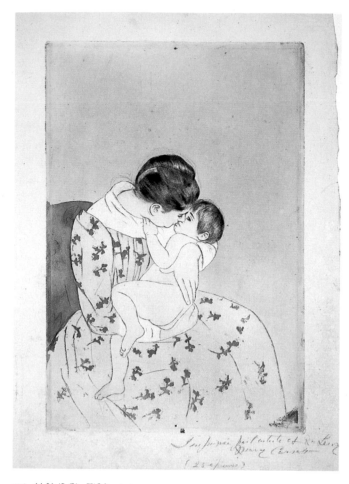

cat. 11-IV Fourth state

cat. 11-V (LC) Fifth state

An impression of this state is found in the NGA, and a variant printing of plate I without plate II is found in the BPL (Hartshorne), which is lightly inked and printed, especially around the hair of the mother and child, and is inscribed "état" by the artist.

V Fifth state, on two plates (editioned state)

Plate I: Drypoint lines are similar to fourth state but with front and back of skirt extended, and hair reinforced and slightly changed, particularly the sideburns of child. Aquatint and drypoint are added to indicate the chair, and aquatint of the flowers on the dress is again altered and made more decorative.

Plate II: Similar to fourth state but with an aquatint tone added to dress and background. Duplicate and faint drypoint lines separate color areas of flesh, dress, and background (easily visible in NYPL impression).

A variant of this state is known in a private collec- tion (Pennsylvania) that shows plate I printed without plate II and with the possible addition of hand-coloring on the child.

Final proofs are found in the following collec- tions: AIC; BAA; BN; BPL (Roger Marx); Bryn Mawr; Carnegie (inscribed *à M. Leroy*); Christie's 1983, lot 188; Clark; LC; McNay; MMA; NGA; NYPL; St. John's; Worcester

Summary of the design on each plate

Plate I: Drypoint lines of mother and child print- ed in black for hair and sanguine for flesh outlines, drypoint and aquatint for floral pattern of dress, and aquatint for back of chair printed in olive green with red for flowers.

Plate II: Aquatint for the flesh tones, and for the tone of the dress and background (both printed in varying shades of blue).

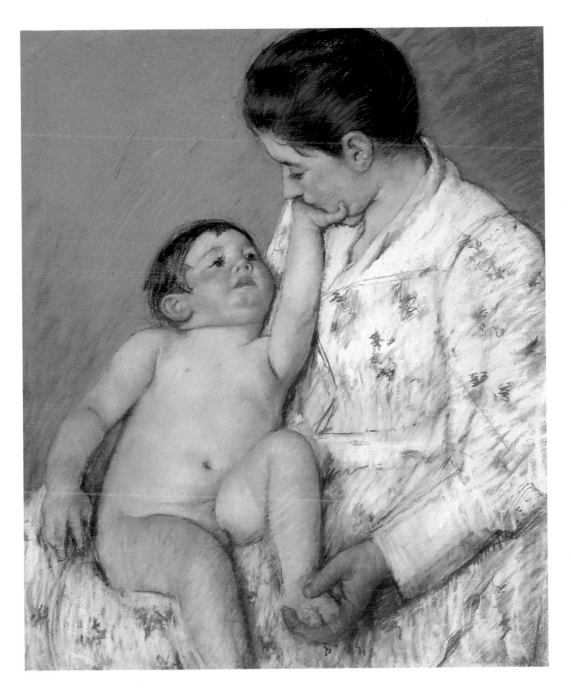

fig 11-2. **Baby's First Caress**, ca. 1890
Pastel on paper
30 x 24 in. (762 x 610 mm)
New Britain Museum of American Art,
Connecticut, Harriet Russell Stanley

cat. 11-I First state
Drypoint on one plate
Cream, medium-weight, oriental-type paper
14⅝ x 10⅞ in. (371 x 275 mm) sheet
Coll.: Vollard
National Gallery of Art, Washington, D.C.,
Rosenwald Collection, 1943.3.2751

cat. 11-II Second state
Drypoint on one plate
Off-white, oriental-type paper
13⅝ x 8⁵⁄₁₆ in. (346 x 227 mm) sheet
Courtesy Sotheby's 1980, lot 733
[not exhibited]

cat. 11-III Third state
Drypoint and aquatint on two plates
Cream, medium-weight, smooth, wove paper
14⅝ x 10⅞ in. (370 x 278 mm) sheet
Museum of Fine Arts, Boston, Gift of William Emerson
and Charles Henry Hayden Fund, 1941
[exhibited in Boston]

cat. 11-IV Fourth state
Drypoint and aquatint on two plates
Off-white, medium-weight, smooth, wove paper
14⅝ x 10¾ in. (371 x 273 mm) sheet
National Gallery of Art, Washington, D.C.,
Rosenwald Collection, 1943.3.2759

cat. 11-V (AIC) Fifth state
[not illustrated]
Drypoint and aquatint on two plates
Off-white, medium-weight, moderately textured, laid paper
17 x 11¾ in. (432 x 298 mm) sheet
Inscribed lower right: "Imprimée par l'artiste et
M. Leroy/Mary Cassatt/(25 épreuves)"
The Art Institute of Chicago, The Mr. and Mrs. Martin A.
Ryerson Collection, 1932
[exhibited in Williamstown]

cat. 11-V (LC) Fifth state
Drypoint and aquatint on two plates
Off-white, medium-weight, moderately textured, laid paper
17⅛ x 11⅞ in. (435 x 302 mm) sheet
Inscribed lower right: "Imprimée par l'artiste et
M. Leroy/Mary Cassatt/(25 épreuves)"
Coll.: Whittemore
Library of Congress, Washington, D.C., Pennell Fund, 1949

cat. 11-V (MMA) Fifth state
[illustrated on page 47]
Drypoint and aquatint on two plates
Cream, medium-weight, moderately textured, laid paper
16⅝ x 12⅜ in. (422 x 314 mm) sheet
Inscribed lower right: "Edition de 25 série Imprimée par
l'artiste et M. Leroy" [no signature]
The Metropolitan Museum of Art, New York, Gift of Paul
J. Sachs, 1916
[exhibited in Washington]

cat. 11-V (Worcester) Fifth state
[illustrated on page 7]
Drypoint and aquatint on two plates
Cream, moderately thick, moderately textured, laid paper
17⅛ x 11⅞ in. (435 x 300 mm) sheet
Watermark: fragment of ARCHES
Inscribed lower right: "Edition de 25 épreuves Imprimée
par l'artiste et M. Leroy/Mary Cassatt"
Worcester Art Museum, Bequest of Mrs. Kingsmill Marrs,
1926
[exhibited in Boston]

12
Maternal Caress, *1890–1891*

(also called *Maternité (Japonisante)*, *Nude Baby*,
Tendresse maternelle)
Breeskin 150
Drypoint, aquatint, and softground etching
14½ x 10⁹⁄₁₆ in. (368 x 268 mm) platemark

The attractive model for the mother in *Maternal Caress*
is also used in *In the Omnibus* and in *The Letter*. Unlike
the other models in this series of prints, such as the
red-haired woman who appears in five of the ten prints
(see *The Fitting*, cat. 9), she was not one of Cassatt's
regular models, and thus she is not familiar to us from
other works. The mother and the child may, however,
appear in the oil sketch called *Mme de Fleury and Her
Child* (fig. 12-1); if so, then they were not professional
models but rather friends of Cassatt's. Mme de Fleury
was the sister-in-law of the sculptor Bartholomé, with
whom Cassatt was especially friendly in the early
1890s.

The appealing drawing (fig. 12-2) with soft-
ground on the verso was directly involved in the trans-
fer process.

Cassatt's own title for this print, *Enfant nue*, em-
phasizes the nudity of the baby, a device that she used
frequently in her mother-and-child compositions in this
period such as the two pastels *Baby's First Caress* (fig.
11-2) and *At the Window* (fig. 18).

Description of the states

I First state, on one plate

Plate I: The subject is drawn in drypoint over
some faint softground lines that vaguely correspond to
the pale softground lines on the verso of the drawing.
In drypoint, Cassatt sketched repeated contour lines,
searching for the proper proportions and placement of
the image.

Only one impression is known: Yale (Roger
Marx)

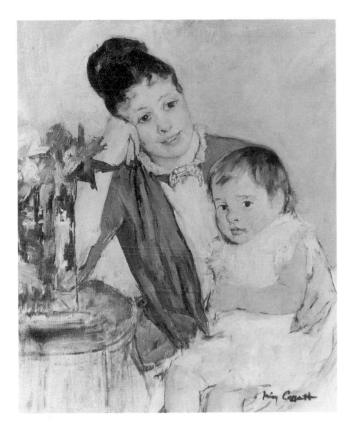

fig. 12-1. *Mme H. de Fleury and Her Child*, ca. 1890–1891
Oil on canvas
28¾ x 23½ in. (730 x 597 mm)
Private Collection, New York

II Second state, on two plates

Plate I: There is further drypoint on the composition with additional skirt lines and a chair partially indicated. Hairlines of mother and child are altered. Some drypoint burr is removed, leaving pale lines.

Plate II: Aquatint is added for flesh tones and printed in color.

One impression is known: NYPL (incorrectly inscribed by Cassatt as "1st state"; she also noted that two impressions were printed)

III Third state, on one plate

Plate I: Further drypoint—with some lines, especially on skirt, reincised—is added to design of dress, upholstered chair pattern, and pattern on floor. Drypoint hairline of mother is again slightly altered. Aqua-

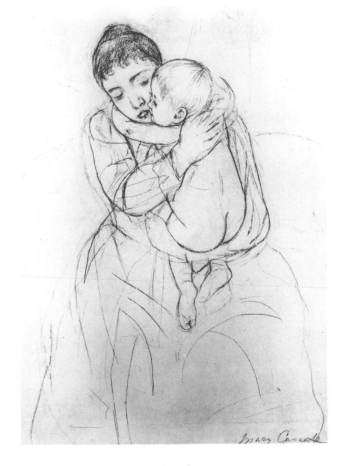

fig. 12-2. *Drawing for* Maternal Caress, 1890–1891
Recto: compressed charcoal and graphite over some charcoal lines
Verso: pale softground lines (sheet lined)
Off-white, medium-weight, smooth, wove paper
14½ x 10⁷⁄₁₆ in. (368 x 266 mm) sheet
Signed lower right: "Mary Cassatt"
The Metropolitan Museum of Art, New York, Gift of Mr. and Mrs. Daniel H. Silberberg, 1964

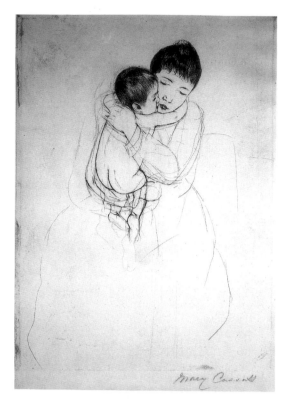

cat. 12-I First state

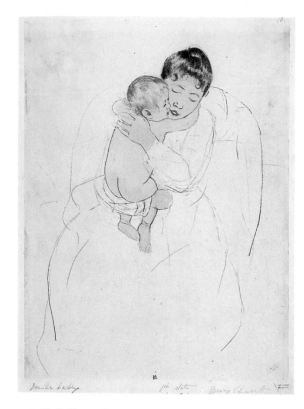

cat. 12-II Second state

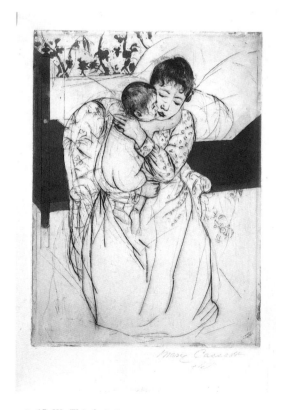

cat. 12-III Third state

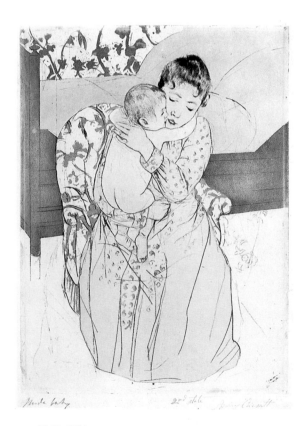

cat. 12-V Fifth state

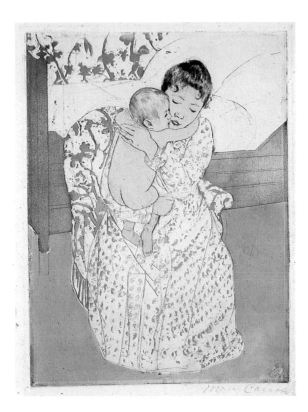

cat. 12-VI (BMA) Sixth state

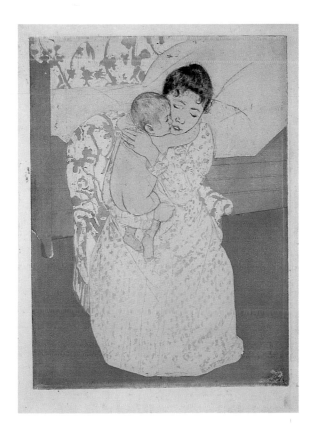

cat. 12-VI (NGA) Sixth state

tint, printed in black, describes the bed frame and a floral wall pattern.

This sheet has pierced holes at top and bottom and, while freshly inked, was apparently laid down onto another plate to give definition or boundaries to the aquatint areas.

Plate II: Not printed

One impression is known: private collection, Boston (Roger Marx)

IV Fourth state, on three plates (not illustrated)

Plate I: No further changes of drypoint, but aquatint is added to the dress pattern, which is expanded over the skirt; it is also added to the chair in order to create a decorative floral design that is now printed in the same color as the wall design.

Plate II: Remains unchanged from the second state

Plate III: Pale aquatint is added to the dress and printed lightly.

One impression, without the bedding aquatinted, is known: St. John's (signed but not inscribed)

V Fifth state, on three plates

Plate I: Remains unchanged from fourth state

Plate II: Aquatint tone colors the background of the chair and walls.

Plate III: A light aquatint tone is added to bedding.

One impression is known: NYPL, with bedding printed in pale gray (incorrectly annotated "2nd state")

VI Sixth state, on three plates (editioned state)

Plate I: No further changes in line work, but additional aquatint is added to the pattern on the dress, printed variously in tones of lavender to gray. Most of the drypoint burr is removed from dress lines.

Plate II: Floor is aquatinted and printed in red-brown.

Plate III: Unchanged from fifth state, with bedding printed in tones that range from pale blue to gray.

Impressions located are: AIC; Amon Carter; BAA; BMA (2, only one signed); BN; Bryn Mawr; Carnegie; LC; McNay; MFA; MMA; NGA (4, only one fully inscribed); NGC; NYPL; private collection, Boston; private collection, Maine (with MC stamp only); St. John's; Worcester

Summary of the design on each plate

Plate I: Black outlines and contours with lips and baby's hair colored *à la poupée*. Dress pattern is aquatinted light gray to lavender, wall and chair patterns in red-brown, and brown bed with its drypoint outlines, also aquatinted.

Plate II: Aquatint added for yellow background of chair and wall, for red-brown floor color, and flesh tone of mother and child.

Plate III: Dress tone and gray to pale blue bedding are all in aquatint.

cat. 12-I First state
Drypoint on one plate
Off-white, medium-weight, smooth, laid paper
17⅜ x 11 in. (441 x 279 mm) sheet
Signed lower right: "Mary Cassatt"
Coll.: Roger Marx
Yale University Art Gallery, New Haven, Connecticut, Gift of Ivy Lee Callender, Walter R. Callender Memorial Collection, 1962

cat. 12-II Second state
Drypoint and aquatint on two plates
Off-white, medium-weight, slightly textured, wove paper
16 x 11½ in. (406 x 292 mm) sheet
Inscribed lower margin: "Nude baby 1st state/2 printed Mary Cassatt"
Coll.: Avery
The Miriam and Ira D. Wallach Division of Art, Prints and Photographs, The New York Public Library

cat. 12-III Third state
Drypoint and aquatint on two plates
White, medium-weight, smooth, wove paper
19 x 12¼ in. (483 x 311 mm) sheet
Inscribed lower right: "Mary Cassatt/état"
Coll.: Roger Marx
Private Collection, Boston

cat. 12-V Fifth state
Drypoint and aquatint on three plates
Off-white, medium-weight, slightly textured, wove paper
15¾ x 11¼ in. (400 x 286 mm) sheet
Inscribed lower margin: "Nude baby 2nd state/(2 printed) Mary Cassatt"
Coll.: Avery
The Miriam and Ira D. Wallach Division of Art, Prints and Photographs, The New York Public Library

cat. 12-VI (AIC) Sixth state
[not illustrated]
Drypoint and aquatint on three plates
Off-white, medium-weight, moderately textured, laid paper
17 x 11⅞ in. (432 x 301 mm) sheet
Watermark: fragment of ARCHES
Inscribed lower right: "Imprimée par l'artiste et M. Leroy/Mary Cassatt/(25 épreuves)"
The Art Institute of Chicago, The Mr. and Mrs. Martin A. Ryerson Collection, 1932
[exhibited in Williamstown]

cat. 12-VI (BMA) Sixth state
Drypoint and aquatint on three plates
Off-white, moderately thick, moderately textured, laid paper
17 x 12 in. (432 x 305 mm) sheet
Signed lower right: "Mary Cassatt"
The Baltimore Museum of Art, Estate of Mrs. Q. A. Shaw McKean, 1953

cat. 12-VI (MMA) Sixth state
[illustrated on page 47]
Drypoint and aquatint on three plates
Cream, moderately thick, moderately textured, laid paper
17 x 12 in. (432 x 305 mm) sheet
Inscribed lower right: "Edition de 25 série Imprimée par l'artiste et M. Leroy/Mary Cassatt"
The Metropolitan Museum of Art, New York, Gift of Paul J. Sachs, 1916
[exhibited in Washington]

cat. 12-VI (NGA) Sixth state
Drypoint and aquatint on three plates
Off-white, medium-weight, slightly textured, laid paper
16⅞ x 12⅜ in. (429 x 314 mm) sheet
National Gallery of Art, Washington, D.C., Rosenwald Collection, 1943.3.2761

cat. 12-VI (Worcester) Sixth state
[illustrated on page 8]
Drypoint and aquatint on three plates
Cream, moderately thick, moderately textured, laid paper
17 x 11¾ in. (432 x 298 mm) sheet
Inscribed lower right: "Edition de 25 épreuves Imprimée par l'artiste et M. Leroy/Mary Cassatt"
Worcester Art Museum, Bequest of Mrs. Kingsmill Marrs, 1926
[exhibited in Boston]

13
Afternoon Tea Party,
1890–1891

(Also called *Afternoon Tea*, *The Cup of Tea*, *The Visit*)
Breeskin 151
Drypoint and aquatint
13¹¹⁄₁₆ x 10⅜ in. (348 x 263 mm) platemark

Although the tea party was one of Cassatt's most fre-
quently used themes in paintings, pastels, and prints,
no other work is directly related to this color print
aside from the transferred drawing (fig. 13-1) in which
the subject is repeatedly sketched and the visitor's
cloak is not indicated. As in *The Fitting* (cat. 9) and
Mother's Kiss (cat. 11), there is a reworking of the heads
and faces (between the fourth and fifth states), showing
that Cassatt tried to capture nuances of mood and
expression.

The many changes in state and in coloration of
this print very likely places it with *The Bath* (cat. 5) and
Mother's Kiss (cat. 11) as one of the early prints that she
did in this series. *Afternoon Tea Party* is printed in two
experimental colorations in the final state—cats. 13-v
(ANG) and 13-v (Brooklyn) and there are several dif-
ferent palettes in the editioned proofs. The tablecloth is
printed in either gray or rose, and the hostess's dress is
either colored pink or left uninked (white). Further-
more, it is the only color print to which Cassatt consis-
tently applied hand touches, painting gold rims on the
cups and saucers.

Description of the states

I First state, on two plates

Plate I: The two women and the room are
sketched in drypoint; aquatint, printed in gray, is added
unevenly for the visitor's cloak.

Plate II: Aquatint is applied for the flesh areas
and printed in color.

One impression is known: NGA (Vollard)

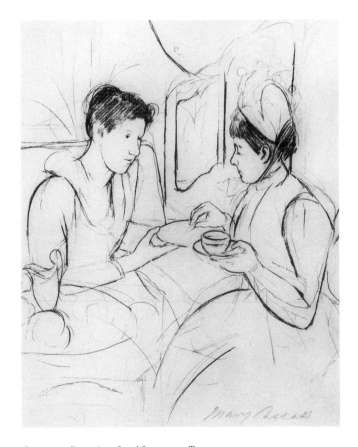

fig. 13-1. *Drawing for* Afternoon Tea
Party, 1890–1891
Graphite and black chalk
13½ x 10½ in. (349 x 267 mm) sheet
Signed lower right: "Mary Cassatt"
Collection Mrs. John W. Griffith

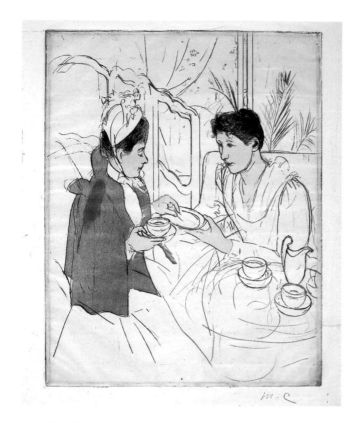

cat. 13-I First state

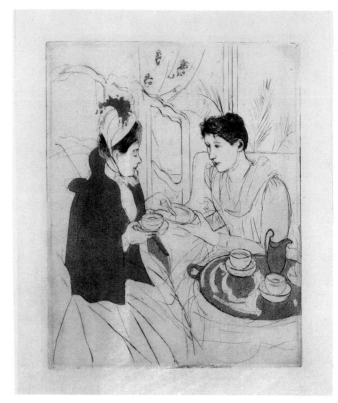

cat. 13-II Second state

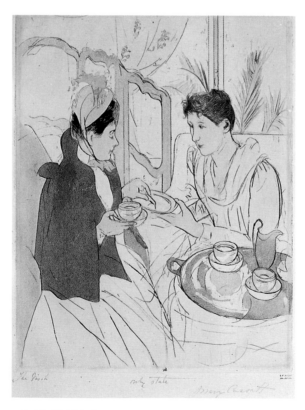

cat. 13-III Third state

146 *Afternoon Tea Party*

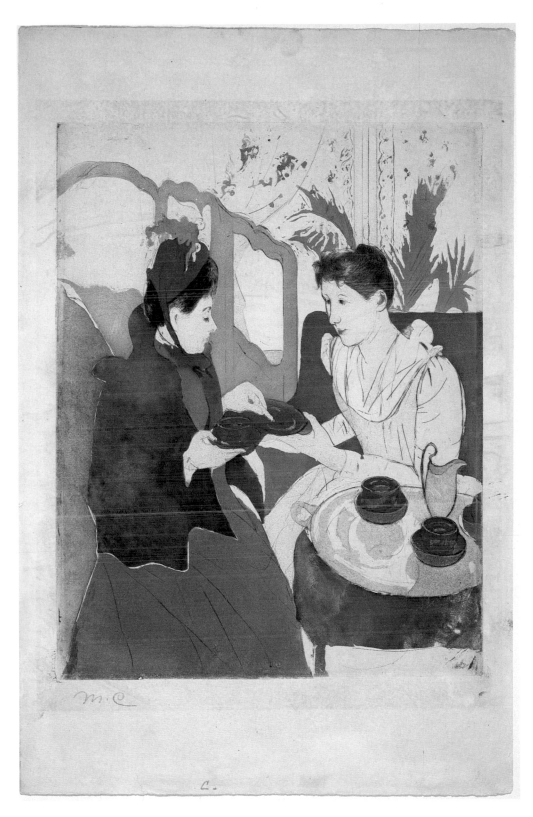

cat. 13-IV Fourth state

II Second state, on one plate

Plate I: Drypoint lines are added to the dresses and to the tray; aquatint is added to the hat, floral pattern on curtain, tray with pitcher, and very lightly on the hostess's blouse. The visitor's cloak is reaquatinted to even the dark patch, to even the edges of the tone, and to extend it on the right side of the jacket down to the edge of the skirt. The plate is printed in black and the registration holes are pierced.

Plate II: Not printed

One impression is known: NGA (Roger Marx and Hartshorne)

III Third state, on three plates

Plate I: Unchanged from second state

Plate II: Aquatint tone is added to the visitor's chair and lightly to the upper wall at left and background of the heavier curtain.

Plate III: New aquatint applied to the hat, cups and saucers, plate, screen, palm fronds, and the central, vertical line of the window. Pale aquatint can be discerned on the hostess's dress.

The only known impression: NYPL (Avery)

IV Fourth state, on three plates

Plate I: Aquatint is placed on the hostess's chair, the tablecloth, and the flowers on the sheer curtain. The visitor's cloak is reaquatinted, and small aquatint amendments are made to the feathery ornament of her hat. New drypoint lines are applied to the hostess's blouse.

Plate II: Similar to the third state, but with additional tone applied to the hostess's dress and to the vertical molding along the center line of the window.

Plate III: Similar to third state, but with new aquatint on the visitor's dress; the cups and saucers are reaquatinted.

One impression is known: NGA (Vollard, with gold touches on the pitcher, plate, and cups and saucers)

V Fifth state, on three plates (editioned state)

Plate I: Drypoint of facial features is reworked as well as visitor's hat and hair and with new drypoint work on skirts. New drypoint lines are added to the hostess's blouse and chair, as well as to visitor's cloak and chair. Aquatint is added to the hostess's blouse and

burnished around collar and to the silver tray, which is also burnished to create highlights.

Plate II: Similar to fourth state, but with additional drypoint on visitor's chair.

Plate III: Unchanged from fourth state

The editioned proofs also show touches of gold paint on the cups, saucers, plate, and pitcher, applied with a brush.

An impression in the National Gallery of Australia (13-v) is an unusual color variant of this state: the three plates are printed in variations of grays—including gray-blue—and flesh color. There are no gold touches on the tea set.

Two impressions are printed on tan paper in muted shades without color on the hostess's dress, flesh areas, or wall behind Brooklyn; NGA (very pale impression as if a second pull, Vollard)

Proofs of the final state are known in: AIC; BN; Bryn Mawr; Hirschl & Adler, 1982; McNay; MFA (without gold on rims of cups and saucers); MMA; NGA (Roger Marx, Hartshorne); NGA (Chester Dale); NYPL; St. John's (inscribed *à M. Leroy* and with some gold touches); St. Louis (without gold); Worcester

Summary of the design on each plate

Plate I: Drypoint lines printed in black and brown (for hair of hostess and outlines of faces), with red for lips. Aquatint on visitor's cloak and feather on hat, hostess's chair, hostess's blouse (varies from white to dark gray), pitcher, and tray; tablecloth and table legs are printed in gray to lavender.

Plate II: Aquatint for flesh tones, visitor's chair (from tan to red-brown), wall and pink curtain, hostess's dress (tan or white).

Plate III: Aquatint for visitor's pale green to orange dress and hat with bow, decorative screen, palm fronds, plate, cups, and saucers.

cat. 13-I First state
Drypoint and aquatint on two plates
Cream, medium-weight, smooth, wove paper
17⅛ x 13⅜ in. (435 x 340 mm) sheet
Initialed lower right: "M. C."
Coll.: Vollard
National Gallery of Art, Washington, D.C.,
Rosenwald Collection, 1943.3.2742

cat. 13-II Second state
Drypoint and aquatint on one plate
Off-white, medium-weight, smooth, wove paper
18 x 13¼ in. (457 x 337 mm) sheet
Coll.: Roger Marx; Hartshorne
National Gallery of Art, Washington, D.C.,
Rosenwald Collection, 1946.21.78
[not exhibited]

cat. 13-III Third state
Drypoint and aquatint on three plates
Cream, thick, moderately textured, laid paper
18¹³⁄₁₆ x 12¼ in. (478 x 311 mm) sheet
Watermark: E D & Cie in shield
Inscribed lower margin: "The Visit only state/Mary
Cassatt"
Coll.: Avery
The Miriam and Ira D. Wallach Division of Art, Prints
and Photographs, The New York Public Library
[not exhibited]

cat. 13-IV Fourth state
Drypoint and aquatint on three plates
Dark cream, thick, moderately textured, laid paper
19 x 12¼ in. (483 x 311 mm) sheet
Initialed lower left: "M. C."
Coll.: Vollard
National Gallery of Art, Washington, D.C.,
Rosenwald Collection, 1943.3.2743

cat. 13-V (AIC) Fifth state
[not illustrated]
Drypoint and aquatint on three plates
Off-white, medium-weight, moderately textured, laid paper
17 x 11⅞ in. (432 x 301 mm) sheet
Inscribed lower right: "Imprimée par l'artiste et
M. Leroy/Mary Cassatt/(25 épreuves)"
The Art Institute of Chicago, The Mr. and Mrs. Martin A.
Ryerson Collection, 1932
[exhibited in Williamstown]

cat. 13-V (ANG) Fifth state
Drypoint and aquatint on three plates
Cream, moderately thick, moderately
textured, laid paper
18¾ x 12½ (478 x 316 mm) sheet
Watermark: PL BAS
Initialed lower left: "M. C."
Australian National Gallery, Canberra

cat. 13-V (Brooklyn) Fifth state
Drypoint and aquatint on three plates
Tan, moderately heavy, smooth, wove paper
18⅞ x 12 in. (479 x 305 mm) sheet
Signed lower right: "Mary Cassatt"
The Brooklyn Museum, Museum Purchase, Bristol Myers
Fund and Frank L. Babbott Fund, 1972
[not exhibited]

cat. 13-V (MMA) Fifth state
[illustrated on page 46]
Drypoint and aquatint on three plates
Cream, moderately thick, moderately textured, laid paper
17⅛ x 12 in. (434 x 305 mm) sheet
Inscribed lower right: "Edition de 25 serie Imprimée par
l'artiste et M. Leroy/Mary Cassatt"
The Metropolitan Museum of Art, New York, Gift of Paul
J. Sachs, 1916
[exhibited in Washington]

cat. 13-V (NGA) Fifth state
Drypoint and aquatint on three plates
Cream, medium-weight, moderately textured, laid paper
16¾ x 12¼ in. (425 x 311 mm) sheet
Inscribed lower right: "Imprimée par l'artiste et
M. Leroy/Mary Cassatt/(25 épreuves)/serie unique"
National Gallery of Art, Washington D.C., Chester Dale
Collection, 1963.10.256

cat. 13-V (Worcester) Fifth state
[illustrated on page 9]
Drypoint and aquatint on three plates
Cream, moderately thick, moderately textured, laid paper
17 x 11⅞ in. (430 x 301 mm) sheet
Inscribed lower right: "Edition de 25 épreuves Imprimée
par l'artiste et M. Leroy/Mary Cassatt"
Worcester Art Museum, Bequest of Mrs. Kingsmill Marrs,
1926
[exhibited in Boston]

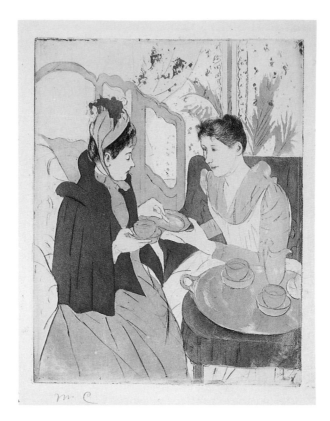

cat. 13-V (ANG) Fifth state

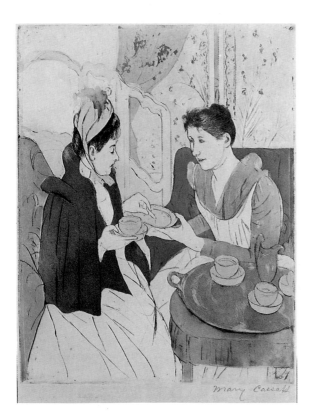

cat. 13-V (Brooklyn) Fifth state

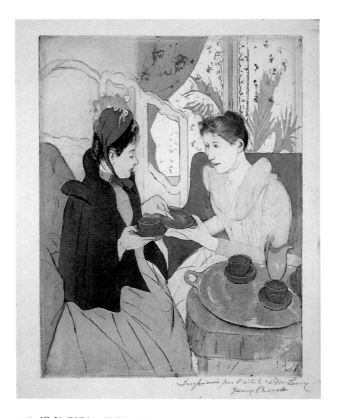

cat. 13-V (NGA) Fifth state

14
The Coiffure,
1890–1891

(also called *Etude, Femme se coiffant, Study of Nude*)
Breeskin 152
Drypoint and aquatint
14⅜ x 10½ in. (365 x 267 mm) platemark

Like *Afternoon Tea Party* (cat. 13), *The Coiffure* shows a theme that was used by Cassatt in a number of other works. Three earlier prints of a woman combing her hair, Br. 96, 99, and 100, as well as the major painting *Girl Arranging Her Hair* (fig. 14-1), were done during the previous five years. In addition, there are two loosely rendered drawings that are considered studies for *The Coiffure* (fig. 14-2 and Br. CR 815), and two drawings (figs. 22, 14-4) that are directly related to the print.

Cassatt's use of nudity in this work, as well as in the other drawings and prints surrounding it, may show the influence of Morisot (see fig. 23) just as the other nude study, *Woman Bathing*, shows the influence of Degas. Cassatt's interpretation of the motif also owes a great deal to the Japanese example, such as Nishikawa Sukenobu's *Girl at Mirror* (fig. 14-3).

The connection to the earlier painting, *Girl Arranging Her Hair*, is strongly established by the use of a similar red-haired model and similar intimate interior with reddish floral design wallpaper. One is tempted to assume that both are set in the same room in Cassatt's apartment; however, the fact that Cassatt changed apartments in 1887 suggests the possibility that she was doing the print as a reprise of the painting—which she had given to her friend Degas—rather than entirely from nature.

Description of the states

I First state, on one plate

Plate I: The slight indication of the subject in drypoint corresponds, in many areas, to the darker lines of the drawing; however, the drawing for this print does not show any evidence of softground or offset lines on the verso, suggesting that another method of transfer-

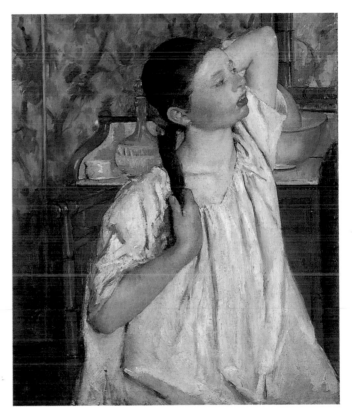

fig. 14-1. **Girl Arranging Her Hair**, 1886
Oil on canvas
29½ x 24½ in. (749 x 622 mm)
National Gallery of Art, Washington,
D.C., Chester Dale Collection
[exhibited in Washington]

fig. 14-2. *Study for* The Coiffure, 1890–1891
Graphite with traces of green and brown
watercolor
Cream, thin, smooth, wove paper
5⅞ x 4½ in. (149 x 114 mm) sheet
Initialed lower left: "MC"
National Gallery of Art, Washington,
D.C., Rosenwald Collection, 1954.12.6

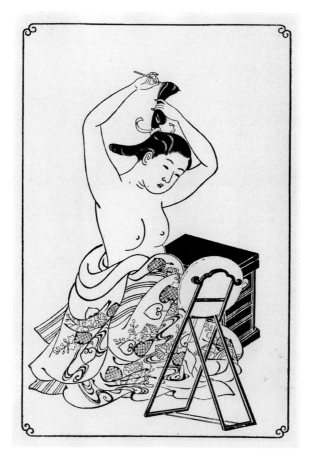

fig. 14-3. Nishikawa Sukenobu
(1671–1751).
Ehon Asakayama
Girl at a Mirror, 1739
Woodcut
The New York Public Library,
Spencer Collection

ring was used, or perhaps, the image was roughly copied in drypoint. There are signs of piercing—but the paper is not broken through—suggesting that plates with holes at top and bottom may have been prepared for registration from the very beginning.

A unique impression of the first state exists: MMA

II Second state, on one plate

Plate I: The composition is more completely drawn in rich drypoint lines, and light aquatint colors the mirror frame. Amendments were made to the skirt; and an armchair and rug pattern, as in the drawing, are now introduced into the print.

One impression is known: NGA (Hartshorne, printed in black ink)

III Third state, on two plates

Plate I: There is additional line work on the rug pattern as well as new aquatint flowers on the floor and in the reflection at left. A reaquatinting of the plate darkens the mirror frame. Many drypoint lines have burr removed and appear lighter; numerous frame lines without burr are suppressed under a denser layer of aquatint.

Plate II: Both the delicate flesh tones and the skirt printed in pale blue are aquatinted and skillful hand-wiping kept the two color areas unmuddied.

One impression of this state is known: NGA (Vollard)

IV Fourth state, on three plates

Plate I: Unchanged from third state
Plate II: Unchanged from third state, but skirt is no longer printed in color
Plate III: The aquatint is printed in a striking pink that colors the chair stripes and decorative wall pattern. The entire background, including the reflection, is aquatinted, then "stopped-out" at varying times during acid biting to create the floral design. Some burnishing has lightened the intense pink in certain areas.

One impression is known: MFA, before floor coloring

V Fifth state, on three plates (editioned state)

Plate I: Remains unchanged from third state
Plate II: Gray panels are introduced between the pink stripes, as seen on the reflection of the chair.
Plate III: A dark pink aquatint tone colors the

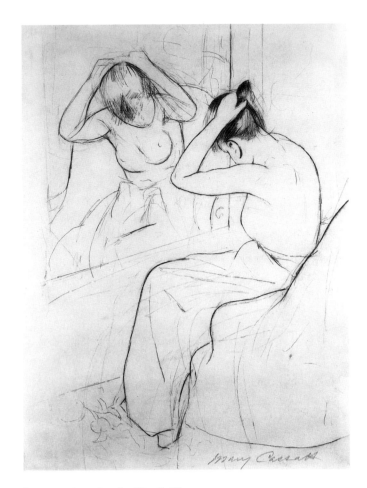

fig. 14-4. *Drawing for* The Coiffure, 1890–1891
Graphite and black chalk
Cream, thin, smooth, wove paper
15⅛ x 10⅞ in. (382 x 278 mm) sheet
Signed lower right: "Mary Cassatt"
National Gallery of Art, Washington, D.C., Rosenwald Collection, 1948.11.50

background of the rug and an additional aquatint widens the pink stripes on the chair reflected in the mirror. Burnishing redefines the floral design on the wall. The varying pinks on the same plate are due to the opacity of the aquatint and to the selection of different colored printer's inks—the unusual, striking pink is offset by a light brown.

Impressions of the final state located are: AIC (2); BMA (inscribed to Mr. Lucas); BN (2); MFA; MMA; NGA (2, one unsigned and imperfectly printed); NGC (2); NYPL; private collection, Boston; private collection, Boston (unsigned but inscribed and with MC stamp); private collection, Maine (unsigned); private collection, England; Shelburne; Worcester

Summary of the design on each plate

Plate I: There are drypoint outlines, aquatint on mirror frame, and linear work on rug pattern as well as beige aquatint flowers on rug and in mirror reflection at left.

Plate II: Aquatint for flesh tones and for skirt (printed in pale blue in third state only); gray-green stripes of upholstered armchair are more clearly noted in mirror reflection.

Plate III: The pink chair stripes, floral wallpaper pattern, and pink color on the rug are etched in varying degrees of aquatint, and inked in different hues of the same color.

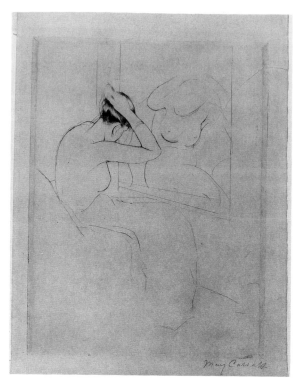

cat. 14-I First state

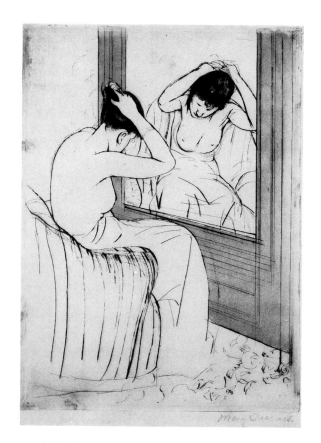

cat. 14-II Second state

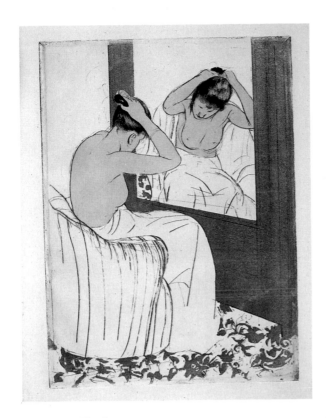

cat. 14-III Third state

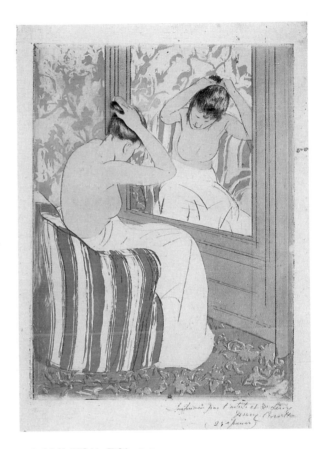

cat. 14-V (NGA) Fifth state

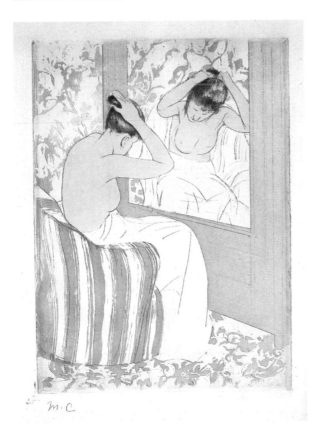

cat. 14-IV Fourth state

cat. 14-I First state
Drypoint on one plate
Cream, thick, moderately textured, laid paper
18¾ x 12⅛ in. (476 x 308 mm) sheet
Watermark: E D & Cie
Signed lower right: "Mary Cassatt"
The Metropolitan Museum of Art, New York, Gift of Mrs.
Gustavus S. Wallace, 1932

cat. 14-II Second state
Drypoint and aquatint on one plate
Off-white, moderately thick, smooth, wove paper
16⅛ x 10⅝ in. (410 x 270 mm) sheet
Signed lower right: "Mary Cassatt"
Coll.: Hartshorne
National Gallery of Art, Washington, D.C.,
Rosenwald Collection, 1946.21.76

cat. 14-III Third state
Drypoint and aquatint on two plates
Dark cream, moderately thick, moderately
textured, laid paper
18¾ x 12 in. (475 x 305 mm) sheet
Coll.: Vollard
National Gallery of Art, Washington, D.C.,
Rosenwald Collection, 1943.3.2745

cat. 14-IV Fourth state
Drypoint and aquatint on three plates
Dark cream, thick, moderately textured, laid paper
19 x 12⅛ in. (480 x 309 mm) sheet
Watermark: E D & Cie in a shield
Initialed lower left: "M. C."
Museum of Fine Arts, Boston, Gift of William Emerson
and Charles Henry Hayden Fund, 1941

cat. 14-V (AIC) Fifth state
[not illustrated]
Drypoint and aquatint on three plates
Off-white, medium-weight, moderately textured, laid paper
17 x 11⅞ in. (432 x 301 mm) sheet
Inscribed lower right: "Imprimée par l'artiste et
M. Leroy/Mary Cassatt/(25 épreuves)"
The Art Institute of Chicago, The Mr. and Mrs. Martin A.
Ryerson Collection, 1932

cat. 14-V (MMA) Fifth state
[illustrated on page 46]
Drypoint and aquatint on three plates
Cream, moderately thick, moderately textured, laid paper
17⅛ x 11⅞ in. (435 x 302 mm) sheet
Inscribed lower right: "Edition de 25 série Imprimée par
l'artiste et M. Leroy/Mary Cassatt"
The Metropolitan Museum of Art, New York, Gift of Paul
J. Sachs, 1916
[exhibited in Washington]

cat. 14-V (NGA) Fifth state
Drypoint and aquatint on three plates
Off-white, moderately thick, moderately
textured, laid paper
17 x 12 in. (432 x 305 mm) sheet
Inscribed lower right in pencil: "Imprimée par l'artiste et
M. Leroy/Mary Cassatt/(25 épreuves)"
National Gallery of Art, Washington, D.C., Bequest of
Chester Dale, 1965.10.257

cat. 14-V (Worcester) Fifth state
[illustrated on page 10]
Drypoint and aquatint on three plates
Cream, moderately thick, moderately textured, laid paper
17 x 11¾ in. (432 x 299 mm) sheet
Inscribed lower right: "Edition de 25 épreuves Imprimée
par l'artiste et M. Leroy/Mary Cassatt"
Worcester Art Museum, Bequest of Mrs. Kingsmill Marrs,
1926
[exhibited in Boston]

15
Gathering Fruit, *ca. 1893*

(Also called *L'Espalier, Le Potager*)
Breeskin 157
Drypoint, softground etching, and aquatint
16⅝ x 11¾ in. (422 x 298 mm) platemark

Cassatt's work on this large print shows a great deal of experimentation. Loosely based on the central panel of her *Modern Woman* mural for the Chicago World's Columbian Exposition (fig. 15-1), it is the only print known to have a preliminary drawing in color (fig. 15-4). It is unusual that no drawings or hand-colored early states exist that would show Cassatt working out her color schemes before actually inking the plates. In addition to the color version of the design, there is also a fully worked composition that was, presumably, used to transfer the design to the plate (fig. 15-3).

In this print, Cassatt attempts subtle effects with strong symbolic associations that are not always noticed at first glance. The garden wall, for instance, harbors both an espaliered pear tree and a grapevine. The woman on the ladder, standing in the midst of golden pears, offers the baby a cluster of grapes. To the right, an open doorway provides a glimpse of an enclosed garden with a path leading up to a sundial in front of the far wall.* This penetration of the shallow foreground space in front of the wall to show a deep space behind it is accomplished without interrupting the flat, decorative quality of the whole composition.

Gathering Fruit, furthermore, is the first of her color prints that Cassatt used as a model for a large-scale work, *Nude Baby Reaching for an Apple* (fig. 15-2).
*We are grateful to Roy Perkinson, who made this observation.

Description of the states

I First state, on one plate

Plate I: The design of the figures, wall, and foliage is sketched lightly in drypoint over some pale softground lines.

One impression is known: NGA (Vollard)

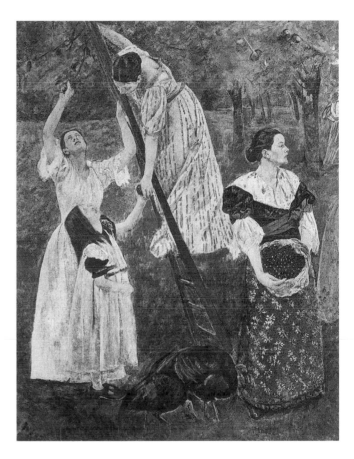

fig. 15-1. (detail from the central section)
Modern Woman
Facsimile typogravure printed by George Barrie
Published by George Barrie and Son, Philadelphia, Pennsylvania, 1893
(titled *Woman's Building of the World's Columbian Exposition,* by William Walton)
Chicago Historical Society

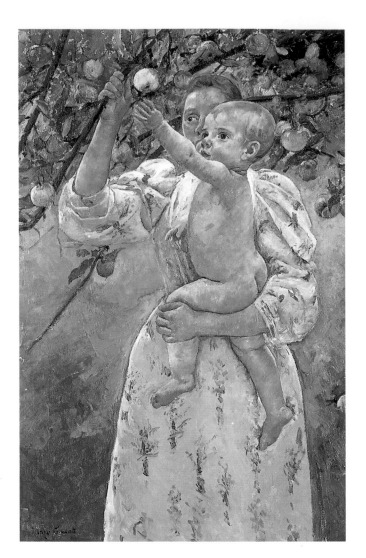

fig. 15-2. **Nude Baby Reaching for an Apple**, 1893
Oil on canvas
39 x 25½ in. (991 x 648 mm)
Virginia Museum of Fine Arts, Richmond

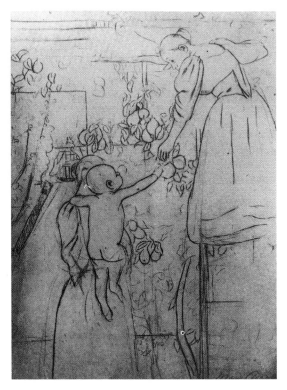

fig. 15-3. *Drawing for* Gathering Fruit, 1893
Br. CR 822
Pencil on paper
16¾ x 11¾ in. (425 x 298 mm) sheet
(whereabouts unknown)

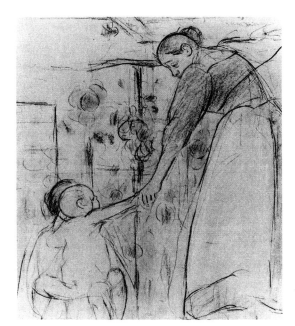

fig. 15-4. *Sketch for* Gathering Fruit, 1893
Br. CR 821
Crayon on paper
11¼ x 10 in. (287 x 255 mm) sheet
(whereabouts unknown)

II Second state, on one plate

Plate I: Similar to the first state with the design reinforced and elaborated with drypoint, especially in the foliage and hair of the women and child. Four pierced registration holes are used—top and bottom, left and right center of sides—and possibly this sheet was used for transfer.

One impression is known: NGA (Vollard)

III Third state, on three plates

Plate I: The drypoint design is completely reworked, close to but not identical to the second state, suggesting that Cassatt burnished most of the design and reworked it almost entirely.

Plate II: Aquatint for the foliage of both the grape and pear leaves is added and printed in green and gold.

Plate III: Aquatint is added for the flesh areas, the ladder, and the dresses, which are printed here in light green and pink.

IV Fourth state, on two plates (not illustrated)

Plate I: The drypoint design is the same as in the third state, but aquatint is now applied to the upper wall.

Plate II: Not printed

Plate III: Unchanged from the third state

The description of this state comes from Breeskin 1979, p. 66: "Only part of the composition is printed. The woman standing at the right holding the baby is cut off just below the baby's feet. The baby is covered with dark gray aquatint. The women and the top of the wall are in dark gray. The foliage and fruit are still in outline (before color)."

(whereabouts unknown)

V Fifth state, on three plates (not illustrated)

Plate I: Unchanged from the fourth state; aquatint on the upper wall is printed in different shades of brown.

Plate II: New aquatint tone is bitten to suggest a light-and-dark leaf pattern of foliage.

Plate III: The horizontal line of the grapevine is aquatinted as well as the sky, which is incompletely inked; additional pale aquatint is now on the ladder legs and the lower trunk of the pear tree.

One impression is known: private collection, California

VI Sixth state, on three plates

Plate I: Unchanged from the fifth state

Plate II: Unchanged from the fifth state, but with some local monotype inking of the fruit (touches of ink are added to the plate with a brush, and not wiped before printing), especially noticeable on the cluster of leaves under the middle rung of the ladder.

Plate III: Similar to fifth state, but with aquatint "stopped-out" to create a white lacy design on the dress yoke of the upper figure. Additional aquatint is on the ladder, tree trunk, and the horizontal grapevine. The sky is reaquatinted and now printed completely.

One impression is known: MFA

VII Seventh state, on three plates (not illustrated)

Plate I: Unchanged from the sixth state

Plate II: Similar to the sixth state, but with aquatint and drypoint creating a floral design for the dress at right and only a partial design for the skirt of the dress at left. Some further aquatint is on the foliage seen through doorway at right.

Plate III: Similar to sixth state, but with a pale aquatint tone on the path at right.

Only one impression is known: Hill-Stead

VIII Eighth state, on three plates

Plate I: Similar to the sixth state, but a few horizontal drypoint lines are added to the distant view at right, and lines now define the right hand of the woman holding the baby.

Plate II: Similar to sixth state, but with the addition of aquatint and fine drypoint lines to complete the floral design on the dress at left. There is minute burnishing of the foliage to expose the mother's right hand.

Plate III: Similar to sixth state, but a new aquatint tone covers the entire wall below the grapevine and the curved tree trunks noted in garden beyond (all printed uniformly in light brown); the path leading through doorway at right is reaquatinted.

Two impressions are known: Johnson; private collection

IX Ninth state, on three plates

Plate I: Unchanged from the eighth state, printed in black except for the hair of the woman and child, which are printed in dark yellow.

Plate II: Aquatint is rebitten to darken fruit tree leaves, making the shapes more uniform and abstract; the foliage of trees in garden at right is rebitten, creating a sense of recession; the garden border at right and sun dial base are also reaquatinted.

Plate III: Similar to the eighth state, but tone on path is evened out to meet the dark green border of the garden at right.

One impression is known: MFA

X Tenth state, on three plates (not illustrated)

Plate I: Similar to eighth state, but a few horizontal and vertical drypoint lines indicate bricks on the upper right wall above doorway (before drypoint lines are drawn in midst of the foliage). Printed in black except for the hair of all three figures, which is in brown.

Plate II: Unchanged from the ninth state

Plate III: Unchanged from the ninth state

The only known impression was formerly: Sotheby's 1981, lot 42

XI Eleventh state, on three plates (editioned state)

Plate I: Similar to tenth state, but vertical and horizontal lines of bricks are added throughout the wall in the midst of the foliage.

Plate II: Remains unchanged from the ninth state

Plate III: Remains unchanged from the ninth state, but the patch of wall at the end of the garden is now printed in a darker brown ink.

According to the Durand-Ruel stock books, this state was printed in an edition of 20, but only a handful of impressions have been located: LC; MMA (not signed); NGA (not signed); NGC; private collection, Boston; private collection, Washington.

Summary of the design on each plate

Plate I: All drypoint lines and aquatint for top zone of wall that is printed in dark brown.

Plate II: Aquatint for the foliage both on the near wall and in garden seen through the doorway to right—printed in shades of green—and the drypoint and aquatint floral patterns on both dresses.

Plate III: Aquatint for areas of blue sky, the background wall in red-brown, the tan garden path, the ladder, the blue and pink background tones of both dresses, and all flesh areas.

cat. 15-I First state
Softground etching and drypoint on one plate
Cream, moderately thick, moderately textured, laid paper
17⅞ x 12½ in. (453 x 320 mm) sheet
National Gallery of Art, Washington, D.C.,
Rosenwald Collection, 1943.2.2754
[not exhibited]

cat. 15-II Second state
Drypoint on one plate
Cream, medium-weight, moderately textured, laid paper
17¾ x 12⅝ in. (450 x 320 mm) sheet
Coll.: Vollard
National Gallery of Art, Washington, D.C.,
Rosenwald Collection, 1943.3.2755

cat. 15-III Third state
Drypoint and aquatint on three plates
Off-white, medium-weight, slightly textured, laid paper
22¼ x 16⅞ in. (465 x 427 mm) sheet
Watermark: Adriaan Rogge and shield
National Gallery of Art, Washington, D.C.,
Rosenwald Collection, 1943.3.2756

cat. 15-VI Sixth state
Drypoint and aquatint on three plates
Cool-white, thin, slightly textured,
laid paper
22¼ x 16¹⁵/₁₆ in. (560 x 430 mm) sheet
Watermark: Adriaan Rogge with a Strasbourg lily in shield
Museum of Fine Arts, Boston, Gift of W. G. Russell Allen, 1963

cat. 15-VIII Eighth state
Drypoint and aquatint on three plates
Off-white, medium-weight, slightly textured, laid paper
20¼ x 15½ in. (514 x 394 mm) sheet
Watermark: D. & C. Blauw
The R. Stanley and Ursula Johnson Collection

cat. 15-IX Ninth state
Drypoint and aquatint on three plates
Off-white, thin, slightly textured, laid paper
19¾ x 15⅜ in. (505 x 390 mm) sheet
Watermark: Fortuna on globe with VDL and VanderLey
Museum of Fine Arts, Boston, Gift of William Emerson and Charles Henry Hayden Fund, 1941
[exhibited in Boston]

cat. 15-XI Eleventh state
Drypoint and aquatint on three plates
Blue-white, thin, slightly textured, laid paper
20½ x 15⅞ in. (521 x 403 mm) sheet
Signed lower right: "Mary Cassatt"
Watermark: F ♡ ANDRIA with AGZ and countermark of grape cluster
The Metropolitan Museum of Art, New York, Rogers Fund, 1918

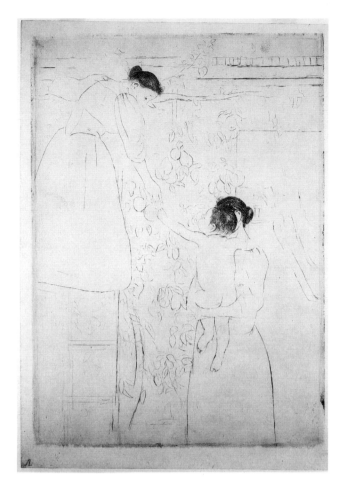

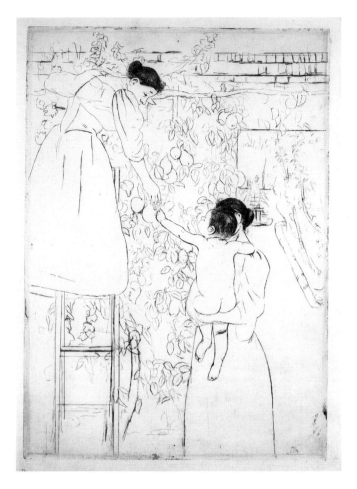

cat. 15-I First state

cat. 15-II Second state

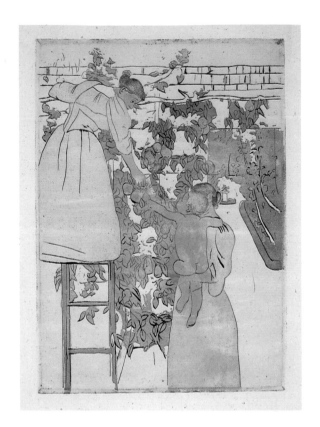

cat. 15-III Third state

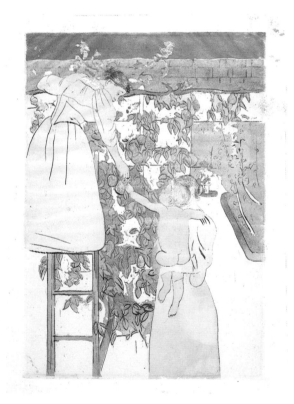

cat. 15-VI Sixth state

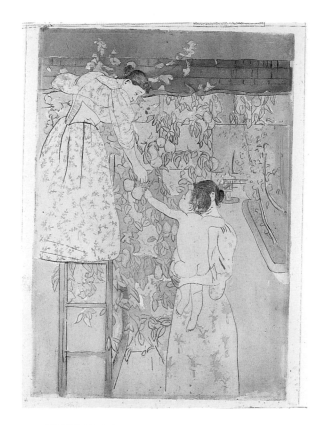

cat. 15-VIII Eighth state

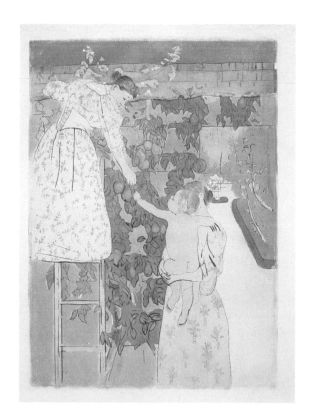

cat. 15-IX Ninth state

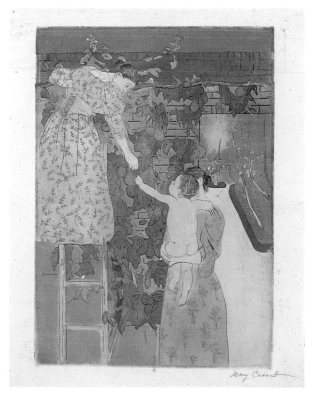

cat. 15-XI Eleventh state

16
The Banjo Lesson, *ca. 1893*

(Also called *The Banjo*)
Breeskin 156
Drypoint and aquatint
11⁹⁄₁₆ x 9³⁄₈ in. (294 x 238 mm) platemark

Compared to *Gathering Fruit*, *The Banjo Lesson* is a much simpler print in design and execution. With only four states and only one known preliminary sketch, Cassatt seems surer of both the composition and the technical means of achieving it. For the first time since *The Bath* (cat. 5) and *Mother's Kiss* (cat. 11), Cassatt worked with only two plates instead of the usual three. The use of heightening by monotype and a method of "stopping-out" the aquatint on the skirt that gives the impression of brushstrokes in the woman's blue dress indicate that Cassatt wanted to achieve a "painterly" print.

The related pastels (figs. 16-1, 16-2) were presumably based on the print, although the existence of a counterproof of the Virginia Museum's pastel opens up the possibility that the print was derived from the counterproof, which would account for the print and the pastels facing in the same direction.

It is worth noting the attention that Cassatt lavished on this subject: the Boston Museum's preparatory study in pastel, the grand finished pastel, a counterproof, and a relatively large edition for the print.

Description of the states

I First state, on one plate

Plate I: The heads and the upper part of the two figures are lightly sketched in drypoint. The printed gray plate tone compensates for the pale drypoint.

A unique impression is at: BAA

II Second state, on one plate

Plate I: The drypoint is further developed and reaches the final design, with the hair darkly shaded and printed in black.

Three impressions are known: MIA; Johnson; McVitty sale 1949

III Third state, on two plates

Plate I: Unchanged from the second state
Plate II: Aquatint is applied for flesh areas, the banjo rim, and the woman's bodice and sleeves. There are now pierced holes and two platemarks.

The one known impression, PMA (McVitty), is printed in black for the drypoint and light brown for the aquatint.

IV Fourth state, on two plates (editioned state)

Plate I: Remains unchanged from second state
Plate II: Aquatint pattern remains unchanged on the woman's bodice, is possibly burnished from her sleeves, and a new aquatint tone is applied to her skirt, all printed in pale blue.

An oily ink is applied in a monotype manner to the woman's sleeves and child's dress, as well as to details such as the woman's collar, to the polka dots scattered at random on her bodice and skirt, and, on occasion, to the neck of the banjo.

According to the Durand-Ruel stock books, *The Banjo Lesson* was printed in an edition of 40; however, only the following impressions have been located: BAA; Berlin; BN; Brooklyn; Carnegie (McVitty); Dresden; Grand Rapids; LC; Munich; NGA; NYPL; Oklahoma; private collection, New Orleans; Terra; Virginia.

Summary of the design on each plate

Plate I: Drypoint only, printed in black.
Plate II: Aquatint for flesh areas, the woman's skirt and bodice, printed in blue, and the brown rim of her banjo. Also on this plate, the monotype inking for the woman's sleeves in dark blue, her yellow to orange collar, the random pink polka dots, the young girl's pink dress, and the neck of the banjo in brown.

cat. 16-I First state
Drypoint on one plate
Off-white, thin, slightly textured, laid paper
15 x 9¾ in. (388 x 248 mm) sheet
Watermark: VanderLey
Inscribed lower right: "Mary Cassatt/état"
Bibliothèque d'Art et d'Archéologie (Fondation
Jacques Doucet), Paris
[not exhibited]

cat 16-II Second state
Drypoint on one plate
Off-white, medium-weight, moderately textured, laid paper
15⁵⁄₁₆ x 10⅛ in. (390 x 256 mm) sheet
Watermark: Fleur-de-lys in crowned shield
The R. Stanley and Ursula Johnson Collection

cat. 16-III Third state
Drypoint and aquatint on two plates
Off-white, medium-weight, smooth, wove paper
13⅝ x 10⅜ in. (346 x 264 mm) sheet
Inscribed lower right: "Mary Cassatt/état" and in another
hand "1889"
Coll.: McVitty
Philadelphia Museum of Art, Temple Fund, 1949

cat. 16-IV (LC) Fourth state
Drypoint and aquatint with monotype inking on two plates
Off-white, thin, medium to slightly textured, laid paper
13½ x 10⅞ in. (340 x 275 mm) sheet
Watermark: VanderLey with seated figure
Signed lower right: "Mary Cassatt"
Coll.: Hartshorne
Library of Congress, Washington, D.C., Pennell Fund

cat. 16-IV (NGA) Fourth state
Drypoint and aquatint with monotype inking on two plates
Buff, medium-weight, slightly textured, laid paper
16½ x 11½ in. (419 x 292 mm) sheet
Signed lower right: "Mary Cassatt"
National Gallery of Art, Washington, D.C., Gift of Mrs.
Jane C. Carey as an addition to the Addie Burr Clark
Memorial Collection, 1959.12.6

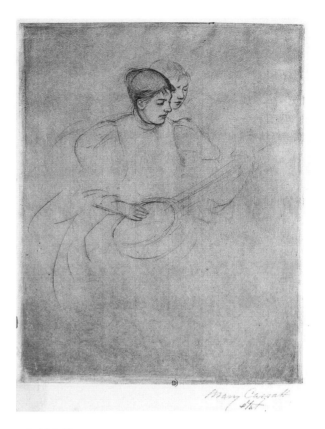

cat. 16-I First state

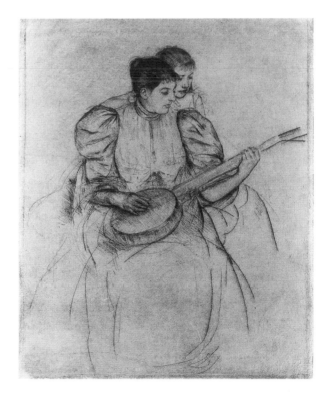

cat 16-II Second state

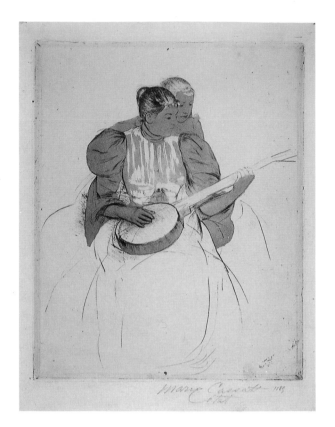

cat. 16-III Third state

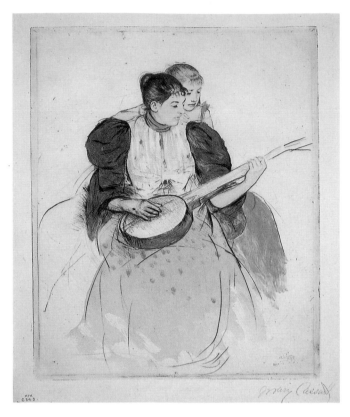

cat. 16-IV (LC) Fourth state

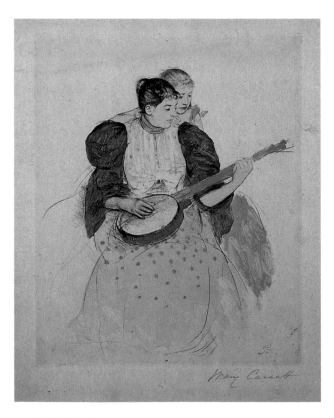

cat. 16-IV (NGA) Fourth state

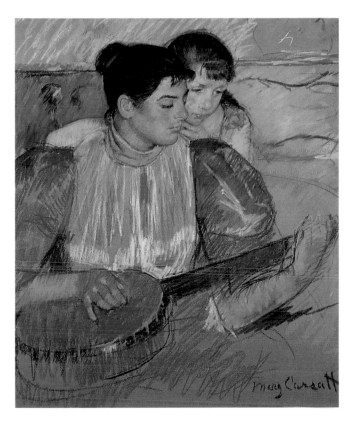

fig. 16-1. **The Banjo Lesson**, ca. 1894
Pastel on paper
28 x 22½ in. (711 x 572 mm)
Virginia Museum of Fine Arts, Richmond

fig. 16-2. **Two Sisters** (*Study for* The Banjo
Lesson), ca. 1894
Pastel on sand-textured paper
17½ x 17½ in. (445 x 445 mm)
Museum of Fine Arts, Boston, Charles
Henry Hayden Fund, 1932
[exhibited in Boston]

17
Peasant Mother and Child,
ca. 1894

(Also called *Maternity, Mother and Child, Mother and Child of the People*) Breeskin 159
Drypoint and aquatint
11 11/16 x 9 5/8 in. (297 x 245 mm) platemark

No preliminary drawing for *Peasant Mother and Child* has survived, although the composition is clearly derived from a pastel sketch (fig. 17-1) and a finished pastel of the same title (Br. CR 232, whereabouts unknown). In this instance, it is possible to surmise that Cassatt was drawing freehand onto the plate since the first attempt at the design (cat. 17-i) was abandoned before another try was carried through to completion. The first attempt was on a slightly smaller plate and is the only example of Cassatt changing to a different size plate once she had begun. *Peasant Mother and Child* went through ten states, mostly showing changes in the tonal areas.

Cassatt's monotype-like inking and irregular areas of aquatint link this print to *The Banjo Lesson* (cat. 16), which makes an interesting pendant to it. The title, *Peasant Mother and Child*, may have been derived from the solemn coloration of the costumes that contrast with the decorative colors and leisure pursuits shown in *The Banjo Lesson*.

Description of the states

I First state, on one plate

Plate I: The child's face is drawn in drypoint with mother's profile lightly sketched in. The plate is apparently abandoned. Its size, 10 1/4 x 7 3/8 in. (260 x 188 mm), is smaller than that used for all subsequent states.

Only impression known is: NGA

II Second state, on one plate

Plate I: The drypoint of the child's face and folds on the arm of his dress as well as the mother's head are drawn anew in some detail, although their bodies are only lightly sketched in. This design may have been

fig. 17-1. *Sketch for* Peasant Mother and Child, ca. 1894
Pastel on paper
27 1/4 x 20 1/4 in. (692 x 514 mm)
National Museum, Belgrade

cat. 17-I First state

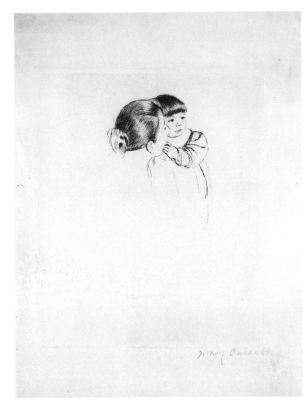

cat. 17-II Second state

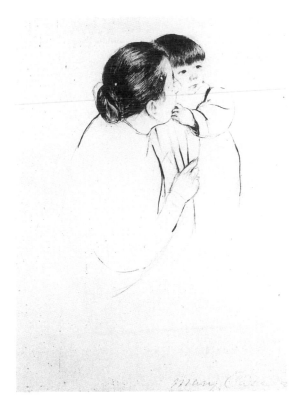

cat. 17-III Third state

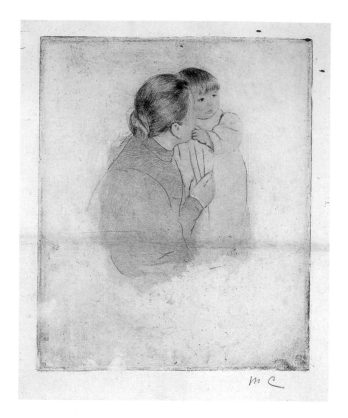

cat. 17-V Fifth state

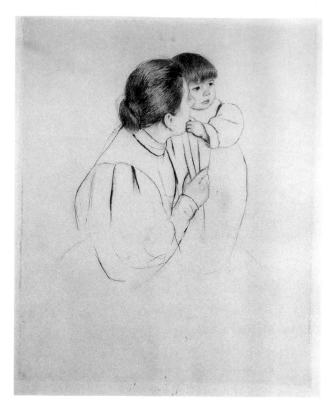

cat. 17-VI Sixth state

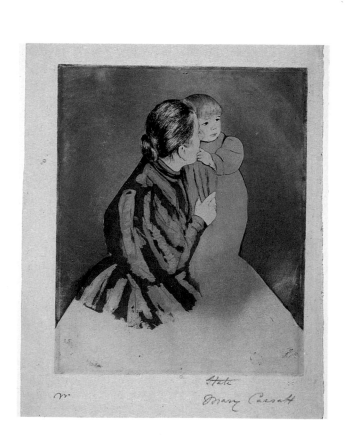

cat. 17-IX Ninth state

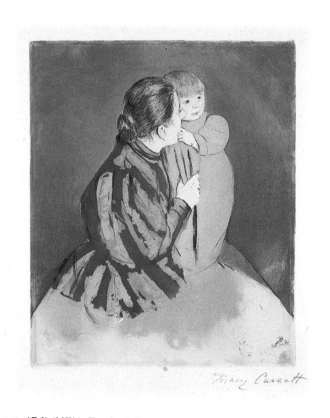

cat. 17-X (MFA) Tenth state

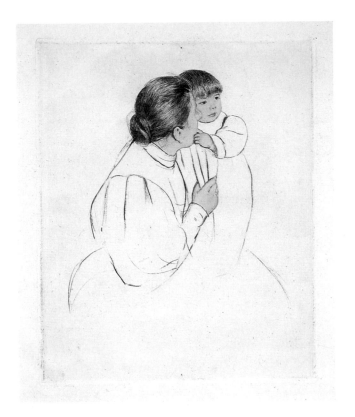

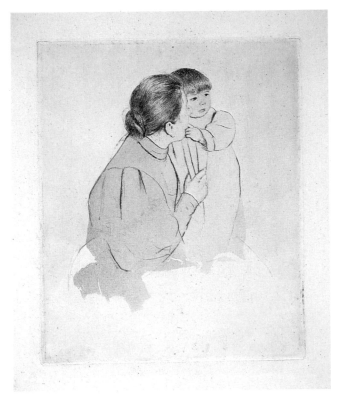

cat. 17-VII Seventh state

cat. 17-VIII Eighth state

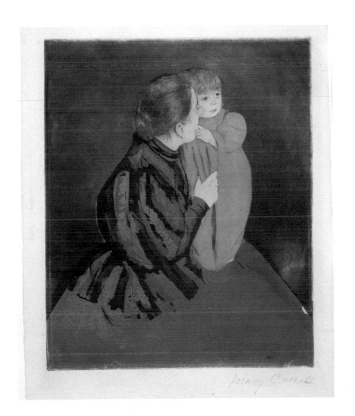

cat. 17-X (LACMA) Tenth state

substantially burnished, as it is difficult to see evidence of this line work in later states.

A unique impression is known: NGA (Hartshorne)

III Third state, on one plate

Plate I: The drypoint designs of both heads and the upper figures differ from the second state, especially in the dress folds on the child's arm and the patterns of hair.

(whereabouts unknown, formerly McVitty sale, 1949)

IV Fourth state, on one plate (not illustrated)

Plate I: The drypoint design is similar to the third state with the line of the mother's back changed, her sleeve and thumb drawn in, and the child's bangs slightly altered. There is evidence of burnishing around the mother's head and chignon.

One impression is known: AIC

V Fifth state, on three plates

Plate I: Unchanged from fourth state, but more lightly printed; extensive plate tone in the background is visible.

Plate II: Aquatinted flesh tones are added and lightly printed.

Plate III: Light aquatint is added in part for the drapery with a distinct monotype inking in brown for the mother's dress and for the child's yellow dress, which extends over and beyond the fine aquatint areas. Registration holes are now pierced.

A unique impression is: NGA (Vollard)

VI Sixth state, on one plate

Plate I: Drypoint work is similar to the fourth state, but with the addition of lines on the mother's sleeve and partial indication of a skirt; other drypoint lines are reinforced on the mother's and child's dresses.
Plate II: Not printed
Plate III: Not printed
One impression is known: MFA (Roger Marx)

VII Seventh state, on two plates

Plate I: Unchanged from the sixth state
Plate II: Flesh tones in aquatint are possibly the same as the fifth state, but more likely they are reaquatinted and printed darkly.

Plate III: Not printed
Only impression known is: NGA (Vollard)

VIII Eighth state, on three plates

Plate I: Remains unchanged from the sixth state
Plate II: Similar to the seventh state but with a light aquatint on the background, printed in pale orange.

Plate III: The clothing is reaquatinted or, more likely, further aquatint is added to even the tone and to extend it to the bottom edge of the dresses.

One impression is known: NGA (Vollard)

IX Ninth state, on three plates

Plate I: There are additional drypoint lines on the mother's blouse extending into the skirt and some delicate hatching on the child's dress as on the sleeve cuff. An aquatint pattern is added to create dark stripes on the mother's blouse. The plate is printed in black with the exception of the child's hair in brown and the stripes in dark green, inked *à la poupée*.

Plate II: Similar to the eighth state, but with additional aquatint applied to the background, especially around the contours of the mother's skirt, inked in a monotype-like manner and printed in blue-green.

Plate III: A reaquatinting of the clothing that partially extends into the mother's skirt and a monotype-like inking covers the light aquatint on this area. Further aquatint of the mother's jacket, bitten in stages, creates a variation of tone for light and medium stripes.

Only one impression is known: NGA (Vollard)

X Tenth state, on three plates (editioned state)

Plate I: Similar to ninth state, but with a reincising of some lines of the child's dress, including a heavy line extending to the bottom of the dress. There are additional modeling lines on the mother's skirt at left and right.

Plate II: Unchanged from the ninth state
Plate III: Unchanged from the ninth state
The final state of this print is inked in two variations. Those impressions that show color covering the whole skirt are: AIC; LACMA (with hand touches of color on the mother's blouse); NGA (Hartshorne); private collection, Pennsylvania. Those that show the color extending just below the mother's jacket are: Carnegie (McVitty); MFA (Denman Ross); MMA (Havemeyer)

Summary of the design on each plate

Plate I: Drypoint lines printed in black with the exception of the child's hair, usually in light red-brown, and the mother's hair, usually in brown; aquatint for the dark green stripes on her jacket.

Plate II: Aquatint for the flesh areas and background, which is now printed in gray-blue or gray-green.

Plate III: Aquatint for the drapery of both figures—the mother's skirt and background tone of her jacket printed in medium green and the child's dress printed in golden brown or olive green.

cat. 17-I First state
Drypoint on one plate
Off-white, thick, slightly textured, wove paper
14 x 10⅞ in. (353 x 273 mm) sheet
Initialed lower right within platemark: "M. C."
National Gallery of Art, Washington, D.C.,
Rosenwald Collection, 1954.12.12

cat. 17-II Second state
Drypoint on one plate
Off-white, thick, slightly textured, wove paper
17⅝ x 12⅜ in. (445 x 310 mm) sheet
Signed lower right: "Mary Cassatt"
Coll.: Hartshorne
National Gallery of Art, Washington, D.C.,
Rosenwald Collection, 1946.21.88

cat. 17-III Third state
Drypoint on one plate
Signed lower right: "Mary Cassatt"
(whereabouts unknown)

cat. 17-V Fifth state
Drypoint, aquatint, and monotype inking on three plates
Off-white, medium-weight, slightly textured, laid paper
16¼ x 12⁹⁄₁₆ in. (415 x 318 mm) sheet
Watermark: VanderLey and Neptune in shield
Initialed lower right: "MC"
Coll.: Vollard
National Gallery of Art, Washington, D.C.,
Rosenwald Collection, 1943.3.2746

cat. 17-VI Sixth state
Drypoint on one plate
Off-white, thick, smooth, wove paper
17 x 11½ in. (432 x 294 mm) sheet
Coll.: Roger Marx
Museum of Fine Arts, Boston, Special Print Fund, 1916

cat. 17-VII Seventh state
Drypoint and aquatint on two plates
Off-white, thick, slightly textured, wove paper
17¼ x 12 in. (435 x 305 mm) sheet
Coll.: Vollard
National Gallery of Art, Washington, D.C.,
Rosenwald Collection, 1943.3.2748

cat. 17-VIII Eighth state
Drypoint and aquatint on three plates
Off-white, moderately thick, moderately
textured, laid paper
17¼ x 11⅞ in. (438 x 302 mm) sheet
Coll.: Vollard
National Gallery of Art, Washington, D.C.,
Rosenwald Collection, 1943.3.2747

cat. 17-IX Ninth state
Drypoint and aquatint on three plates
Dark cream, moderately thick, slightly textured, laid paper
18⅜ x 11½ in. (467 x 292 mm) sheet
Inscribed lower right: "state/Mary Cassatt"
Coll.: Vollard
National Gallery of Art, Washington, D.C.,
Rosenwald Collection, 1943.3.2749

cat. 17-X (MFA) Tenth state
Drypoint and aquatint on three plates
Cream, moderately thick, moderately textured, laid paper
18¼ x 13 in. (444 x 330 mm) sheet
Signed lower right: "Mary Cassatt"
Museum of Fine Arts, Boston, Gift of Denman W. Ross, 1903

cat. 17-X (LACMA) Tenth state
Drypoint and aquatint on three plates with hand touches
Off-white, medium-weight, moderately textured, laid paper
17¹⁄₁₆ x 10¹⁵⁄₁₆ in. (449 x 278 mm) sheet
Watermark: PLANCHER BAS
Signed lower right: "Mary Cassatt"
Los Angeles County Museum of Art, Graphic Arts Council fund in memory of Ruth Sprecher, 1976

18
Feeding the Ducks,
ca. 1895

Breeskin 158
Drypoint, softground etching, and aquatint
11⅝ x 15½ in. (295 x 393 mm) platemark

In comparison to *Peasant Mother and Child* (cat. 17), *Feeding the Ducks* is remarkably simple in its development. Based on an oil sketch, *On the Water* (fig. 18-1) and related to *Summertime* (fig. 18-2), the design is worked out for the first three states on one plate and printed in black and white. The final state (cat. 18-iv) was the first state to include color. Specific touches of color were frequently added to the ducks and to the reflections in the water before the plate was printed.

Description of the states

I First state, on one plate

Plate I: The drypoint defines the figures in the boat that are incompletely detailed but their hair is darkly shaded. Two ducks are sketched in at the lower left and some indications of two ducks are at the upper right. There are pierced holes on the sides of this sheet, which may have been used for transfer of the design. (According to Breeskin, the boat in the first state is toned dark but no impression has been found to confirm this.)

A unique impression is known: MMA (Roger Marx)

II Second state, on one plate

Plate I: There is additional drypoint work on the dresses, particularly on the woman's dress at left; further delineation of ducks at left increases them to four.

One impression is known: formerly on deposit to the Achenbach

III Third state, on one plate

Plate I: Drypoint work is similar to second state, but ducks increase to five at left and one with reflection is at bow of boat; aquatint is also added to darken boat.

One impression is known: Hom

IV Fourth state, on three plates (editioned state)

Plate I: Further drypoint lines and aquatint tone are added to the boat and to its reflection.

Plate II: Aquatint is applied and printed in color on the pink dress, the flesh-colored yoke, the orange-red blouse on woman at left and her purple/blue skirt (with areas "stopped-out" to form polka dots), the pale yellow ducks, for the flesh tones, and for the background of sky and water in various tones of green.

Plate III: A green pattern on the pink dress and pink-beige trim or ruffle on yoke of woman's dress at right, child's dress in lavender, and green-brown bench in boat are all added in aquatint. There are varying amounts of monotype touches applied to the purple-to-black duck at left as well as to the ducks' yellow beaks and to the pink reflections of water below. These monotype additions were probably made while the plate was on the bed of the press.

The impressions known are: BAA; Berlin; BN; MMA; Oberlin; private collection; private collection, Europe; Prouté; Terra (a color variant); Toledo

Summary of the design on each plate

Plate I: All the drypoint line work including the boat and its eventual aquatinted shadow.

Plate II: Aquatint coloring of pink dress and its yoke of woman at right, orange to red blouse with the purple to blue skirt of woman at left, the pale yellow ducks, the flesh tones, and the background in green.

Plate III: Aquatint of green pattern and ruffle on the pink dress at right, the child's dress in lavender, and the small bench in the boat.

fig. 18-1. **On The Water**, 1895
Oil on canvas
23¾ x 28¾ in. (603 x 730 mm)
Private Collection, Mickelson Gallery,
Washington, D. C.

fig. 18-2. **Summertime**, ca. 1895
Oil on canvas
29 x 38 in. (737 x 965 mm)
Armand Hammer Foundation,
Los Angeles, California

cat. 18-I First state

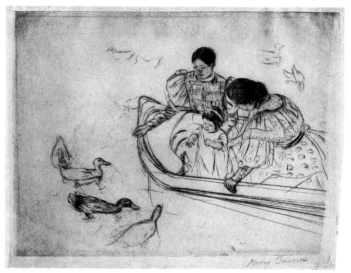

cat. 18-II Second state

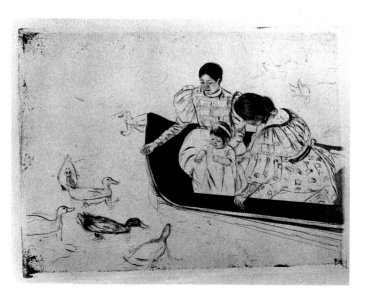

cat. 18-III Third state

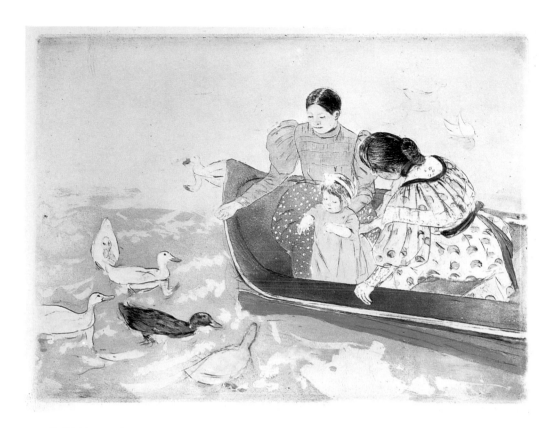

cat. 18-IV (Terra) Fourth state

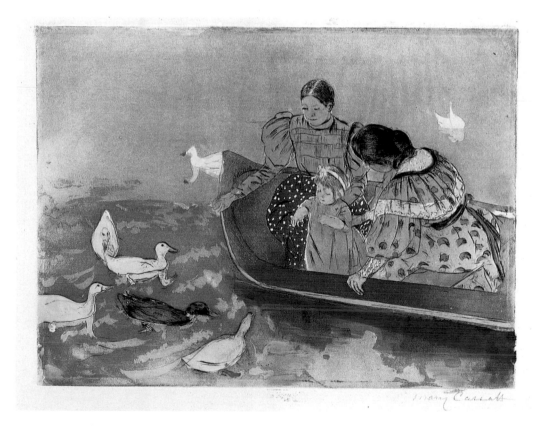

cat. 18-IV (PC) Fourth state

cat. 18-I First state
Drypoint on one plate
Off-white, medium-weight, smooth, wove paper
13⅞ x 17⅜ in. (352 x 441 mm) sheet
Signed lower right: "Mary Cassatt"
Coll.: Roger Marx
The Metropolitan Museum of Art, New York, Bequest of
Mrs. H. O. Havemeyer, The Havemeyer Collection, 1929

cat. 18-II Second state
Drypoint on one plate
(whereabouts unknown)

cat. 18-III Third state
Drypoint and aquatint on two plates
Buff, moderately textured, laid paper
15⅝ x 16½ in. (312 x 419 mm) sheet
Collection of Mr. and Mrs. Jem Hom

cat. 18-IV (Terra) Fourth state
Drypoint and aquatint on three plates
Off-white, medium-weight, slightly textured, laid paper
15 x 20⅛ in. (381 x 511 mm) sheet
Signed lower right: "Mary Cassatt":
Terra Museum of American Art, Chicago, Daniel J. Terra
Collection

cat. 18-IV (PC) Fourth state
Drypoint and aquatint on three plates
Off-white, thin, slightly textured, laid paper
15⅝ x 19¾ in. (397 x 502 mm) sheet
Watermark: Fortuna on globe with VDL and VanderLey
Signed lower right: "Mary Cassatt"
Private Collection

19
The Album,
ca. 1895

Breeskin 175 +
Monotype in color
16⅝ x 12¾ in. (424 x 328 mm) platemark

Cassatt's only known monotype exists in two versions achieved by reinking the plate after the first pull. Probably the related drawing on thin tracing paper (fig. 19-1) was used to transfer the softground outlines and possibly reused for the second version to add the hand at left. Cassatt followed her working methods for the color prints—here, however, she used a softground etched line instead of a drypoint framework upon which she introduced color.

Cassatt's monotype is similar to Pissarro's works in the same medium that were executed during 1894–1895 (fig. 19-2). Her handling of the inks in a broad painterly fashion and her application of the pigments in numerous directions with a rag or brush show a correspondence to Pissarro.

The two models are seen in the related pastel, *The Child's Picture Book* (fig. 19-3) and also in the bow of the boat in *Feeding the Ducks* (cat. 18) and its sketch, *On the Water* (fig. 18-1).

Description of the impressions

I. First impression
Contours are lightly indicated in softground. Mother and child are painted in colored inks on a large beveled plate with areas of the book, the lower dress, and the mother's hand left blank. The overall palette is less brilliant than the second impression.
This unique impression is at the BN
II. Second impression
The design of the mother reading to the child is completed. The colors are bright and resemble the palette used in *Feeding the Ducks* (cat. 18), especially the green background. Both impressions, signed within the platemark, are printed on a thin paper—one has a VanderLey watermark. This was the same paper used for most of the impressions of the late color prints.
This unique impression is at the BAA

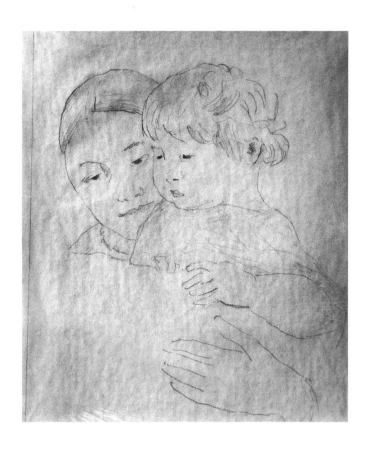

fig. 19-1. *Sketch for* The Child's Picture
Book, 1895
Pencil on tracing paper
15 x 11 in. (381 x 279 mm)
(whereabouts unknown)

fig. 19-2. Camille Pissarro (1830–1903)
Woman Combing Her Hair, 1894–1895
Monotype in color
5 x 7⅛ in. (128 x 180 mm) platemark
Museum of Fine Arts, Boston, Lee M.
Friedman Fund, 1960

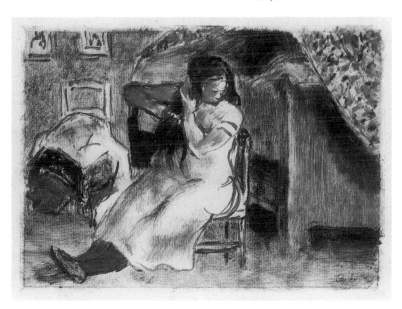

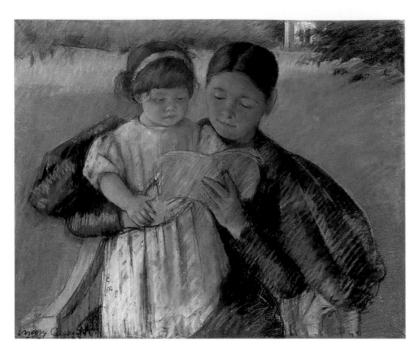

fig. 19-3. **Nurse Reading to a Little Girl**, 1895
Pastel on paper
23¾ x 28⅞ in. (603 x 733 mm)
The Metropolitan Museum of Art, New York,
Gift of Mrs. Hope Williams Read, 1962

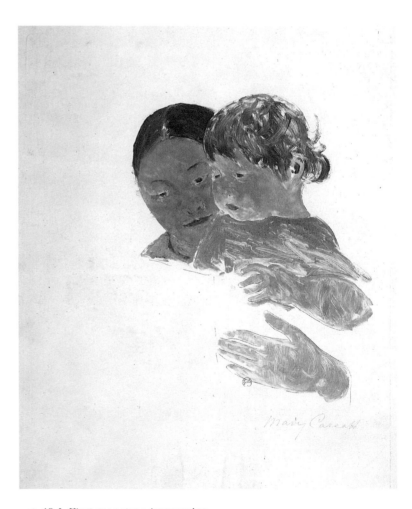

cat. 19-I First monotype impression

cat. 19-I First monotype impression
Off-white, thin, slightly textured, laid paper
18⅝ x 15½ in. (472 x 393 mm) sheet
Watermark: VanderLey
Signed lower right: "Mary Cassatt"
Bibliothèque Nationale, Paris
[not exhibited]

cat. 19-II Second monotype impression
Off-white, laid paper
18⅞ x 15½ in. (480 x 393 mm) sheet
Signed lower right within platemark: "Mary Cassatt"
Bibliothèque d'Art et d'Archéologie (Fondation Jacques Doucet), Paris
[not exhibited]

20
Under the Horse Chestnut Tree, *1896–1897*

(also called *Femme et enfant dans l'herbe*, *Sur l'herbe*)
Breeskin 162
Drypoint and aquatint
15⅞ x 11¼ in. (404 x 286 mm) platemark

Under the Horse Chestnut Tree and *By the Pond* (cat. 21) are two of many works that grew out of the playful poses struck by these same models. They can also be seen in the oil sketch *Two Young Girls with a Child* (fig. 20-1) and *A Kiss for Baby Anne* (fig. 20-2), as well as numerous other pastels from 1897. The oil sketch shows the same pose of the woman holding up a child while behind her another woman plucks something from the tree, perhaps indicating that Cassatt's first idea was to return to the *Gathering Fruit* (cat. 15) theme of a few years before. *A Kiss for Baby Anne*, because it faces the same direction as the print, may have been done after it.

One can only speculate whether Cassatt was reminded of her neighbor Camille Pissarro's color woodcut (see fig. 37), which was engraved on the block by Lucien and issued in 1895; it included a similar outdoor setting with a high horizon line.

According to oral tradition from members of the Cassatt family, the artist was experimenting with *Under the Horse Chestnut Tree* and printed the first three impressions, each one unique, on a small etching press kept in the "little mill" at her country estate in Beaufresne. These three pictures were hidden in a barn on the property during World War II.

Description of the states

I First state, on one plate

Plate I: The composition is fully described in drypoint with the mother's hair shaded.

Only one impression exists: private collection, Maine

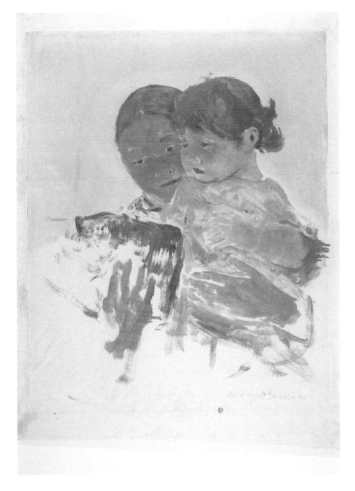

cat. 19-II Second monotype impression

II Second state, on one plate

Plate I: The line work remains unchanged but an aquatint—here colored black—suggests an expanse of lawn. This second state also exists in a unique impression (private collection, Maine), and both impressions are considered to be working proofs that were printed by the artist.

III Third state, on three plates

Plate I: Hatching lines model the child's face and body, and additional lines strengthen the hair of both mother and child. The grass is still colored black.

Plate II: Other colors are introduced, including aquatint for flesh tones, the light green leaves, and the yellow skirt.

Plate III: Aquatint is used for the gray-blue sky, the light blue blouse, and light polka dots on the skirt.

This unique impression (private collection, Maine) is a color proof and represents an exploration of color harmony before the published print.

III Third state, on three plates (editioned print)

The editioned print of this state was supposedly published in 45 impressions for the first issue of *L'Estampe nouvelle*, in October 1897. Some impressions, however, are numbered over 50, suggesting the possibility of an edition slightly larger than 45.

The plate was apparently given to a professional printer who chose with the artist only a few bright colors, deep in value. It would have been impossible to duplicate the intricate printing procedures of her 1891 color prints for an edition that was being offered—unlike her usual custom—to a larger audience. Her palette was extended by specially inking (*à la poupée*) the child's hair in yellow and the mother's in dark brown.

Impressions have been located at: BAA (No 11); BN (2, one numbered 45 and one dedicated by Eugène Rodriquez, president of the founding members of *L'Estampe nouvelle*); BPL (21/50); CMA (No 39); LC (No 17); MFA (No 1); MMA (signed and initialed but not numbered); MOMA (No 20); NGA (No 7); NYPL (No 36); private collection (not numbered or stamped EN); Smith (No 25; No 33); Sotheby's 1980, lot 745 (No 10); Terra (No 9)

Summary of the design on each plate

Plate I: All the drypoint line work as well as the aquatint on the lower ground area is black and becomes green in the final state.

Plate II: The flesh tones, green leaves, and yellow skirt are all in aquatint.

Plate III: Aquatint was applied for the blue sky, the blue blouse, and spotted dress pattern.

cat. 20-I First state
Drypoint on one plate
Off-white, moderately thick, slightly textured, wove paper
17⅝ x 12¾ in. (448 x 325 mm) irregular sheet
Private Collection, Maine

cat. 20-II Second state
Drypoint and aquatint on one plate
Off-white, medium-weight, slightly textured, laid paper
17½ x 13¼ in. (447 x 337 mm) irregular sheet
Watermark: VanderLey with shield
Private Collection, Maine

cat. 20-III (PC) Third state
Drypoint and aquatint on three plates
Cream, moderately heavy, slightly textured, laid paper
18¾ x 14⅝ in. (477 x 373 mm) irregular sheet
Private Collection, Maine

cat. 20-III (MFA) Third state
Drypoint and aquatint on three plates
Off-white, medium-weight, slightly textured, laid paper
18¾ x 15½ in. (477 x 394 mm) sheet
Watermark: VanderLey with shield
Signed and numbered lower left and right: "No 1 Mary Cassatt"
Stamp in image lower right corner: EN (Lugt 886)
Museum of Fine Arts, Boston, Bequest of W. G. Russell Allen, 1963

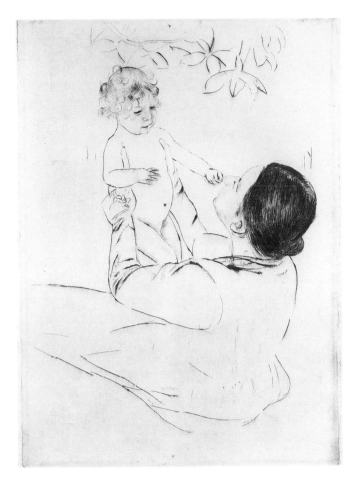

cat. 20-I First state

cat. 20-II Second state

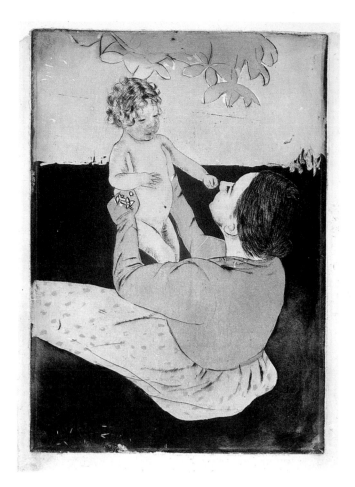

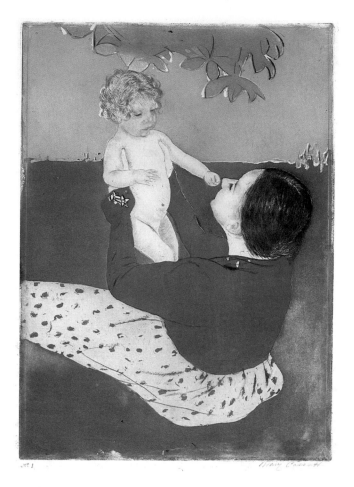

cat. 20-III (MFA) Third state

cat. 20-III (PC) Third state

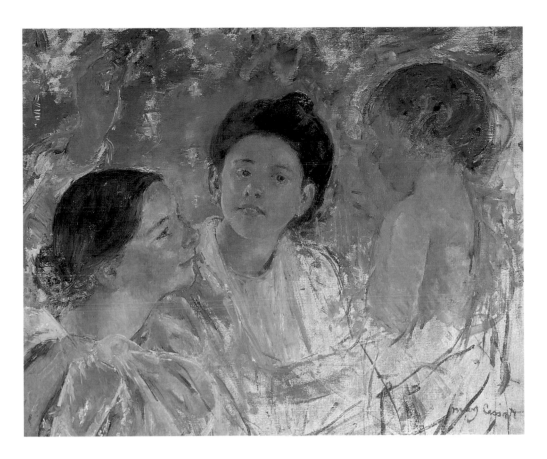

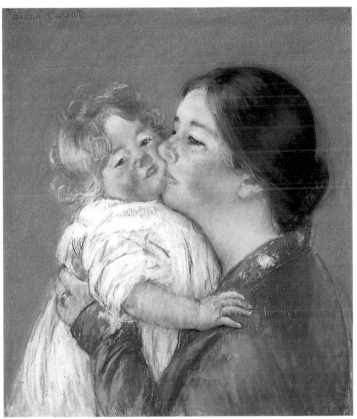

fig. 20-1. **Two Young Girls with a Child**,
ca. 1897
Oil on canvas
21¼ x 25½ in. (540 x 648 mm)
Collection Marsha Mauh, Santa Barbara,
California

fig. 20-2. **A Kiss for Baby Anne (No. 2)**,
ca. 1896–1897
Pastel on paper
21½ x 17¾ in. (546 x 451 mm)
The Baltimore Museum of Art, The Helen
and Abram Eisenberg Collection, 1976

21
By the Pond, *ca. 1896*

(also called *Mother and Child before a Pool, Young Motherhood*)
Breeskin 161
Drypoint and aquatint
13 x 16⅞ in. (330 x 429 mm) platemark

By the Pond shows the same costumes as the oil sketch *Two Young Girls with a Child* (fig. 20-1) but otherwise is not closely related to works in Cassatt's 1897 series as is *Under the Horse Chestnut Tree* (cat. 20). Breeskin's description of a drypoint impression with some color, inked *à la poupée*, on one plate is of great interest because this is a method that she had not used since *The Bath* executed in 1890–1891 (cat. 5). *By the Pond* and *The Barefooted Child* (cat. 22) are not developed in a complex state sequence. Both are handled more simply in style and technique.

There are color variations in this print owing to Cassatt's manipulation of the inks in a monotype-like fashion. The relatively large number of impressions located suggest the possibility that Cassatt intended this print for a publication.

Description of the states

I First state, on one plate

Plate I: Drypoint lightly defines the head of the child and partially indicates the mother's head. There is fine drypoint hatching on the child's face and light plate tone colors the sheet.

Only one impression is known: PMA

II Second state, on one plate (not illustrated)

Plate I: Drypoint work is continued but not completed except for the mother's head. According to Breeskin 1948 and 1979, there are two impressions, but neither impression has been located.

III Third state, on one plate (not illustrated)

According to Breeskin 1948 and 1979, there is an impression with the composition completed but before the addition of aquatint. The drypoint was printed in

colors with flesh tones, yellow hair for the child, and black hair for the mother. Its present location is unknown.

IV Fourth state, on three plates

Plate I: The drypoint work remains unchanged from the composition as probably completed in the third state.

Plate II: Aquatint is applied and printed in color for the yellow blouse, and the pink-buff bodice of the woman; some pale aquatint tone is used to enhance the flesh tones of the mother and child. There are blue patches in the sky and fencelike devices in the background.

Plate III: Aquatint is applied for the green-blue trees, the fields, and the pond, which are printed in varying tones of blue for the reflections in the water. The prints are usually signed, often diagonally, on the sleeve within the image or below the platemark at right.

Impressions known are: AIC; BAA; BMA (inscribed to Mr. Lucas); BN; Brooklyn; Carnegie; CMA; Honolulu; LC; MIA; MOMA; NYPL (inscribed to Mr. Avery); Oregon; PMA; private collection (not signed); Prouté; St. John's; Smith; Terra; Weil; Weston

Summary of the design on each plate

Plate I: All drypoint outlines and extensive hatching are printed in black, sepia, and yellow for the child's hair.

Plate II: Aquatint was added for the yellow blouse, pink-buff bodice, and to enhance the flesh tones; also on the horizontal fencelike bars in the background and the blue patches of sky.

Plate III: The green-blue trees, fields, and pond created by aquatint are inked and wiped in the manner of monotypes to create color variants.

cat. 21-I First state
Drypoint on one plate
Pale blue, medium-weight, slightly textured, laid paper
16 x 20⅜ in. (406 x 518 mm) sheet
Watermark: F ♡ ANDRIA (ACL and grape device)
Signed lower left within platemark: "Mary Cassatt"
Coll.: Barrion; Hartshorne
Philadelphia Museum of Art, Gift of R. Sturgis Ingersoll,
Frederic Ballard, Alexander Cassatt, Staunton B. Peck and
Mrs. William Potter Wear, 1946
[not exhibited]

cat. 21-IV (PMA) Fourth state
Drypoint and aquatint on three plates
Off-white, thin, slightly textured,
laid paper

14⅞ x 18¾ in. (378 x 476 mm) sheet
Watermark: VanderLey and armorial device
Coll.: Barrion; Hartshorne
Philadelphia Museum of Art, Gift of R. Sturgis Ingersoll,
Frederic Ballard, Alexander Cassatt, Staunton B. Peck and
Mrs. William Potter Wear, 1946

cat. 21-IV (Terra) Fourth state
Drypoint and aquatint on three plates
Cream, thin, slightly textured, laid paper
17½ x 19⅝ in. (403 x 471 mm) sheet
Signed lower right within platemark: "Mary Cassatt"
Watermark: fragment of Adriaan Rogge with
fleur-de-lys and crown
Terra Museum of American Art, Chicago,
Daniel J. Terra Collection

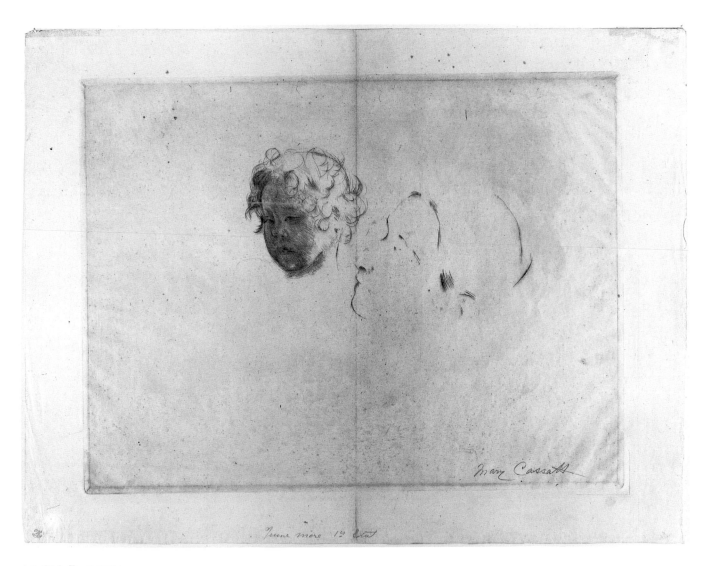

cat. 21-I First state

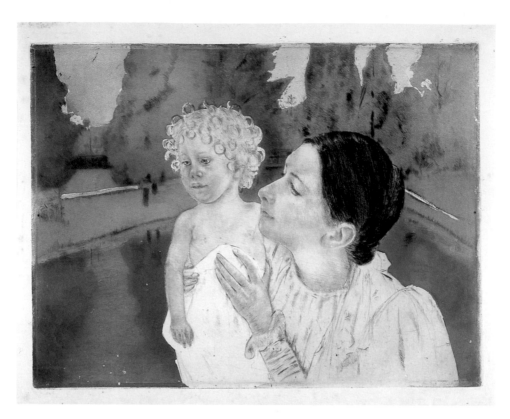

cat. 21-IV (PMA) Fourth state

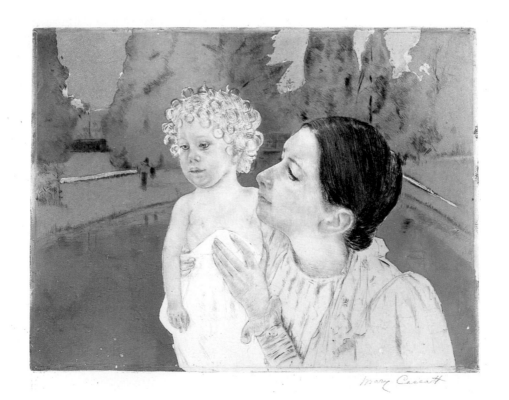

cat. 21-IV (Terra) Fourth state

22
The Barefooted Child,
ca. 1896–1897

(also called *Child and Nurse, Les Marionettes*)
Breeskin 160
Drypoint and aquatint
9⅝ x 12⅝ in. (244 x 320 mm) platemark

No preliminary drawings have survived for the prints in Cassatt's last "set," including *The Barefooted Child*. The pastel *Patty-cake* (fig. 22-1) may have served as Cassatt's only guide in sketching the design freehand onto the plate.

As in all the later color prints, there is much use of fine drypoint hatching combined with aquatint to create modeling and texture. This practice was quite unlike the stylistic methods used for the earlier color prints in which the color areas were kept clear and unshadowed. *The Barefooted Child* is less daring and inventive—it is more simply drawn, the wiping is straightforward, and the separation of the color areas is not as precise.

The printing order of the plates has changed from the 1891 color works in which the line plate was printed last. Here, the second plate with color was printed over the first, softening the linear effects of the drypoint; then the third plate completed the composition.

Description of the states

I First state, on one plate

Plate I: The subject is incompletely sketched in drypoint on a thin sheet of paper.
One impression is known: PMA

II Second state, on two plates

Plate I: There are small additions of drypoint work throughout the image, especially on the mother, whose hair is darkly shaded. The child's hair is selectively inked in yellow.

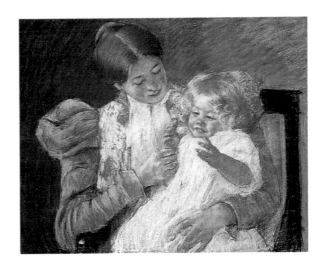

fig. 22-1. Patty-Cake, ca. 1897
Pastel on paper
23¾ x 28¼ in. (603 x 718 mm)
The Denver Art Museum

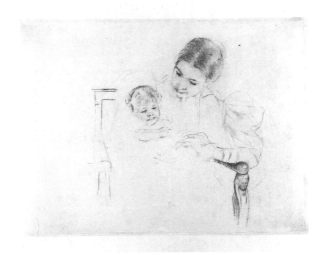

cat. 22-I First state

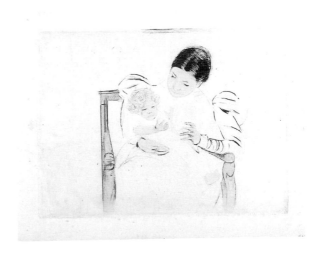

cat. 22-II Second state

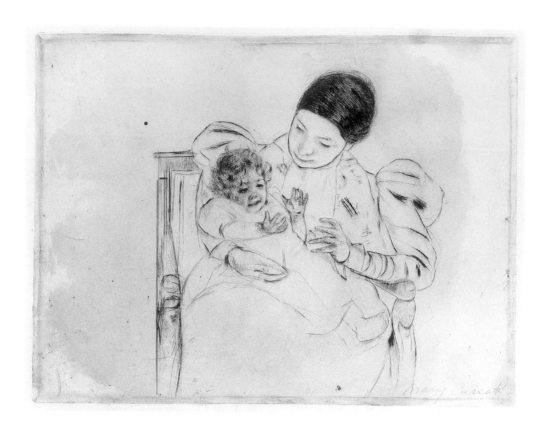

cat. 22-III Third state

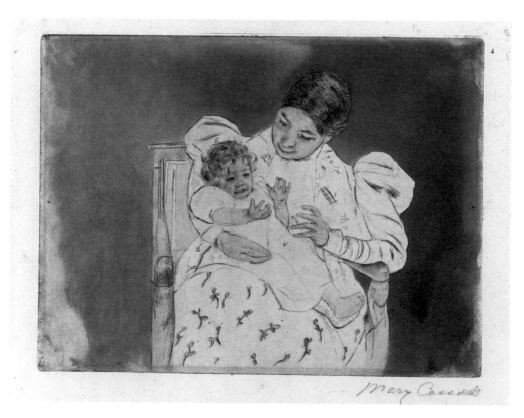

cat. 22-IV Fourth state

Plate II: Aquatint is tentatively added for flesh tones and chair frame. Pierced registration holes are on both sides of the sheet.

There is one impression known: PMA

III Third state, on two plates

Plate I: Additional drypoint lines better define the mother's dress, especially the jacket, the child's face, and the chair; a light background tone is aquatinted onto the plate in an irregular shape.

Plate II: Not printed

The pierced holes and a second platemark suggest that this impression served as a guide to transferring the lines.

One impression is known: MMA (Roger Marx)

IV Fourth state, on two plates

Plate I: There is further definition of the child's dress and feet; flowers on the skirt are added in fine drypoint lines and minute tonal areas, which are inked and wiped together. The background is reaquatinted but is still irregular in tone and shape.

Plate II: A light aquatint tone is added to the chair frame and back of seat and printed along with the flesh tones.

One impression has been located: MIA

V Fifth state, on three plates (editioned state)

Plate I: There is no further line work, but the background is reaquatinted to even the tone. Aquatinted flowers on the mother's skirt are inked *à la poupée* and printed in red and green.

Plate II: There are no further changes except for the chair, which now is printed in brown and green.

Plate III: The skirt is covered with a fine aquatint along with the bib and jacket with a patterned lapel, both printed in blue. The intervening blue color on the bodice design was achieved by a different and lighter biting of the aquatint. One trial impression (private collection), is printed with an orange background and a light red skirt tone. For the edition of the print, a different coloration, with green predominating, was chosen.

According to Breeskin, an edition of 50 was printed, but the present authors have not located nearly that number.

The following impressions are known: AIC (not signed); BAA; Brooklyn; Grand Rapids; Kansas; LC; MFA (Hartshorne); MIA (initialed only); MMA (Roger Marx, not signed); Oregon; Toledo; Weston (not signed)

Summary of the design on each plate

Plate I: The drypoint outlines and aquatint background tone, as well as lines depicting flowers and small aquatinted flower areas on dress are included.

Plate II: Aquatint and fine drypoint hatching lines are used for flesh tones; the brown chair with green back are both in aquatint and there are drypoint lines added into these aquatint areas.

Plate III: Aquatint is used for the skirt color, blue bib, blue sleeves with intermediate blue tone, and patterned lapels of the mother's dress.

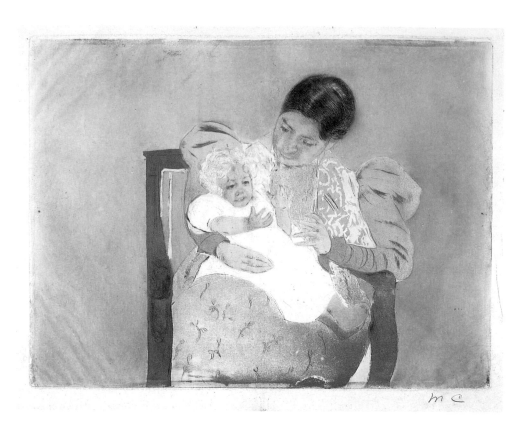

cat. 22-V (PC) Fifth state

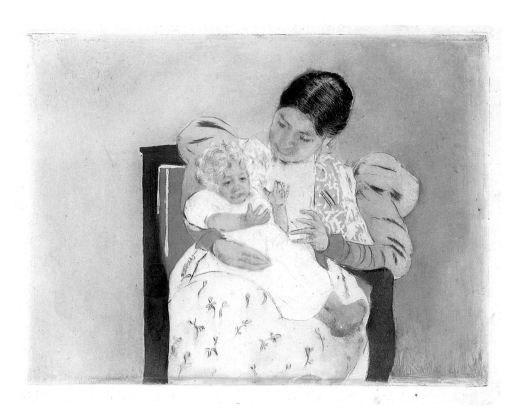

cat. 22-V (MMA) Fifth state

cat. 22-I First state
Drypoint on one plate
Off-white, thin, smooth, laid paper
12⅜ x 16¼ in. (314 x 413 mm) sheet
Watermark: VanderLey with shield
Philadelphia Museum of Art, Gift of
Mrs. Horace Binney Hare, 1956
[not exhibited]

cat. 22-II Second state
Drypoint and aquatint on two plates
Off-white, medium-weight, moderately textured, laid paper
12 x 16⅝ in. (305 x 422 mm) sheet
Watermark: fragment of ARCHES
Philadelphia Museum of Art, Gift of Mrs. Horace Binney
Hare, 1956

cat. 22-III Third state
Drypoint and aquatint on two plates
Pale blue, thin, moderately smooth, laid paper
10⅛ x 13⅝ in. (257 x 346 mm) sheet
Watermark: undecipherable
Signed lower right within platemark: "Mary Cassatt"
Coll: Roger Marx
The Metropolitan Museum of Art, New York, Bequest of
Mrs. H. O. Havemeyer, The Havemeyer Collection, 1929
[not exhibited]

cat. 22-IV Fourth state
Drypoint and aquatint on two plates
Off-white, medium-weight, moderately smooth,
antique laid paper
12⅝ x 16¹⁵⁄₁₆ in. (323 x 430 mm) sheet
Watermark: Crowned shield with letter B;
Signed lower right: "Mary Cassatt":
The Minneapolis Institute of Arts, Ladd Collection, Gift of
Herschel V. Jones, 1916

cat. 22-V (PC) Fifth state
Drypoint and aquatint on three plates
Cream, medium-weight, moderately smooth,
antique laid paper
13¾ x 17 in. (349 x 432 mm) sheet
Watermark: NICOLAS LE BE below
Initialed lower right: "MC"
Private Collection

cat. 22-V (MMA) Fifth state
[editioned print]
Drypoint and aquatint on three plates
Cream, moderately thick, moderately textured, laid paper
11⅞ x 17⅛ in. (302 x 435 mm) sheet
Watermark: fragment of ARCHES
Coll.: Roger Marx
The Metropolitan Museum of Art, New York, Bequest of
Mrs. H. O. Havemeyer, The Havemeyer Collection, 1929

23
Picking Daisies in a Field,
ca. 1896–1897

Breeskin 156+
Drypoint and aquatint
13¼ x 17 in. (336 x 432 mm) platemark

The last of Cassatt's major prints remains unfinished. It is linked to the *Barefooted Child* in its intimate mood and in the use of a finished pastel (fig. 23-1) as a model. Judging from the charm of the two known states, it is unfortunate that it was never completed.

Description of the states

I First state, on two plates

Plate I: Generally light drypoint lines with some burr are incised on the plate with the mother's hair darkly shaded. The overall condition of the paper for this unique impression suggests that Cassatt may have put it aside in her studio.

Plate II: Aquatint colors the composition in part: flesh tones, the mother's jacket, and the child's dress.

A unique impression is known: private collection, Norfolk

II Second state, on two plates

Plate I: Additional drypoint models the mother's jacket, adds detail to her bodice, and more fully defines her skirt and its floral pattern.

Plate II: Further aquatint printed in color describes the mother's dress and enhances the flower design, all inked *à la poupée*.

A unique impression is known: private collection, New York

Summary of the design on each plate

Plate I: Drypoint lines define the composition.
Plate II: Aquatint is added for flesh tones, pink-rose flowers on mother's dress, pale green on child's dress. Accidental areas of aquatint extend beyond contour lines of both faces.

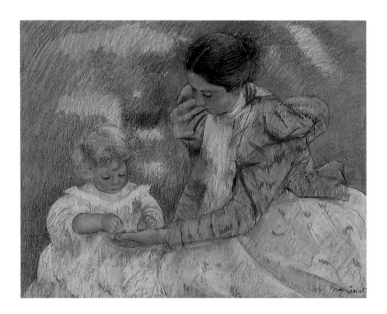

fig. 23-1. Mother Playing with Her Child,
ca. 1897
Pastel on paper
25½ x 31½ in. (648 x 800 mm)
The Metropolitan Museum of Art,
New York, from the Collection of James
Stillman, Gift of Dr. Ernest Stillman, 1922

cat. 23-I First state
Drypoint and aquatint on two plates
Off-white, moderately smooth, laid paper
12⅝ x 15¾ in. (320 x 400 mm) sight
Initialed lower right: "M. C."
Private Collection, Norfolk, Virginia

cat. 23-II Second state
Heavy-weight, laid paper
Private Collection, New York
[not exhibited]

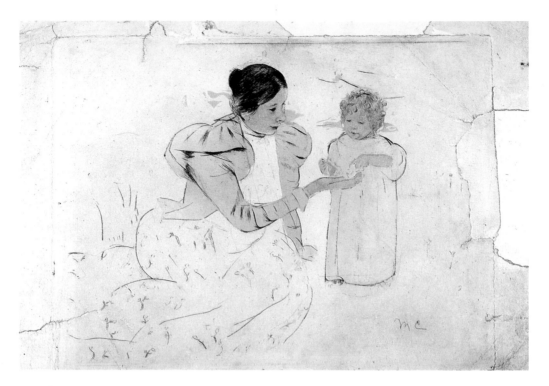

cat. 23-I First state

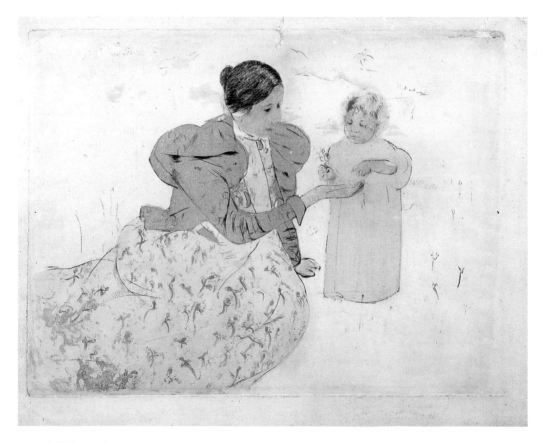

cat. 23-II Second state

Appendix

There are four late Cassatt drypoints that are found in colored impressions.[1] Two of these, *The Manicure* (Br. 199) and *Looking into the Hand Mirror, No. 2* (Br. 202) were printed with colored inks. The other two, *Margot* (also called *Jeanette*) *Wearing a Bonnet, No. 1* (Br. 179) and *Sara Smiling* (Br. 195), are proofs that were hand-colored after printing.

Since no colored impressions of these prints are noted in the Durand-Ruel stock books, which constitute the only systematic recording of the prints made by Cassatt, they are difficult to account for. As a rule, they have been considered later impressions from plates that had been executed between 1900 and 1910 but were reprinted in 1923 by Eugène Delâtre upon Cassatt's request. However, not one of the four prints cited here is included in the list compiled by Breeskin of the Delâtre restrikes,[2] nor can they be found among the set of these prints donated by Cassatt to the Petit Palais in 1924 or to those given by members of her family to the Philadelphia Museum of Art in 1927.

Nonetheless, the two drypoints printed in color, *The Manicure* and *Looking into the Hand Mirror*, may have been pulled by Delâtre during Cassatt's lifetime, since the authors have only located a unique example of each. Traditionally, it has been accepted that no copper plates survived the artist, but there is now some evidence that this is not true, and the possibility of a posthumous printing must be considered.[3]

On the other hand, *Margot Wearing a Bonnet* and *Sara Smiling*, hand-colored after printing, clearly differ in method of execution from any of the artist's known color prints. They are either the result of alterations made to monochrome impressions after Cassatt's death, or more likely, they are "modern" printings from existing plates.

The following impressions in color were located:

The Manicure: Library of Congress [see p.198]
Looking into the Hand Mirror, No. 2: The University of Michigan Museum of Art, Ann Arbor
Margot (Jeanette) Wearing a Bonnet, No. 1: Allen Memorial Art Museum, Oberlin College; Delaware Art Museum, Wilmington; Mead Art Museum, Amherst College; Sheldon Memorial Art Gallery, University of Nebraska; University of Wyoming Art Museum, Laramie [see p.198]
Sara Smiling: Emory University Museum of Art and Archaeology, Atlanta; private collections, Houston and Memphis (2)

Another problematic print is an apparent copy of *The Banjo Lesson* (cat. 16). The authors are aware of at least two such impressions. The drypoint contour lines are not firmly drawn and are especially weak in the hair of the two young women. A comparison with an authentic impression reveals slight differences in the quality of the lines; for example, there are five curved lines at the bottom of the player's skirt near the center of the image instead of six. All the coloring has been applied by hand, ignoring the fact that the pale blue dress on the editioned print was a fixed tone produced by fine aquatint.

On one impression the platemark measures 11⅝ x 9¼ in. (294 x 235 mm) and it is printed on a heavy wove paper; all the known impressions of the final state are on a laid paper, many of which bear the VanderLey watermark. The signature "Mary Cassatt" found at right on the lower margin of the copy does not seem correct.

1. Breeskin records a fifth, *Margot Wearing a Bonnet, No. 4* (Br. 182), and William Weston noted another, Br. 181, but the authors were unable to locate impressions of these prints.
2. Br. 1979, p. 33
3. Mr. Weston has kindly shared with the authors his belief that a handful of plates were found and printed posthumously, sometime after World War II. Although he has no documentary proof of the existence of these plates, he has personally seen a relatively large number of impressions in color of Br. 179, 181, and 195, in which the drypoint lines are pale and the smudges of color are weak and uneven.

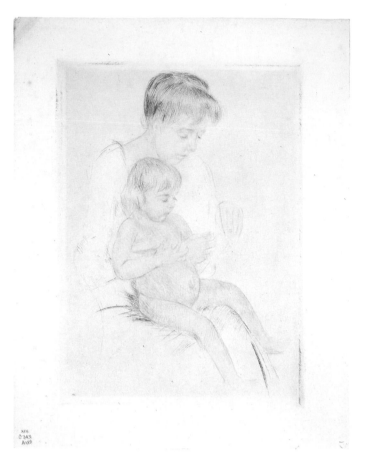

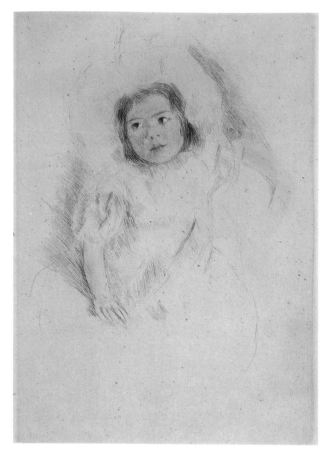

The Manicure, ca. 1908
Br. 199 Second state
Drypoint, printed in color
Off-white, medium-heavy, stiff, laid paper
8¼ x 5⅞ in. (210 x 149 mm) platemark
Library of Congress, Washington, D.C.

Margot Wearing a Bonnet (No. 1), 1903
Br. 179
Drypoint with hand coloring
9³⁄₁₆ x 6½ in. (234 x 165 mm) platemark
Delaware Art Museum, Wilmington, Gift of
Helen Farr Sloan, 1978

Selected Bibliography

The American Register (April 11, 1891): 6.

Bailly-Herzberg, Janine. "Marcellin Desboutin and His World." *Apollo Magazine* 65 (June 1972): 496–500.

————. "Les Estampes de Berthe Morisot." *Gazette des beaux-arts* 93 (1979): 215–227.

————. *Dictionnaire de l'estampe en France, 1830–1950.* Paris: Flammarion, 1985.

Biddle, George. *An American Artist's Story.* Boston: Little, Brown, and Co., 1939.

Boggs, Jean Sutherland, et al. *Degas.* Paris: Ministère de la Culture et de la Communication, Editions de la Réunion des Musées Nationaux, 1988.

Boyle-Turner, Caroline. *The Prints of the Pont-Aven School: Gauguin and His Circle in Brittany.* Washington, D.C.: Smithsonian Institution Press, 1986. Exhibition catalogue.

Breeskin, Adelyn D. *The Graphic Art of Mary Cassatt.* Washington, D.C.: Museum of Graphic Art and Smithsonian Institution Press, 1967. Exhibition catalogue.

————. *The Graphic Work of Mary Cassatt, A Catalogue Raisonné.* New York: H. Bittner and Co., 1948. 2d ed., Washington, D.C.: Smithsonian Institution Press, 1979.

————. *Mary Cassatt, A Catalogue Raisonné of the Oils, Pastels, Watercolors, and Drawings.* Washington, D.C.: Smithsonian Institution Press, 1970.

Brettell, Richard, and Lloyd, Christopher. *Catalogue of Drawings by Camille Pissarro in the Ashmolean Museum, Oxford.* Oxford: Clarendon Press; New York: Oxford University Press, 1980.

Buerger, Janet, and Shapiro, Barbara Stern. "A Note on Degas' Use of Daguerreotype Plates." *The Print Collector's Newsletter* 12 (1981): 103–106.

Caldwell, Eleanor B. "Exposition Mary Cassatt." *Modern Art* 3 (Winter 1895): 4–5.

Carlson, Victor I., and Ittmann, John W., et al. *Regency to Empire: French Printmaking 1715–1814.* Minneapolis: Minneapolis Institute of Arts, 1984.

Catalogue de collection Edgar Degas: Estampes, ancienne et modernes. Sale catalogue. Paris: Hotel Drouot, November 6–7, 1918.

Cate, Phillip Dennis. *Charles Maurin.* New York: Lucien Goldschmidt, 1978. Exhibition catalogue.

————. "Printing in France, 1850–1900: The Artist and New Technologies." *Gazette of The Grolier Club* (June/December 1978): 57–73.

————. "The 'Revolutionary Intrigue' among 19th-century Printmakers." *Art News* 77 (March 1978): 77–84.

———— and Boyer, Patricia Eckert. *The Circle of Toulouse-Lautrec: An Exhibition of the Work of the Artist and of His Close Associates.* New Brunswick, N.J.: Jane Voorhees Zimmerli Art Museum, Rutgers, State University of New Jersey, 1986. Exhibition catalogue.

———— and Hitchings, Sinclair Hamilton. *The Color Revolution: Color Lithography in France 1890–1900.* Santa Barbara, California: Peregrine Smith, Inc., 1978.

Chisolm, Lawrence. *Fenellosa: The Far East and American Culture.* New Haven: Yale University Press, 1963.

Collection des estampes modernes composant la collection Roger Marx. Sale catalogue. Paris: Hotel Drouot, April 27–May 2, 1914.

Correspondance de Camille Pissarro. Edited by Janine Bailly-Herzberg. Vol. 1, *1865–1885* (Paris: Presses Universitaires de France, 1980). Vol. 2, *1886–1890* (Paris: Editions du Valhermeil, 1986). Vol. 3, *1891–1894* (Paris: Editions du Valhermeil, 1988).

The Correspondence of Berthe Morisot. Edited by Denis Rouart, translated by Betty W. Hubbard, London: 1986.

Crabbe, James I. *Among the Curios: The Student's Guide to the Japonesque.* Chicago and New York: Belfond, Clark & Co., 1885.

Dargenty, G. "Exposition de dessins et de gravures." *Courrier de l'art* 10 (March 28, 1890): 98–99.

Degas Letters. Edited by Marcel Guérin. Translated by Marguerite Kay. Oxford: B. Cassirer, 1947.

Distel, Anne. "Un achat par l'Etat d'estampes de Camille Pissarro en 1890." *Nouvelle de l'estampe* (March/April 1894): 8–13.

Druick, Douglas, and Zegers, Peter. *La Pierre Parle: Lithography in France 1848–1900.* Ottawa: National Gallery of Canada, 1981.

Exposition générale de la lithographie, April 26 to May 24, 1891, Paris: Ecole des Beaux-Arts. Exhibition catalogue.

Félix Fénéon, Oeuvres plus que complètes. Edited by Joan U. Halperin. Geneva: Droz, 1970.

Ficke, Arthur Davison. *Chats on Japanese Prints.* Rutland, Vt.: C. E. Tuttle Co., 1958. (Originally published 1915.)

Floyd, Phylis. "Documentary Evidence for the Availability of Japanese Imagery in Europe in Nineteenth-Century Public Collections." *Art Bulletin* 68 (March 1986): 105–141.

Forrer, Matthi, ed. *Essays on Japanese Art: Presented to Jack Hillier.* London: Robert G. Sawers, 1982.

Fuller, Sue. "Mary Cassatt's Use of Soft-Ground Etching." *Magazine of Art* 43 (February 1950): 54–57.

Goncourt, Edmond and Jules de. *Journal, Memoires de la vie littéraire.* Edited by R. Ricatte. Monaco: Editions de l'Imprimerie Nationale de Monaco, 1956. (Originally published 1887–1896.)

Gonse, Louis. *L'Art Japonais.* Paris: Quantin, 1883.

Hamerton, Philip G. *The Etcher's Handbook.* London: Charles Roberson and Co., 1871.

Havemeyer, Louisine W. *Sixteen to Sixty, Memoirs of a Collector.* New York: privately printed, 1961.

Hillier, Jack. *The Art of Hokusai in Book Illustration.* Berkeley: University of California Press, 1980.

Hoebner, Arthur. "'The Century's' American Artists Series—Mary Cassatt." *The Century Magazine* 57 (March 1899): 740–741.

Isaacson, Joel. *The Crisis of Impressionism 1878–1882.* Ann Arbor: University of Michigan Museum of Art, 1980.

Ives, Colta Feller. *The Great Wave: The Influence of Japanese Woodcuts on French Prints.* New York: Metropolitan Museum of Art, 1974.

Jacques Villon: Master of Graphic Art (1875–1913). Boston: Museum of Fine Arts, 1964.

Lant, Antonia. "Purpose and Practice in French Avant-Garde Print-Making of the 1880s." *The Oxford Art Journal* 6 (1983): 18–29.

Lecomte, Georges. "A côté des peintres-graveurs." *L'Art dans les deux mondes* (April 18, 1891): 261–262.

———. "Expositions à Paris, pastellistes français, peintres-graveurs: Camille Pissarro, Mary Cassatt." *L'Art moderne* (April 26, 1891): 137.

Lethève, Jacques. "Le Public du cabinet des estampes au dix-neuvième siècle." *Humanisme actif: Mélange d'art et de littérature offerts à Julien Cain.* Paris, 1968.

Lettres de Degas. Edited by Marcel Guerin. Paris: Grasset, 1931.

Lindsay, Suzanne G. *Mary Cassatt and Philadelphia.* Philadelphia: Philadelphia Museum of Art, 1985. Exhibition catalogue.

Lostalot, A[lfred] de. "Exposition des oeuvres de Miss Mary Cassatt." *La Chronique des arts et de la curiosité* (December 9, 1893): 299.

———. "L'Exposition des peintres-graveurs." *La Chronique des arts et de la curiosité* (March 15, 1890): 82.

Lugt, Frits. *Les Marques de collections de dessins et d'estampes.* Amsterdam: Vereenigde drukkerijen, 1921.

_____. *Les Marques de collections de dessins et d'estampes. • Supplément.* The Hague: M. Nijhoff, 1956.

Mathews, Nancy Mowll. *Mary Cassatt and Edgar Degas.* San Jose, California: San Jose Museum of Art, 1982. Exhibition catalogue.

_____, ed. *Cassatt and Her Circle: Selected Letters.* New York: Abbeville Press, 1984.

Mellerio, André. *Exposition de tableaux, pastels et gravures de Mary Cassatt.* Paris: Galeries Durand-Ruel, November–December 1893. Exhibition catalogue.

Melot, Michel. *L'estampe impressioniste.* Paris: Bibliothèque Nationale, 1974. Exhibition catalogue.

Mourey, Gabriel. "Coloured Etchings in France." *The Studio* (February 1901): 3–14.

Nochlin, Linda. *Impressionism and Post-Impressionism, 1874–1904: Sources and Documents.* Englewood Cliffs, N.J.: Prentice-Hall, 1966.

Peet, Phyllis. *American Women of the Etching Revival.* Atlanta: High Museum of Art, 1988.

Pissarro: Camille Pissarro 1830–1903. London: Arts Council of Great Britain; Boston: Museum of Fine Arts, 1980.

Camille Pissarro: Letters to His Son Lucien. Edited, with the assistance of Lucien Pissarro, by John Rewald. Salt Lake City: Peregrine Smith, Inc., 1981.

Camille Pissarro, Lettres à son fils Lucien. Edited, with the assistance of Lucien Pissarro, by John Rewald. Paris: Edition Albin Michel, 1950

Portalis, Baron Roger. "La Graveur en couleurs." *Gazette des Beaux-Arts* (February 1890): 118–128.

Reed, Sue Welsh, and Shapiro, Barbara Stern. *Edgar Degas: The Painter as Printmaker.* Boston: Museum of Fine Arts, 1984.

Richards, Louise S. "Mary Cassatt's Drawing of 'The Visitor'." *Bulletin of the Cleveland Museum of Art* 65 (October 1978): 268–277.

Riggs, Timothy A. "Mr. Koehler and Mrs. Marrs: The Formation of the Mrs. Kingsmill Marrs Collection." *Worcester Art Museum Journal* 1 (1977–1978): 3–13.

Riordan, Roger. "Miss Mary Cassatt." *The Art Amateur* 38 (May 1898): 130.

Roger-Marx, Claude. *Graphic Art of the Nineteenth Century.* New York, Toronto, London: McGraw-Hill, 1962.

Schwartz, William L. *The Imaginative Interpretation of the Far East in Modern French Literature 1800–1925.* Paris: Champion, 1927.

Segard, Achille. *Mary Cassatt, Un Peintre des enfants et des mères.* Paris: Librairie Paul Ollendorf, 1913.

Shapiro, Barbara Stern. *Mary Cassatt at Home.* Boston: Museum of Fine Arts, 1978. Exhibition catalogue.

Société des Peintres-Graveurs Français: Exhibitions of the Society of Printmakers, 1889–1897. New York: Garland, 1981.

Stein, Donna. *L'Estampe originale: A Catalogue Raisonné.* New York: Museum of Graphic Art, 1970.

Stuckey, Charles. "Recent Degas Publications." *Burlington Magazine* 127 (July 1985): 465–467.

Sweet, Frederick. *Miss Mary Cassatt, Impressionist from Pennsylvania.* Norman, Oklahoma: University of Oklahoma Press, 1966.

Venturi, Lionello. *Les Archives de l'Impressionisme.* 2 vols. Paris and New York: Durand-Ruel, 1939.

Watrous, James. *A Century of American Printmaking.* Madison, Wisconsin: University of Wisconsin Press, 1984.

Weber, Eugen. *France: Fin de Siècle.* Cambridge, Mass.: Harvard University Press, 1986.

Weisberg, Gabriel; Cate, Phillip; Needham, Gerald; Eidelberg, Martin; and Johnston, William. *Japonisme: Japanese Influence on French Art, 1854–1910.* Cleveland: Cleveland Museum of Art, 1975. Exhibition catalogue.

White, Frank Linstow. "Younger American Women in Art." *Frank Leslie's Popular Monthly* (November 1893): 538–544.

Index

In the index all works are by Cassatt unless otherwise noted. Pages on which illustrations appear are in *italics*.

Lenders to the Exhibition

The Art Institute of Chicago
Australian National Gallery
The Baltimore Museum of Art
Boston Public Library
The Cleveland Museum of Art
The Denver Art Museum
The Fine Arts Museums of San Francisco
Mrs. John W. Griffith
Mr. and Mrs. Jem Hom
Hunter Museum of Art
The R. Stanley and Ursula Johnson Collection
Library of Congress
Los Angeles County Museum of Art
Marsha Mault
The Metropolitan Museum of Art

The Minneapolis Institute of Arts
Museum of Fine Arts, Boston
National Gallery of Art
The National Gallery of Canada
The New York Public Library
Philadelphia Museum of Art
St. John's Museum of Art
Sterling and Francine Clark Art Institute
Terra Museum of American Art
Virginia Museum of Fine Arts
Worcester Art Museum
Yale University Art Gallery
and
Anonymous lenders

Photograph Credits

Fig. 11-2: E. Irving Blomstram; cat. 19-ii: S.A.B.A.A., Paris;
cat. 21-i: Andrew Harkins, 1988; cat. 22-i: Andrew Harkins, 1988